Art of Edo Japan

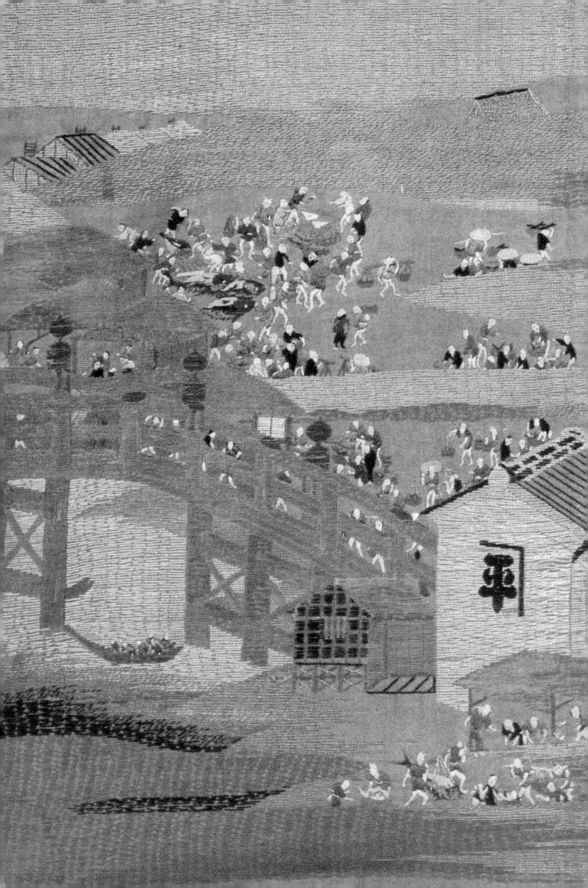

Art of Edo Japan
The Artist and the City 1615-1868

Christine Guth

PERSPECTIVES

HARRY N. ABRAMS, INC., PUBLISHERS

Acknowledgments

I would like to thank Karen Brock, Sandy Kita, Ann Lee Morgan, Thomas Shepherd, and especially Money Hickman, for their helpful comments and suggestions for improvement of the text. In the course of preparing this book for publication, Jacky Colliss Harvey and Ingrid Cranfield provided clear organizational and editorial guidance. Stephen Addiss and Bruce Coats provided invaluable assistance in obtaining photographs, but I owe a special debt of gratitude to Sue Bolsom-Morris whose tireless pursuit of transparencies yielded the profuse illustrations.

Frontispiece Back of robe *(juban)* with scenes of the city of Edo, page 91 (detail)

Series Consultant Tim Barringer (Birkbeck College, London)
Series Director, Harry N. Abrams, Inc., Eve Sinaiko
Senior Editor Jacky Colliss Harvey
Designer Karen Stafford, DQP, London
Cover Designer Miko McGinty
Picture Editor Susan Bolsom-Morris

Library of Congress Cataloging-in-Publication Data
Guth, Christine.
 Art of Edo Japan : the artist and the city 1615—1868 / Christine Guth.
 p. cm. — (Perspectives)
 Includes bibliographical references and index.
 ISBN 0-8109-2730-6 (pbk.)
 1. Art. Japanese — Edo period, 1600—1868. I. Title. II. Series : Perspectives
(Harry N. Abrams, Inc.)
N7353.5.G88 1996
709'.52 — dc20 95—24694

Copyright © 1996 Calmann and King, Ltd.

Published in 1996 by Harry N. Abrams, Incorporated, New York
A Times Mirror Company

This book was produced by Calmann and King, Ltd., London

Printed and bound in Singapore

Contents

CHRONOLOGY

JAPAN

Nara Period: 710-794

Heian period: 794-1185

Kamakura period: 1185-1333

Muromachi period: 1333-1573

Momoyama period: 1573-1615

Edo (Tokugawa) period: 1615-1868

CHINA

Tang dynasty: 618-906

Five Dynasties 906-960

Northern Song dynasty: 960-1127

Southern Song dynasty: 1127-1279

Yuan dynasty: 1279-1368

Ming dynasty: 1368-1644

Qing dynasty: 1644-1911

MAJOR ERA NAMES USED IN THE TEXT

Genroku era: 1688-1704

Kyōhō era: 1716-1736

Kansei era: 1789-1801

The romanization of Japanese words is based on the Hepburn system; that of Chinese words on the Pinyin system. Words such as daimyo, shogun, and netsuke that now appear in Webster's dictionaries, as well as common place names, such as Kyoto and Osaka, are anglicized. Elsewhere diacriticals are used throughout. Names are given in Japanese order, surname first, followed by personal or artistic name. After the first occurrence artists are referred to solely by the artistic name, e.g. Yosa Buson is referred to simply as Buson.

Sources for translations and quotations cited in the text
are indicated in the Bibliography with an ⋆.

Japan during the Edo period, with major cities, provinces, roads, and sea routes.

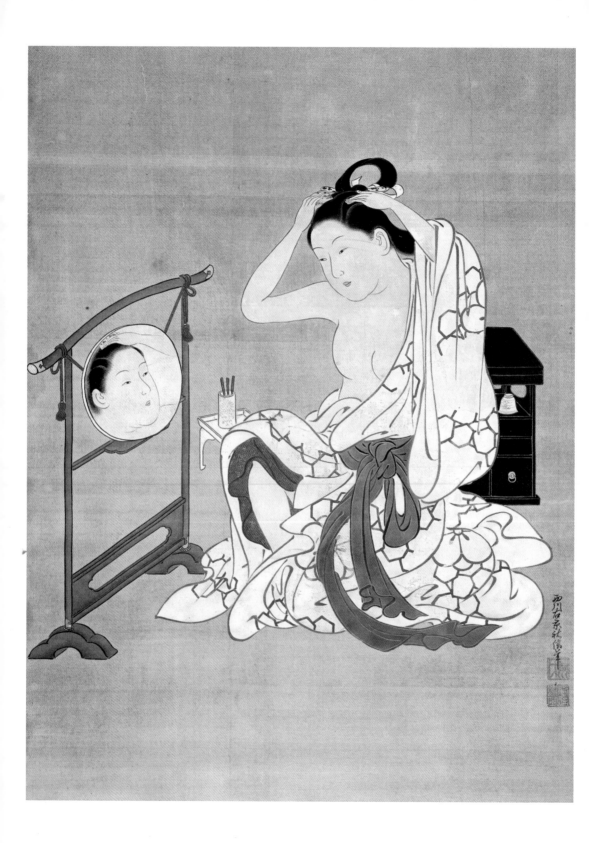

Mapping the Artistic Landscape

1. NISHIKAWA SUKENOBU
(1671-1750)
Beauty at her Toilette, first
half of the eighteenth
century. Hanging scroll, ink
and colors on silk, 33¹/₂ x
17¹/₂" (85 x 44.5 cm).
MOA Museum of Art, Atami.

A rounded face with
upturned nose and slender
but sensuous body are
distinguishing characteristics
of this Kyoto artist's
portrayals of women.
Sukenobu's paintings and
book illustrations reflected
the taste in feminine beauty
in the Kyoto-Osaka area.

The establishment of Edo (now Tokyo) as headquarters of the Tokugawa shogunate in 1603 had a profound and irrevocable impact on the Japanese artistic landscape. When Ieyasu (1543-1616), the first Tokugawa shogun, chose this location as his administrative and military hub, Edo was little more than a garrison surrounding a castle. Yet by the beginning of the eighteenth century, this former backwater had a population of a million inhabitants, making it the largest city in the world. It also boasted a vibrant culture rivalling that of Kyoto, the residence of the emperor and court and Japan's traditional cultural heart. Over the two hundred and fifty years of Tokugawa rule, the dominant modes of visual expression would, for the most part, be shaped by developments in Kyoto and Edo.

Ieyasu established his headquarters in Edo after the emperor appointed him paramount military leader in recognition of his completion of the process of national reunification begun by Oda Nobunaga (1534-82) and Toyotomi Hideyoshi (?1536-98). However, it was not until 1615, when remaining forces loyal to Hideyoshi were eliminated in the siege of Osaka Castle, that Ieyasu could begin institutionalizing his control over the nation. The administrative system he and his immediate successors put in place lasted until 1868, a period known as Tokugawa, after the fifteen generations of shoguns of that name, or Edo, after the city they made their headquarters.

During this period, Japan enjoyed national peace and stability longer than any it had previously known. One of the most immediate consequences of this *pax Tokugawa* was a change in the nature of the ruling warrior or samurai class – a hierarchy consisting of the shogun (commander-in-chief), the daimyo (domain

lords), and their feudal retainers. With the end of internecine warfare, many of these men moved to the city and assumed bureaucratic posts. No longer able to distinguish themselves on the battlefield, they had to demonstrate their ability through wise and skillful administration of the nation. Their military heritage was by no means forgotten, however. On the contrary, with the passage of time, its warrior values and trappings became all the more potent symbols of the right to rule. The shift in focus from the arts of war to the arts of peace also contributed to a new emphasis on cultural pursuits of all kinds. Patronage and practice of the arts were not merely personal vocations but central to the expression and display of the authority of the ruling class.

The Tokugawa shoguns enacted many measures to extend their authority across the nation. They assumed direct administrative control over major cities and ports, including Kyoto, Osaka, and Nagasaki. They implemented policies designed to prevent the country's approximately two hundred daimyo, especially those who had only sworn allegiance to Ieyasu after 1600, from gaining wealth or power that might threaten shogunal authority. They issued directives to the emperor and the hereditary nobility in Kyoto, with whom they maintained an uneasy relationship, enjoining them to devote themselves exclusively to cultural matters and to refrain from involvement in politics. They also instituted what amounted to a national seclusion policy for fear that Christianity might threaten Japanese religious institutions and that daimyo in western Japan might ally themselves with Europeans to the detriment of central authority. The Edo period coincides roughly with this period of national isolation, beginning with the imposition of the policy of seclusion and ending with the re-establishment of trading rights with the USA and other nations in the 1850s and the restoration of direct imperial rule in 1868.

A further part of the Tokugawa government's effort to foster stability and order was the creation of an official social hierarchy, with samurai at the top, followed in descending order by farmers, artisans, and merchants. Farmers were honored above artisans because they were the primary producers of rice, the harvest of which was the source of the annual stipends received by the samurai class. Merchants were relegated to the bottom of the hierarchy because it was held that they produced nothing of value to society. This class, along with craftsmen, became the lifeblood of the city. Together they were often referred to as *chōnin*, literally "residents of the block."

The Edo period saw the blossoming of an urban culture of extraordinary richness, diversity, and originality. This efflorescence resulted both from the creative transformation and commercialization of cultural forms formerly associated with the nobility and warrior elite as well as from new developments, many of them the result of stimuli from the provinces and abroad. Although many scholars have drawn sharp distinctions between "elite" and "popular" culture, such divisions belie the growth of a system of shared cultural values that transcended class.

Until the sixteenth century, artistic patronage had been the exclusive preserve of the court, the shogunate, and religious institutions, which through their artistic choices dictated political ideology and religious dogma. In the Edo period, the phenomenal growth of urban centers with large concentrations of wealthy townspeople (*chōnin*) challenged efforts by the ruling elite to maintain centralized control over artistic production. The economic power of the bourgeoisie, especially in Edo, Kyoto, and Osaka, not only undermined the shogunate's artistic hegemony but, by enabling aesthetic choice, contributed to a new artistic pluralism.

Since artistic accomplishment was a sign of personal cultivation that was highly regarded at all levels of the increasingly literate Edo society, men and women of all classes took up the practice of one or more art forms. They had a wide range of specialities from which to choose. The "Four Accomplishments" of music, painting, calligraphy, and games of skill enjoyed the greatest popularity and cachet, partly because they were so highly esteemed in China, traditionally Japan's cultural mentor. The intimate relationship between painting, poetry, and calligraphy that prevailed in China also characterized artistic expression in Japan.

While the shogunate was able to control the themes and styles of official art through its patronage, it was not able to impose this canon of taste among merchants, artisans, and farmers (FIG. 2), or even its feudal vassals. Feudatories could not ignore the official canon in the decoration of their residences, but they could follow their personal tastes and interests in commissioning works for their private enjoyment. Consequently, many innovative artists expressed themselves in ways that were not officially sanctioned

2. KI BAITEI (1774-1810)
Woman taking Food to Farmer in the Rice Fields,
from *Kyūrō's Picture-album (Kyūrōgafu),* 1797.
Woodblock-printed book,
10¼ x 7⅓″ (26.1 x 18.6 cm).
British Museum, London.

Late eighteenth- and nineteenth-century literati artists often celebrated the simple pleasures of rural life.

by the government. Indeed, some, recognizing the advantages of setting themselves up in opposition to official taste, created a kind of self-conscious counterculture.

Aesthetic choices imply competition, and one of the basic facts of artistic survival in the urban milieu was finding and keeping an audience. Competition contributed to the stylistic eclecticism and pursuit of novelty characteristic of the arts of the Edo period. It underlay artists' attentiveness to the packaging and merchandizing of both their art and their personae. That art took on the aspect of a commodity also helps to explain why great importance was attached to the issue of amateur versus professional artistic status. Like the nineteenth-century aesthetic in the West that sought to place the work of art in an ideal world outside the socio-economic realm, the amateur ideal professed to represent an alternative to the materialism pervasive in the artistic world of the Edo period – in spite of the fact that it too was party to that very materialism.

The rivalry between the Kansai or Kamigata region in the southwest, dominated by the cities of Kyoto and Osaka, and the Kantō region in the northeast, dominated by Edo, is a striking leitmotif in Japanese cultural history. There had been a conspicuous linguistic, political, and cultural gulf between the western and eastern parts of the country since ancient times, but it grew more pronounced during the Edo period as Kyoto strove to remain the nation's cultural arbiter in the face of the growing challenge from Edo.

The dichotomy in aesthetic tastes and values was especially sharp in the urban milieu. Residents of Kyoto affirmed and identified with the refined aesthetic traditions of the imperial court, which had for centuries resided in Kyoto. Those of Edo, which had no such legacy, took pride in their modernity, and were especially receptive to novelty. Residents of Kyoto also believed they possessed a more elegant and understated sense of urban chic than their brasher Edo counterparts. Tastes in theatre also diverged: in Kabuki drama, residents of Osaka and Kyoto favored the refined and sometimes sentimental *wagoto* or "soft style," while their Edo counterparts preferred the braggadocio of *aragoto* or "rough style."

The dynamics of the relationship between Kyoto and Edo fluctuated over the course of the period. Kyoto, which had long held the nation's greatest concentration of population and wealth, was the first to recover from the ravages of the civil war that ended with Ieyasu's unification of the country. Production of the luxury goods for which the city had long been renowned

flourished by the turn of the seventeenth century. Although the emperor and nobility were impoverished, the cultural legacy they embodied was a defining force in Kyoto's cultural renaissance. In the early years of the Edo period, the arts of Kyoto fed chiefly on values and idioms of the nobility as adapted and interpreted by and for newly affluent merchants and artisans. The influence of this courtly aesthetic was not limited to the pictorial arts but also gave a distinctive character to the ceramics, lacquer, and especially the textiles used for fashionable clothing created in this city. Both the exploration and re-use of its literary and artistic past and a close inter-relationship between the various media would remain hallmarks of Kyoto art throughout the Edo period.

In the eighteenth century, Kyoto's prosperity and prestige began to decline in the face of expanded commercial and cultural activity in other cities, especially Edo. Nonetheless, Kyoto's artistic and intellectual ambience continued to make it a magnet for innovative artists, particularly those who sought to express through their art their alienation from shogunal culture. While some plumbed Kyoto's ancient imperial and court traditions, others were inspired by new influences from China and the West.

Edo assumed a recognizable, autonomous cultural identity in the mid-eighteenth century, roughly simultaneously with the advent of the full-color woodblock print. While prints were by no means the sole art form produced in Edo, they were the most ubiquitous. Because they could be produced cheaply and in large numbers, they made artistic production and consumption possible on a scale previously unknown in Japan. Popularly known as *ukiyoe*, "pictures of the floating world," prints celebrating the ephemeral beauty and fame of Edo's courtesans and actors as well as the seasonal attractions of the city's scenic spots became the hallmark of Edo art. Like many forms of pictorial expression that flourished during the Edo period, prints focusing on the fashionable activities and interests of the urban bourgeoisie evolved from genres of painting that had first appeared in late sixteenth-century Kyoto.

Single-sheet prints and woodblock-printed book illustrations both shaped and reflected the vibrant culture of the theaters and pleasure quarters, realms that offered an appealing alternative to the official culture supported by the shogunate. Although many of the subjects and styles featured in such prints had appeared earlier in paintings produced in Kyoto, Edo artists adapted them to reflect local tastes and priorities (see FIG. 1, page 9). They depicted women according to local canons of feminine beauty and actors in the *aragoto* roles popularized on Edo stages. Tighter

government control over artistic activity in the shogunal city also channeled the energies of many artists into subversive forms of humor, satire, and irony that had no counterparts in Kyoto. While Kyoto painters generally gave expression to an affirmative, optimistic outlook, Edo print designers embraced an aesthetic of visual doubt, highlighting the discrepancies between what is seen and what is represented.

Edo's extraordinarily rapid growth was a function not simply of its status as the nation's political and administrative center but rather of a peculiar institution established by the shogunate in 1634. Known as "alternate attendance" (*sankin kōtai*), it required all the nation's feudal lords to maintain large, lavishly decorated establishments in Edo where they could alternate periods in attendance to the shogun and where their families would remain as hostages when they returned to their fiefs. This system, designed to prevent daimyo from accumulating wealth or power that might threaten central authority, was the catalyst for Edo's becoming a center of unparalleled wealth and consumption. Because it required the daimyo's large retinue to reside in the capital for long periods of time without their own wives and families, it also fueled the culture of the pleasure quarters.

The institution of "alternate attendance" also fostered artistic developments outside Edo. In order to facilitate trade and travel by feudal lords and their extensive retinues, the Tokugawa government built up a vast network of highways and waterways linking the nation's three major cities of Edo, Kyoto, and Osaka with provincial towns and ports. In the late eighteenth and nineteenth centuries, the movement of daimyo and their vassals, as well as merchants, peddlers, pilgrims (FIG. 3), and pleasure-seekers along these and other routes contributed to the growth of distinct regional cultures within the broader framework of an increasingly integrated national culture.

While Kyoto and Edo dictated the dominant cultural trends, these were inflected by stimuli from other cities, most notably Osaka and Nagasaki, and from provincial and rural regions. Osaka, some thirty miles southwest of Kyoto, a temple and commercial town in Momoyama times, became in the Edo period a vast mercantile and shipping center with a population of 400,000. Because of its size and commercial importance, Osaka was considered one of Japan's

3. ANONYMOUS
Ise Pilgrimage Mandala, late sixteenth century (detail of FIG. 106, page 158). Hanging scroll, ink and colors on paper, 3′4″ x 5′11″ (1 x 1.8 m). Jingū Chōkokan, Ise.

While some pilgrims cross the bridge leading to the Inner Shrine at Ise, others purify themselves in the river below.

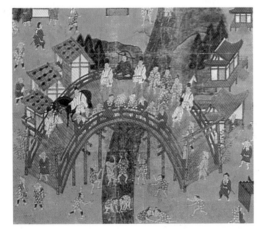

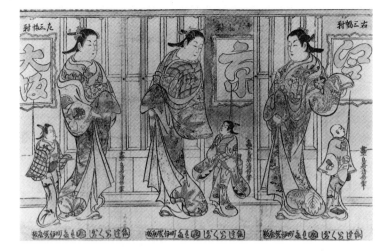

4. TORII KIYOMASU (?-1716) *Courtesans of the Three Cities*, c. 1696-1716. Woodblock print, triptych, each sheet 18 x 11½" (46 x 29 cm). Worcester Art Museum, Mass.

Woodblock prints comparing the attractions of courtesans of Kyoto, Osaka, and Edo reflect the intense interurban rivalry that prevailed in the eighteenth century.

three great metropolises (*santō*), and in the late seventeenth and early eighteenth centuries, cultural rivalry between Osaka, Kyoto, and Edo was intense (FIG. 4). Osaka's inhabitants supported theaters and pleasure quarters as well as publishing houses noted for the quality of their illustrated books and prints. The wealth and intellectual curiosity of its merchants also attracted many painters.

Although its inhabitants were prohibited from traveling abroad after the 1630s by the shogunal policy of national seclusion, Edo-period Japan was by no means cut off from the outside world. Indeed, foreign influences were an important ingredient in the cultural mix that gives the arts of this period their distinctive flavor. For the most part, these influences filtered into Japan via the port of Nagasaki, on the southern island of Kyushu. A Chinese community living in Nagasaki proper and a small number of Dutch residents, mostly associated with the Dutch East India Company and confined to Deshima island in Nagasaki harbor, made this port a mecca for artists seeking to learn about the outside world.

In the Edo period Japan's relationship with China, traditionally its chief cultural mentor, was multi-faceted and highly complex. Many developments in the arts of this era reflected the image of Chinese culture held by Japanese artists and their audiences, an image which, however, bore no more resemblance to historical China than that of nineteenth-century European Japonistes did to Japan.

Chinese culture was revered, emulated, and used as part of a strategy to legitimize and classify Japan's own culture. The ethical values of Confucianism were a particularly pervasive influence, for notions of loyalty to one's master and filial piety were central

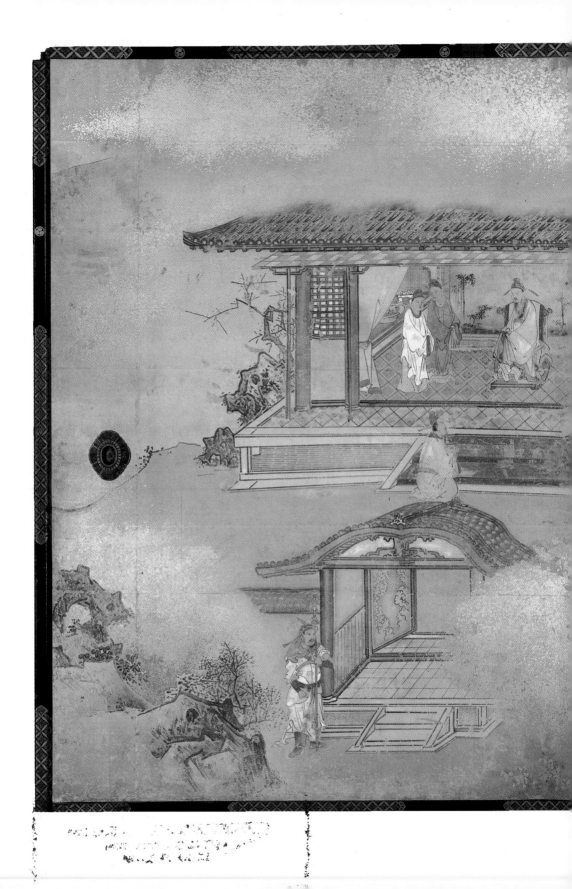

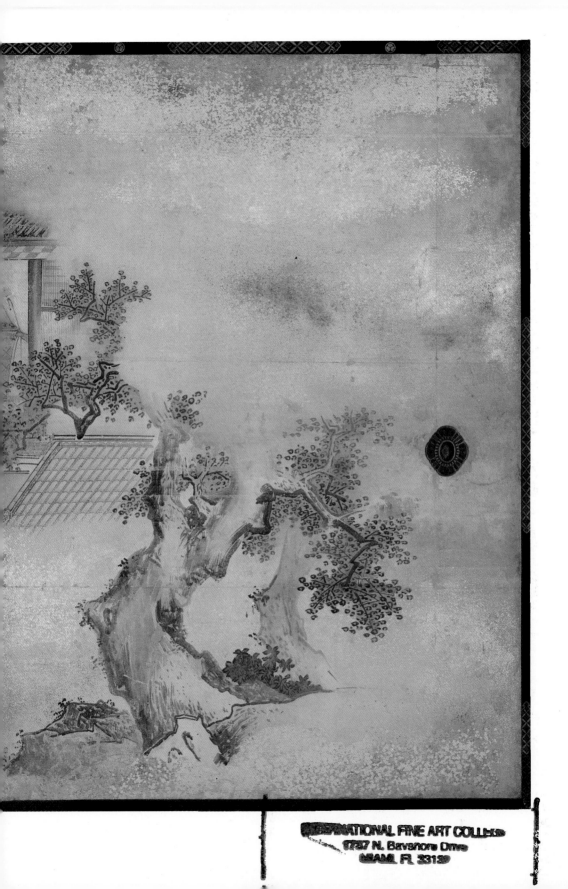

to feudal culture. Moreover many of the Tokugawa shogunate's attitudes towards art were rooted in the Confucian tenet that the personal practice and promotion of the arts by the ruling elite served to legitimate the regime, impart the proper moral values to the nation, and ensure cosmic order (FIG. 5). The contentious divide between "amateur" and "professional" artists was also rooted in Chinese tradition: in China this distinction, more ideal than real, had sought since the twelfth century to distinguish cultivated gentleman painters, often called literati, from those who made their living from the sale of their art.

Despite, or perhaps because of, the official closure of the country, government bureaucrats, intellectuals, and artists were eager to learn about the West. Awareness of developments in European sciences and technology (FIG. 6), especially botany, anatomy, geography, and other natural sciences, intensified after 1720, when the shogunate lifted the ban on imported books. The diffusion of such publications, many of them illustrated, stimulated a growing empiricism in the arts. By the end of the eighteenth century, while nativists disillusioned with the shogunate's moral and intellectual decay turned to the study of antiquity, others turned to European modalities of thought and art.

The experience of travel within Japan was important for many artists of the Edo period. Urban artists made journeys of personal discovery by visiting famous holy spots, by retracing the steps of a famous poet or religious leader, or simply by contemplating the beauties of the natural world. In the nineteenth century, the growing numbers of wealthy and literate farmers also prompted urban artists to travel to remote areas in search of patronage, contributing in the process to the blurring of the boundaries between urban and rural culture.

Cultural movement along the nation's roads and waterways was by no means a one-way process. Although city dwellers delighted in poking fun at ignorant country bumpkins, in fact urban culture was constantly nourished and revitalized by the comings and goings of people from the countryside. The tides of men and women flowing to the city in search of employment carried traditional beliefs and practices that were incorporated into its arts. Travelers also brought back souvenirs in the form of local textiles, lacquer, and ceramics that offered novel and often unpretentious alternatives to the art available in the urban milieu. High-quality regional crafts produced under the auspices of daimyo in provincial fiefs and tribute articles sent from the distant islands of the Ryūkyūan archipelago also influenced metropolitan artistic taste and fashions.

This book takes as its premise that a strong sense of urban and regional identity is one of the distinguishing features of Edo-period culture. It surveys the activities of selected artists in their physical and socio-economic environment to bring into relief the cultural dynamics within and among four major cities: Kyoto, Edo, Osaka, and Nagasaki. Since the movement of artists between cities, and between city and country, played such an important role in artistic developments, it also touches on these reciprocal and mutually reinforcing relationships.

Within this framework, I develop themes that highlight the impact of the urban environment on the artist. What role did the physical setting play in shaping the artist's vision? How did artists see themselves in relation to other artists and to society? What was the nature of the relationship between artist and patron? How did competition among urban artist's influence the making and marketing of art? No study of this length can discuss the artistic activities of an entire nation over a 250-year period in all their rich diversity. Therefore, although some practitioners of calligraphy, sculpture, ceramics, lacquer, and textiles are discussed, the study's main focus is the painters and print designers whose work both shaped and mirrored the dominant trends in the vibrant cultural life of the city.

6. KEISAI MASAYOSHI, SHIBA KŌKAN, AND OTHERS *The Treatment of a Patient with Hiraga Gennai's Static Electricity Device,* from *A Miscellany of Dutch Studies* (*Kōmo Zatsuwa*), 1787. Woodblock-printed book, 8²/₃ x 6″ (22.3 x 15.7 cm). British Museum, London.

Hiraga Gennai built several devices for generating static electricity following Dutch models. These machines were used (unsuccessfully) to treat various medical disorders.

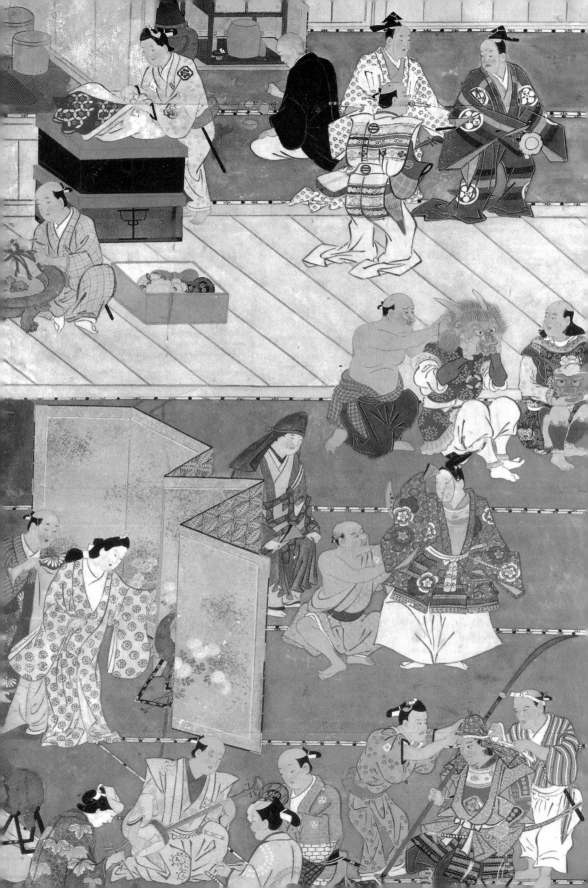

The Artist and the City

7. HISHIKAWA MORONOBU
(c. 1618-94)
Backstage at a Kabuki Theater (detail). Pair of six-panel folding screens, ink, colors, and gold powder on paper, each screen 5'8" x 12'11" (1.7 x 3.9 m). National Museum, Tokyo.

Moronobu adopted an aerial perspective to allow a panoramic view of actors backstage at Edo's Nakamuraza, dressing, putting on make-up and tuning their instruments before a performance.

Japanese artists first began painting panoramic views of the city of Kyoto and its environs in the early sixteenth century. These cityscapes, known as "Views in and around the Capital" ("Rakuchū rakugai-zu"), are typically in the form of pairs of six-panel folding screens with the eastern part of Kyoto on the right and the western part on the left. They combine aerial views of the city's celebrated palaces, temples, and shrines with glimpses of the public and private activities of its citizenry (FIG. 8). By the end of the seventeenth century, idealizing views of Edo and other urban centers had become ubiquitous in artistic media ranging from painting and prints to textiles and lacquer. The advent and enduring popularity of this pictorial genre tells much about the growing importance of the city and the artist's place within it.

The city transformed the artist's sense of himself as well as his sense of space, of time, and of society. Although the city did not entirely replace nature as the governing metaphor in art, it offered a new ideal of abundance and energy that was shaped by human rather than divine hands. The city brought together people from all walks of life from throughout the country, offering them drama and pageantry, day and night, regardless of season. In the city, information, material goods, and leisure pastimes previously limited to the elite were readily available to all.

Artists were attracted to the city because of the economic opportunities it offered. Kyoto had an active and diverse artistic community before the Edo period, but other centers developed during the sixteenth century under the patronage of feudal lords or because of an advantageous location. Some artists moved from countryside to city or one city to another of their own volition,

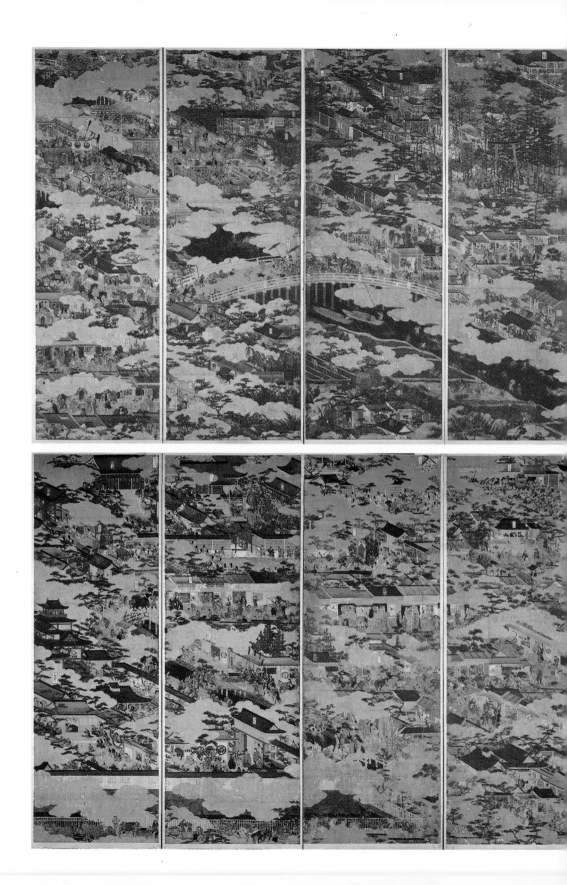

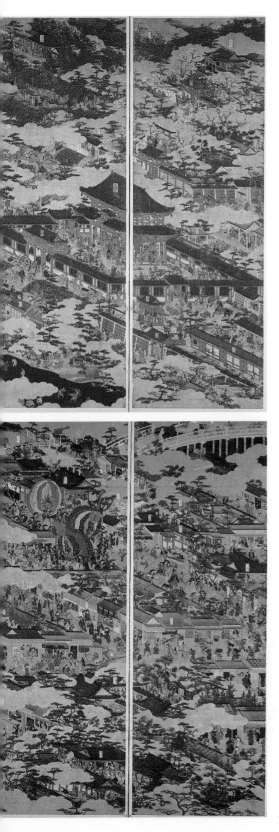

8. ANONYMOUS

Views in and around the Capital, first half of the seventeenth century. Pair of six-panel folding screens, ink and colors on gold, each screen 5'4" x 11'3" (1.6 x 3.4 m). National Museum, Tokyo.

The architectural landmarks, seasonal beauties, and cultural activities in this panoramic view of Kyoto and its environs are shown with map-like clarity through bands of gold-leaf clouds. The screens (the right at the top and the left below) invite vicarious travel from the hilly suburbs, dotted with temples and shrines, into the city's grid-like streets, dominated by the imposing residences of the nobility and military elite. In the bustling commercial districts is an eye-catching procession of colorful floats, the highlight of the Gion Festival, held annually in mid-July. Autumn foliage and snow-covered hills in the periphery further reinforce the image of the city as a coherent and orderly universe.

but most, especially in the early seventeenth century, were offered incentives or even coerced to do so. Once established, they built up hereditary workshops, the most successful of which often flourished for generations.

The artist's new-found identification with the city is clear from the fact that so many incorporated into their signatures the words Edo, Heian, or Miyako, the last two being alternative names for Kyoto. Some ateliers were also known by their location within the city. The Kyoto school founded by Maruyama Ōkyo (1733-95) and Matsumura Goshun (1751-1811) was known as Maruyama-Shijō, after Shijō ("Fourth Avenue"), where Goshun resided. The four main branches of the Kano school in Edo were also known by the location of their studios as Kajibashi ("Blacksmith's Bridge"), Nakabashi ("Central Bridge"), Kobikichō ("Lumbermill District"), and Hamachō ("Beach District").

The Castle Town

Pictures of places celebrated in poetry (meishoe) had figured prominently in the artistic repertory since the Heian period (794-1185) but, for the most part, these were scenic spots remote from major centers of population, valued for their metaphorical associations. The new emphasis on the urban landscape as a microcosm of the state and human society parallels the remarkable growth of towns and cities between 1580 and 1700, and the slower but continuing growth thereafter. As its population nearly doubled, to approximately thirty million, with more than ten per cent living in towns of ten thousand or more inhabitants, Japan became one of the most urbanized nations in the world.

There had been a number of sizable towns and cities before the sixteenth century, most notably Kyoto, the residence of the emperor and the court; Nara, capital from 710 to 784; Kamakura, the headquarters of the shogunate from 1185 to 1333; and the port of Sakai, which thrived during the Muromachi (1333-1573) and Momoyama (1573-1615) periods. However, most of the urban centers that sprang up during the sixteenth and early seventeenth centuries began as castle towns (jōkamachi), and were newly constructed in undeveloped areas of strategic importance to local warlords.

Many of the more than two hundred castle towns across the country were developed between 1580 and 1610, during the turbulent final phase of the national reunification by Nobunaga, Hideyoshi, and Ieyasu. So powerful was the image of Kyoto as an urban ideal that many provincial warlords even incorporated

replicas of Kyoto's landmark buildings into their castle towns. While some of these rose rapidly only to fall into equally rapid decline after the death of their lords, others continued to flourish throughout the Edo period. Osaka, earlier known as Ishiyama after the fortified religious community headquartered there, was refashioned by Hideyoshi with the construction of an exceptionally large and opulent castle. Although Osaka Castle was largely destroyed by Ieyasu's forces in 1614-15, the surrounding city developed into one of Japan's leading commercial centers. Hideyoshi also enlarged and remodeled an already existing castle at Himeji in western Japan, and in so doing, stimulated the growth of this town (FIG. 9). Nagoya, seat of the Owari branch of the Tokugawa family, and Kanazawa, seat of the Maeda family domain, also originated as *jōkamachi*, as did Edo under the Tokugawa.

Jōkamachi were initially designed as military garrisons with towering, walled castle-forts at their center. Knowledge of European castles, gained through books and prints brought to Japan by sixteenth-century Portuguese traders and missionaries, as well as the advent of firearms (also introduced by the Portuguese),

9. Himeji Castle, Himeji, Hyōgo Prefecture, late sixteenth century.

Like most sixteenth-century castles, Himeji has been extensively restored, but its soaring keep is the best preserved in Japan. Because of its striking white walls and unusually elegant proportions, it is popularly known as the "Castle of the White Herons."

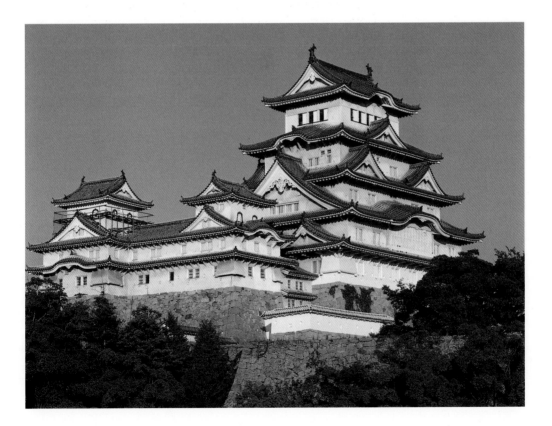

may have influenced their design. The castle and surrounding area, the central, most elevated quarter of the city, was reserved for feudal lords and warriors. Unlike medieval castle towns in Europe, those in Japan lacked fortified city walls, but had moats and winding approaches ending in culs-de-sac to inhibit easy passage by enemies. The moats, many of them incorporating streams and rivers, also served to separate the residential areas of the feudal lord and his immediate vassals from those of the craftsmen and merchants who supplied their many needs. Farmers who provided comestibles for the city lived in the surrounding areas.

Castle construction and decoration were magnets for talented and ambitious carpenters, painters, sculptors, tilemakers, and other craftsmen from all over the country. The still unsettled social conditions of the sixteenth and early seventeenth centuries made it possible for artists of even the most humble background to achieve sudden professional success. The founder of the Raku tradition of pottery, for instance, was employed as a tilemaker in the construction of Hideyoshi's Jūrakudai Castle when he was commissioned by the tea master Sen no Rikyū (1522-91) to make

10. Jōdan no ma, Shiroshoin, c. 1632. Nishi Honganji, Kyoto.

This audience hall was once thought to have formed part of Hideyoshi's Fushimi Castle, but recent research indicates that it dates from the Kan'ei era (1624-44). The raised area (*jōdan*) in front of the *tokonoma* and staggered shelves, designed for use by high-ranking persons, is a feature of the most formal audience halls.

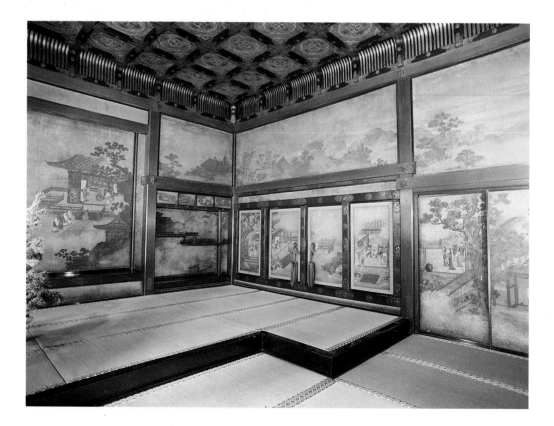

a new type of teabowl that conformed to the latter's aesthetic. The Raku lineage remained active in Kyoto throughout the Edo period, creating their trademark handmolded bowls with dull matte glazes for use in the austere (Jap.: *wabi*) style of tea ceremony popularized by Rikyū.

Although many of the artistic lineages that flourished during the Edo period got their start under the patronage of feudal lords of the Momoyama era, few were as influential or as long-lived as the Kano school of painters. The military leaders in this age of territorial consolidation were acutely sensitive to the value of private and public symbols of wealth and power, and the Kano painters succeeded better than any others in giving artistic expression to this concern. Kano Eitoku (1543-90) and other members of the Kano school developed ambitious decorative programs for Nobunaga's Azuchi Castle and later for Hideyoshi's Fushimi, Jūrakudai, and Osaka Castles. Painting on the interior sliding screens that functioned as room partitions, they established the opulent norms for castle, palace, and temple decoration for centuries to come.

Function dictated the decor of each room. Public audience halls generally featured Chinese cultural heroes, sages, political role models, or flora and fauna of the four seasons, painted in bold colors against lavish, gold-foil backgrounds. To create an aesthetically and psychologically differentiated environment, more contemplative landscapes painted in ink and light colors decorated the private chambers.

Castle interiors featured many elements that became standard in the residential architecture of all classes during the Edo period. These included the use of wood- or paper-covered sliding screens (*fusuma*) to divide interior space, straw mats (*tatami*) covering the floor, and a decorative alcove (*tokonoma*) and adjoining, built-in staggered shelves (*chigaidana*) for displaying painting or calligraphic scrolls and other *objets d'art* (FIG. 10). Unlike castles, however, later palaces, residences, and temples built in this so-called *shoin* ("book hall" or "study") style were single-story structures and were often surrounded by carefully landscaped gardens (FIG. 11).

In the long period of peace that followed Ieyasu's consolidation of power and institution of a centralized feudal system with headquarters in Edo, the castle town lost its primarily defensive role and became the administrative and commercial center for each feudal domain.

11. KAWAHARA KEIGA
Painter in his Studio with Pupils, 1820s (detail of FIG. 22, page 40). Album leaf, ink and colors on silk, 25 x 31½″ (64.4 x 80.5 cm). National Museum of Ethnology, Leiden.

A view of a tiny courtyard garden dominated by a group of stones and a tree, glimpsed through a pair of open sliding door screens.

This shift was accelerated by the shogunate's order to dismantle and destroy many castles, limiting each of the country's approximately two hundred feudal domains to a single castle town. The construction of networks of highways and waterways linking the remaining castle towns with Kyoto, Osaka, and Edo, the nation's three major commercial centers, further hastened this transformation. By fostering urban migration and interregional trade, these roads contributed to the physical and economic growth of towns and cities all over Japan.

Urban Culture

Despite the shogunate's efforts to maintain status-based distinctions, cultural tastes among the samurai, merchants, and artisans in the city were not as different as is commonly held. Rising income, increasing leisure, and growing literacy enabled most residents to engage in social and cultural activities to a degree unknown in earlier eras. Of the many pastimes available to them, the theater and pleasure quarters were by far the most popular, but there were also festivals, painting and poetry gatherings, and tea ceremonies (FIG. 12) to name only a few. Since nearly all residents participated in such activities to some extent, it may be argued that the cultivation of leisure was a key element in urban culture.

In theory, the Confucian ethic espoused by the feudal authorities held participation in pastimes without morally uplifting or didactic value to be frivolous, and the shogunate periodically admonished the populace about indulgence in leisure pursuits. Activities that stimulated the imagination or gratified sexual appetites were deemed a special threat to social stability and, though tolerated, were controlled with varying degrees of severity from one administration to another. The government treated courtesans and actors as social outcasts whose activities required especially careful monitoring. Artists who associated with these two groups were also regarded as potentially dangerous, and their work was often censored. The activities of those itinerant entertainers and artists who lived outside the major cities or traveled from town to town were more difficult to monitor, however.

The pleasure quarters and nearby Kabuki theaters were primary centers of artistic activity and sources of inspiration for many urban artists. Although Edo's Yoshiwara was the most famous, every large city had a licenced district with its own name and special identity. A popular eighteenth-century saying

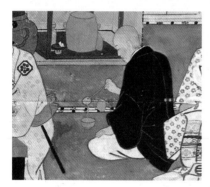

12. HISHIKAWA MORONOBU (c. 1618-94)
Backstage at a Kabuki Theater (detail of FIG. 7, page 21). Pair of six-panel folding screens, ink, colors, and gold powder on paper, each screen 5′8″ x 12′11″ (1.7 x 3.9 m). National Museum, Tokyo.

A monk prepares ceremonial tea using utensils arranged on the rectangular stand before him.

held that the courtesans of Kyoto's Shimabara were the most beautiful, those of the Yoshiwara the most spirited, and those of Nagasaki's Maruyama the best dressed, while Osaka's Shinmachi was unmatched in the splendor of its decor.

The women of the pleasure quarters ranged from the sumptuously gowned and coiffed beauties known as *tayū*, who were exceedingly difficult to meet, to slovenly streetwalkers, who might serve dozens of men in a single night. (An *obi* or sash tied in the front was the hallmark of the *tayū*.) These high-ranking courtesans were idealized figures to whom were attributed many of the qualities traditionally ascribed to the hereditary nobility. They were expected to be skilled in music, poetry, painting, calligraphy, and other arts (FIG. 13). Mastery of calligraphy was deemed especially important since the exchange of letters played such a key role in the game of love. While glamorous and talented courtesans were especially influential in setting standards in personal cultivation, dress, and hairstyle, occasionally beauties from the world outside the pleasure quarters also achieved temporary fame and inspired prints celebrating their attractions.

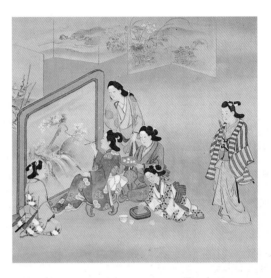

The entertainment district was a place not merely to find sexual gratification but one where artistic experience and ephemeral love combined as a means of escaping time. As implied by its sobriquet *ukiyo* ("floating world"), it was a realm of the imagination that fostered a kind of aesthetic which cherished the passing moment and temporal flux for their own sake. Asai Ryōi (d. 1691), in his *Tales of the Floating World* (*Ukiyo monogatari*, c. 1660), a satirical account of the life of a bumbling priest named Ukiyobō, characterized the floating world as "living only for the moment, savoring the moon, the snow, the cherry blossoms, and the maple leaves, singing songs, drinking sake, and diverting oneself just in floating, unconcerned by the prospect of imminent poverty, buoyant and carefree, like a gourd carried along with the river current" (cited by M. Hickman). In the following decades, the term took on other connotations as well, ranging from up-to-date and fashionable to erotic and *risqué*. The fluidity of the alternative social and cultural values associated with the *ukiyo* posed a threat to the stable, hierarchical, official culture promoted by the government.

13. MIYAGAWA CHŌSHUN *Courtesan Painting a Standing Screen,* from *Popular Amusements in Edo* 1716-36 (detail). Handscroll, ink and colors on paper, 15³/₄" x 16'7" (40 cm x 5.1 m). British Museum, London.

The courtesan painter was a popular theme in Edo prints and paintings. Here a fashionably dressed and coiffed woman paints a landscape, with her attendants assisting by preparing ink and holding pigments.

Affluent merchants and artisans (*chōnin*) were particularly attracted to the aesthetic values of the *ukiyo*, which to them represented a strategic response to their exclusion from political power. Their cultural heroes were free-spending urban sophisticates, versed in the ways of the world and the heart, known in the Kyoto-Osaka area as *sui* and in Edo as *tsū*. Although both terms celebrated amatory dalliance as an art form, *sui* emphasized the mastery of the classical arts, while *tsū* emphasized the art of living well.

By expressing themselves through dress and conspicuous consumption, often in defiance of sumptuary regulations, *chōnin* claimed cultural authority for themselves. They were prohibited from wearing silk, but this did not prevent them from flaunting equally costly garments made of other materials or from wearing luxurious undergarments. Circumvention of the law by means of such covert displays of luxury was central to the sense of urban chic (see FIG. 56, page 91).

Both men and women wore the *kosode* ("small-sleeved robe," a reference to the small wrist opening), an unfitted garment secured with a sash, which was the predecessor of the modern kimono. The *kosode* had evolved from a simple undergarment worn by commoners, but its cut and construction changed little over the course of the Edo period. Instead, changes in fashion and personal taste were given expression primarily through choice of fabric, surface decoration, and color. Although there were exceptions, men generally wore robes with more subdued patterns than women. Auspicious and seasonal motifs with literary associations such as pine, bamboo, plum blossoms, and cranes were common, as were views of famous places, but more daring dressers might also choose garments with bold, oversize pictorial motifs or even visual and verbal puns (FIG. 14). Selection was often made by consulting printed pattern books containing the latest designs. Published primarily in Kyoto, Osaka, and Edo, these illustrated booklets captivated prospective buyers as well as women who lacked the means to acquire their offerings.

14. Outer robe (*uchikake*) decorated with stream and irises, first half of the nineteenth century. Tie-dyeing, paste-resist dyeing, and silk-thread embroidery on white, figured satin, 5'10" x 4'1½" (1.7 x 1.2 m). Kanebo Museum of Textiles.

The decoration of this robe was influenced by Rinpa design. The motif of irises by a meandering stream alludes to a celebrated episode in the *Tales of Ise*.

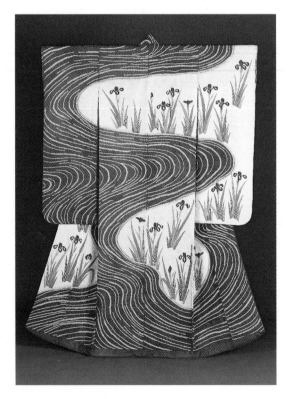

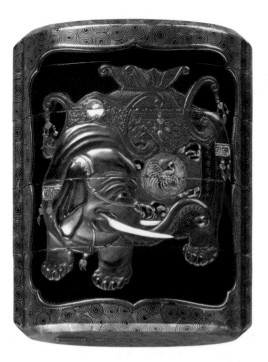

Because fashion was a measure of urban status and taste, wealthy merchants lavished vast sums of money on their own and their wives' clothing. In the eighteenth century, this conspicuous consumption occasionally took the form of fashion contests between the wives of rival merchants in the same or even different cities. However, if the public delighted in spectacles of this kind, the shogunal government did not: one Edo merchant was banished and his property confiscated as a result of the unseemly extravagance displayed in a fashion contest between his wife and the wife of a rival merchant from Kyoto.

The preoccupation with fashion was not limited to women's dress. Men displayed their taste by their choice of accessories such as *inrō*, small, exquisitely crafted boxes originally used to hold medicine. In the absence of pockets, an *inrō* suspended from the sash served to hold small personal possessions (FIG. 15). The materials, forms, and styles of *inrō* varied widely according to season, occasion, and personal taste, but for the most part they were made of lacquer, sometimes inlaid with precious materials. Since an affluent individual might own many *inrō*, nearly every major urban center had a number of lacquerers who specialized in their production.

Not all who aspired to do so could gain entrée to the realm of conspicuous consumption of which courtesans and high fashion were the most visible emblems. Tasteful attire and an evening's

15. ŌGAWA HARITSU (RITSUŌ) (1663-1747)
Inrō with elephant. Four cases, lacquer, raised, sprinkled design and inlay, 4 x 5 x 1½" (10.3 x 12.9 x 3.8 cm).

The immense elephant on this oversize *inrō* was fashioned using raised lacquer and brightly colored ceramic inlays, techniques for which this Edo lacquerer was especially noted. Haritsu's novel combination of materials and unusual themes made him one of the most celebrated lacquerers in Edo. It has been suggested that this unusually large *inrō* was designed for use by a sumo wrestler.

16. UTAGAWA KUNISADA
(1786-1865)
Hour of the Monkey,
1816-17. *Ōban* woodblock
print. Private collection.

The actor Iwai Hashirō V
was a renowned female
impersonator (*onnagata*)
who dressed as a woman in
private life. Kunisada shows
him with arms raised to
arrange his hair, a graceful
pose common in portrayals
of courtesans.

entertainment in the pleasure quarters were costly, and the best most could hope for was vicarious enjoyment through paintings, prints, and books. These, moreover, had the advantage of insulating viewers from the hard realities of the labor in the pleasure quarters, while fostering its image as a utopian realm populated exclusively by sensuous, elegant beauties.

Like the licenced quarters, Kabuki theaters were closely regulated by the government, with Kyoto, Edo, and Osaka limited to four each. The theaters in Kyoto and Osaka were especially noted for their tragic domestic dramas while those in Edo specialized in plays recounting the imaginative exploits of valiant warriors. Although there were some highly versatile actors, most specialized in particular types of roles: male or female, good or evil, ghosts, and so forth. Their performances attracted audiences of both men and women of all classes. Like modern movie fans, Kabuki fans were often as fascinated by the personal lives and behind-the-scenes preparations of their favorite actors as they were by the action on stage, and painters and print designers catered to this voyeuristic curiosity (see FIG. 7, page 21).

The origins of Kabuki are traditionally traced to the year 1603 when an itinerant former Shinto shrine dancer and prostitute named Okuni and her troupe performed to great acclaim at Shijokawara, the dry bank of the Kamo River in Kyoto. The success of her dances and mimes – often performed in outlandish costumes that poked fun at the elite – soon led Kyoto courtesans to imitate her, but the resulting excesses of sexual activities and public disturbances led the authorities to ban all female performers. This prohibition, enacted around 1629, contributed to the rise of the *onnagata*, a male actor specializing in female roles.

In order to assimilate the patterns of female behavior they enacted on stage, many *onnagata* lived and dressed as women both on stage and off (FIG. 16). So influential were they that women often patterned their behavior and dress styles after those of celebrated female impersonators. Such role reversals, which were central to Kabuki's titillating appeal, were among the factors that roused government officials to attempt repeatedly to exert tight control over the theater and its actors. They never completely succeeded, however, in severing the association between Kabuki and sex, and both homosexual and heterosexual liaisons between actors and their fans were common.

Although Japan under the Tokugawa is often described as a secular society, religious institutions left their stamp on urban culture in many ways. Neither the rationalism fostered by Confucianism nor the attractions of the theater and pleasure quarters

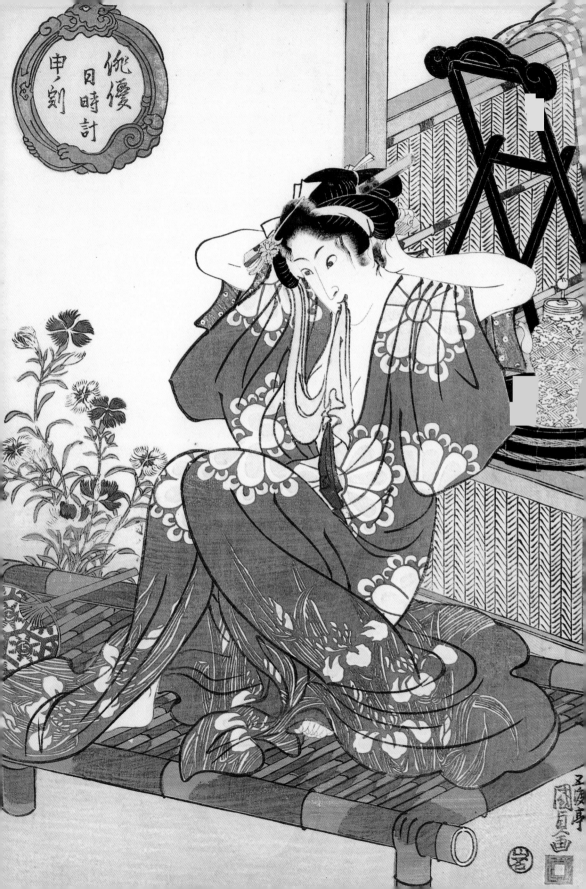

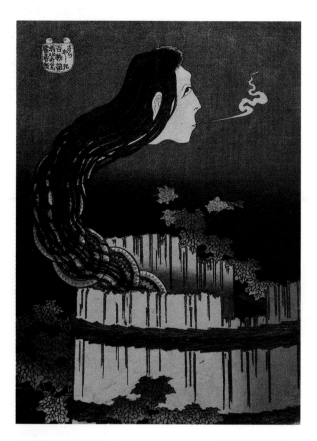

17. KATSUSHIKA HOKUSAI (1760-1849) *The Plate Mansion Ghost* (*Sara yashiki*), from the series *One Hundred Ghost Tales*, c. 1830. *Chūban* woodblock print. Musées Royaux d'Art et d'Histoire, Brussels.

Thrown into a well by her master in punishment for breaking plates, the ghostly form of the servant Okiku, her long hair entwined around a set of plates, emerges from a wooden well.

entirely quelled the power of religion, and it would be a mistake to assume, as is often the case, that urban artists spoke in a purely secular language. Nearly all professional painters filled commissions for devotional images; many also gave expression to their own personal beliefs through their art. Kyoto had an exceptionally large number of distinguished temples affiliated with Zen Buddhism, the form of Buddhism that emphasizes meditation and intuition. Thus in Kyoto the aesthetic values and pictorial traditions associated with Zen Buddhism were especially influential. The phenomenal popularity in the nineteenth century of imagery celebrating the bizarre and ghostly also suggests that, while institutionalized religion may have lost some of its appeal, this was more than offset by the power of popular religious beliefs and practices (FIG. 17).

In the millennium since Buddhism had been introduced to Japan in the sixth century, Buddhist ideals had become so tightly woven into the Japanese cultural fabric that its individual threads were not always readily apparent. Buddhism provided not only the promise of salvation but also a world view that underlay many unquestioned values and practices. Of these none was more fundamental to Edo cultural developments than the Buddhist tenet that all phenomena are impermanent. A preoccupation with transience, in both nature and human affairs, gave rise to the predilection for travel and the rich and creative use of seasonal and travel imagery in the literature, theater, and visual arts of the period. A keen awareness of the brevity of human life and its fleeting pleasures also explains why the brothel and entertainment quarters were designated a "floating world."

Japanese cities, unlike many of their European counterparts, did not have a single dominant religious institution at their center. They were characterized instead by a multitude of Buddhist temples and Shinto shrines, often built in close proximity to one another both within the city and along its periphery. These

played a variety of roles in individual, family, and community life. Their annual ritual cycle provided stability and reassurance. Their deities could be addressed with daily concerns ranging from safe childbirth, illness, and prosperity in business to prevention of fire and theft. They were the site for rites of passage as well as funeral and memorial ceremonies. Many also maintained schools for the education of commoners. Being affiliated with or living in proximity to a particular temple or shrine fostered the growth of a strong sense of local identity and, in cases where the institution was part of a larger network, a sense of regional identity as well.

The residences of the shogun, daimyo, and ranking samurai were often surrounded by expansive gardens, but large spaces open to the public were few. Many temples and shrines had substantial property where large numbers of people could gather for seasonal rituals and festivals. Such events were often accompanied by the display of famous icons, dramatic performances, sumo wrestling, or other spectacles that attracted participants and spectators from the city and beyond (FIG. 18). Open spaces on the floodplains and riverbanks – along the Kamo River in Kyoto, the Sumida River in Edo, and the Yodo River in Osaka – were also popular gathering-places with bustling shops, teahouses, and entertainments of all kinds. Spectacles held along city riverbanks often included the display of exotic animals, pseudo-scientific curiosities, and artistic wonders from abroad, offering the public tantalizing glimpses of the outside world.

Participation in such activities played an important part in the professional lives of many artists. The painter Ike Taiga (1723-76) supported his travels by giving demonstrations of finger-painting (FIG. 19) while his contemporary, Maruyama Ōkyo, launched his

18. SUMIYOSHI HIROMORI (1705-77)
Horse Races at the Kamo Shrine (detail). Handscroll, ink and colors on paper, 13½" x 12' (34 cm x 3.6 m). Mary and Jackson Burke Foundation, New York.

This annual Kyoto ritual featuring ten pairs of riders attired in court costume was among the traditional seasonal and religious activities represented by Tosa and Sumiyoshi school painters.

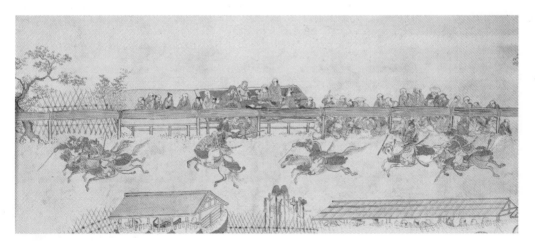

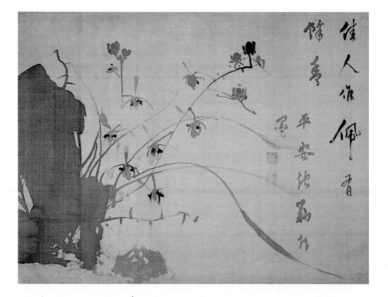

19. IKE TAIGA (1723-76)
Orchid and Rock. Hanging
scroll, ink on silk, 18 x 20"
(45.5 x 51.7 cm). Sansō
Collection, USA.

Flowering orchids are a
time-honored Chinese
pictorial subject
emblematic of beauty and
nobility in the face of
adversity. Taiga's
interpretation of this theme
is unusual in that it was
painted using only his ink-
dipped fingers. The seven
character inscription
("Orchid flowers worn by a
person of elegance emit
extra fragrance") is a partial
quotation from a Chinese
poem accompanying an
illustration in the Chinese
painting manual known in
Japan as *Hasshu gafu.*

career as a painter of perspective pictures (*meganee*) used in a
kind of stereoscopic device popular at fairs. Katsushika Hokusai
(1760-1849) enhanced his reputation by giving public painting
demonstrations before a spellbound audience.

In addition to such boisterous public events, townspeople
could participate in various cultural pastimes of a quieter and
more private nature. These were especially influential in foster-
ing the emergence of identity groups that crossed class lines,
while maintaining various levels of exclusiveness. Both informal
salons formed around a charismatic personality and well-orga-
nized clubs requiring membership fees were common. Poetry
clubs, especially those where members composed epigrammatic
haikai (known today as *haiku,* three-part poems usually of sev-
enteen syllables) or witty *kyōka* (literally "crazy verse") under
the guidance of a master, were popular in cities, towns, and vil-
lages throughout the country. Some of the most sumptuous
woodblock-printed books and New Year greetings (*surimono*)
were privately published under the auspices of such groups. Also
popular were painting and calligraphy gatherings where ama-
teurs were guided by professionals or worked jointly on a single
composition (FIG. 20). The works created in such social settings
were often seen as part of a continuous dialogue between friends.
Temples and shrines were occasionally the setting for such events
but, because of the spirited and carefree ambience prevailing
there, tea-houses in and around the pleasure quarters became the
favorite gathering place for the leading literary and artistic per-
sonalities in every city.

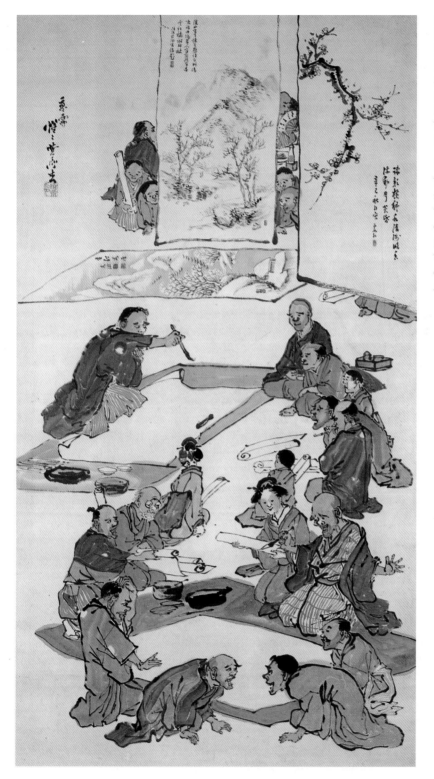

20. KAWANABE KYŌSAI
(1831-89)
Painting Party, 1881.
Hanging scroll, ink
and light colors on
paper, 7'6¹/₂" x
3'2¹/₂" (2.3 x 1 m).
Tiger Collection,
USA.

Brushes in hand,
two artists,
surrounded by
fellow painters and
calligraphers,
prepare to paint. In
the background,
completed scrolls
are displayed.

The tea ceremony, *chanoyu*, an important vehicle for inter-class association and for transmission and popularization of classical Chinese and Japanese cultural values, was avidly practiced in many urban centers, but especially Kyoto and Osaka. Its greatest following was among those with the means to acquire the many costly ceramics and lacquer utensils required for preparing and serving the powdered green tea. The most intimate style of *chanoyu* involved retreat to a tiny, artlessly crafted interior that symbolically refused access to the outside world by requiring visitors to discard their swords and crawl through a tiny doorway. The irregular rhythms of the architecture and interior decor of the tearoom were guided by an aesthetic of which the measure was nature, subtly reshaped by human hands.

With the growing admiration for Chinese customs and culture in the early eighteenth century, *chanoyu* was overshadowed in popularity by gatherings at which *sencha* (steeped tea) was served. *Sencha* was prepared in a small teapot and served in tiny individual cups. *Sencha* drinking, which originated in China, fostered a more informal gathering compatible with the cultivated spirit of the learned class. It also helped to revitalize ceramic production in Kyoto and elsewhere.

Reading was without doubt the single most popular recreational activity among all classes, sexes, and ages. The growing literacy and demand for books among all classes spurred significant expansion and diversification of the publishing industry during the seventeenth century. Before 1590, Buddhist temples held a near monopoly on printing, and most of the books they issued were religious in nature, but within a century more than 10,000 works had been printed. These ranged from illustrated Japanese literary classics such as the *Tales of Ise* (mid-10th century) and *Tale of Genji* (early 11th century) and contemporary novels written predominantly in easy-to-read Japanese syllabary (*kana*) to botanical treatises and guides to female etiquette. Publishing was dominated by firms in Kyoto, Edo, and Osaka but smaller operations existed in other cities such as Nagoya and Nagasaki. For a brief period in the first half of the seventeenth century, movable type was employed in printing, the technology having been introduced to Japan via Korea and, simultaneously, by Portuguese missionaries. However, this vogue soon gave way to woodblock printing, which was less costly. Since many publications were illustrated-and the demand for designs so varied in subject and style, publishers offered employment to many artists. In the eighteenth and nineteenth centuries, artists of nearly every school sought to expand their following by issuing instruction

manuals providing both professional and amateur artists with pictorial models, motifs, and brush techniques (FIG. 21). The dissemination of these and other picture-books by peddlers, lending libraries, and schools gave aspiring painters and craftsmen in even the remotest village access to metropolitan themes and styles.

21. WANG GAI (n.d.) Landscape in round fan format from the *Mustard Seed Garden Painting Manual (Kaishien gaden)*, 1753. Woodblock-printed book, 11 x 7¼″ (28.4 x 18 cm). Ravitz Collection, Santa Monica.

This Japanese edition of a popular seventeenth-century Chinese painting manual (*Jieziyuan huazhuan*) was one of the first multicolor woodblock books printed in Japan. It had a profound influence on many artists of the Edo period, especially those of the literati school.

The Urban Artist

Although there was a time-honored tradition of artists secluding themselves from society to devote themselves to their art, most Edo-period artists were neither isolated nor solitary. Artistic and intellectual exchanges across school lines were common, and painting and calligraphy, like poetry, often functioned as a kind of dialogue that strengthened the sense of group identity among participants.

Most artists lived in urban centers, clustered together in districts where potential clients, equipped with the guides to the city – which were issued in great numbers over the course of the Edo period – could readily find them. Although there were social distinctions among them, there was no clear-cut differentiation between the "craftsmen" and "artist" or the "decorative" and "fine arts," such as developed in Renaissance Europe. Calligraphy and painting were regarded as sister arts. Their practitioners, who employed the same tools, materials, and techniques, were the most highly esteemed among artists because of their ability

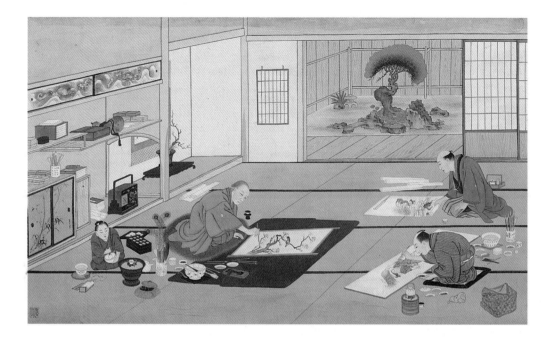

22. Kawahara Keiga
Painter in his Studio with Pupils, 1820s. Album leaf, ink and colors on silk, 25 x 31½″ (64.4 x 80.5 cm). National Museum of Ethnology, Leiden.

A painter gives instruction to two samurai pupils in a luxuriously appointed interior. Keiga painted this idealized image of the artist at work for his patron von Siebold, physician to the Dutch on Deshima island in Nagasaki harbour from 1823 to 1829 (see page 146).

to apprehend the "spirit" or "essence" of things and transmit it through their brush (FIG. 22). Their activities, however, were not limited to hanging scrolls and screens. Many also used their talents to decorate ceramics, furnish designs for lacquer, and even hand-paint garments. Calligraphers and painters were also active in the design of woodblock prints and illustrated books. Sculptors, esteemed in earlier periods because of their specialized technical skills, were not as highly regarded as those who wielded the brush. On the other hand, the requirements of official decor, gift-giving, and the tea ceremony, all of which made use of a wide range of lacquer, ceramics, and metal utensils, gave potters, lacquerers, and metalworkers respect and status not shared by their pre-modern European counterparts.

The most important division in the Edo art world was between the amateur and professional artist, a distinction, however, that was generally more ideal than real. Amateur artistic status conferred special prestige because of its association with the cultivated Chinese scholar-gentleman or literatus (Chinese: *wenren*; Japanese: *bunjin*). Indeed, to the extent that a distinction between artist and craftsman was recognized in Edo culture, it was based on the conviction that the refined personality of the amateur imbued his art with special qualities not found in the work of a professional. This outlook was especially prevalent after the eighteenth century and applied chiefly to painting and

calligraphy, but it also influenced the creation and appreciation of other art forms. The Raku teabowls and bamboo tea scoops fashioned by aficionados of the tea ceremony for presentation to friends and disciples, for example, were often more sought after than those made by professional potters and carvers of bamboo (FIG. 23).

Most artists belonged to groups based on kinship or artistic affinity. The hereditary Kano and Tosa schools exemplify the former, and the more loosely linked Rinpa and literati the latter. Belonging to a recognized lineage or tradition, artistic family, school, or faction was so important that even those who subsequently broke away to form independent studios continued to be identified in relation to the master under whom they had first studied. Some artists even manipulated or fabricated claims to distinguished pedigrees. Urban artists lacking such affiliations were rare and regarded as eccentric or unconventional, although from the late eighteenth century such attributes assumed positive connotations.

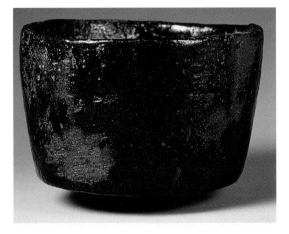

23. HON'AMI KŌETSU
(1558-1637)
Black Raku teabowl,
seventeenth century. Height
c. 3¹/₂″ (8.7 cm). Gotoh
Museum, Tokyo.

Kōetsu was a devotee of
chanoyu and an amateur
potter who made Raku
teabowls for his own use or
for gifts to friends. Hand-
molded Raku was the ware
of choice since amateur
potters generally lacked the
technical skills required for
wheel-turned vessels.

The largest, most successful, and long-lived artistic groupings such as the Kano school were commercial enterprises organized along family lines and directed by individuals who combined artistic talent with entrepreneurial and managerial skills. All these attributes were essential to operate a large workshop with many employees and carry out artistic commissions in a timely and cost-effective manner. In these workshops succession generally passed from father to son but, when the latter was deemed unworthy, a talented apprentice was sometimes adopted as heir to the family profession. This familial structure also included set procedures for the formation of branch workshops either within the same city or elsewhere, providing younger sons with artistic opportunities while at the same time contributing to the perpetuation and dissemination of the house style. The lack of a clear separation between family and work life suggests that, although their names figure but rarely in artistic genealogies, women were active in many workshops. Transmission of house themes and styles was by means of pictorial models and written manuals that were jealously guarded from rivals' eyes. Kano Tan'yū (1602-74), for instance, kept copies of the Chinese and Japanese paintings that people showed him for authentication. These continued to

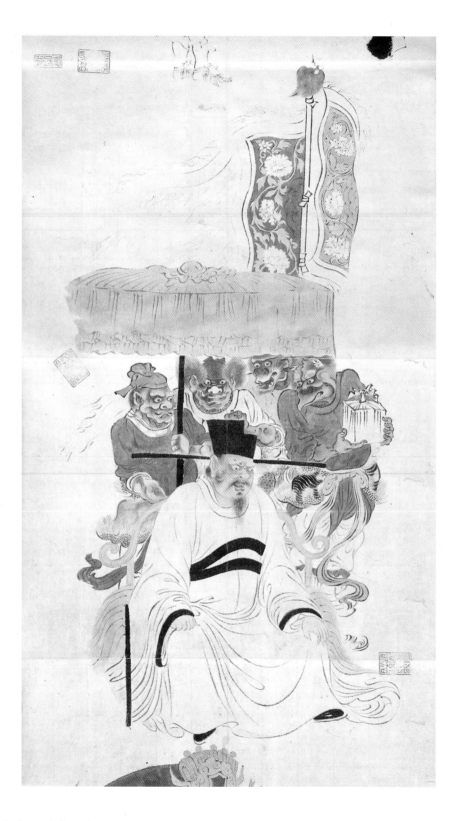

guide his followers until the end of the Edo period. While some copies were in the form of small, rough, monochrome sketches, others, especially those of highly regarded paintings imported from China, were more carefully executed, in color (FIG. 24).

Despite the corporate nature of most artistic production, individual artistic identity was a major concern among Edo-period artists and patrons. Signatures and seals had been adopted as a means of personalizing a painted or calligraphic scroll in the fourteenth century, but over the course of the Edo period they were added to ceramics, lacquer, and other arts as well. In many instances, however, their presence merely indicates that the work in question emanates from a particular workshop or was made under the supervision or with the authority of the artist whose name it bears. In Japan, unlike China, collectors only rarely added their seals to a piece as a sign of ownership.

Artists hailed from all levels of society, but the vast majority belonged to the artisanal or *shokunin* class. As scenes in "Views in and around the Capital" indicate, craftsmen generally lived in single-storey, wooden terraced houses with a raised place for conducting business in the front, facing the street, and workshops at the back (FIG. 25). Their residences were concentrated in areas according to their specialities. The legacy of such residential patterns can still be found in the names of city streets or districts such as Kamisuki-chō ("Paper-making Block"), Kasaya-machi ("Umbrella Ward"), and Nushi-machi ("Lacquer Ward").

Although the Tokugawa government recognized *shokunin* as a clearly defined social entity, it would be a mistake to view them, or, for that matter, the three other classes, in monolithic terms. There was in fact considerable diversity and professional and economic stratification within each group. There was also a limited degree of social mobility within classes and from one class to another. The purveyors of fans pictured in the "Views in and around the Capital," for instance, are probably representative of a relatively lowly class of artists known as "town painters" (*machi eshi*). Their primary product was ready-made items, such as fans, hanging scrolls, and screens that had already been decorated within a well-established range of themes and styles. Such works were relatively inexpensive compared to works painted on commission, and therefore were attractive to buyers of modest means and to tourists, whose numbers swelled with the growing popularity and ease of travel in the nineteenth century. However, through talent, even a fan painter of modest background could achieve great renown, as did Tawaraya Sōtatsu (d. 1643) and Ike Taiga.

Left
24. KANO TAN'YŪ (1602-74)
King of Hell, copy of a painting attributed to Lu Xinzhong, 1658. Ink and colors on paper, height 16³/₄" (42.6 cm). Sackler Art Museums, Harvard University, Cambridge, Mass.

Following pages
25. ANONYMOUS
Views in and around the Capital, seventeenth century (detail). Pair of six-panel folding screens, ink and colors on gold, each screen 5'4" x 11'3" (1.6 x 3.4 m). National Museum, Tokyo.

This Kyoto street scene highlights the kinds of artisanal activities typical of most large cities. The shops flanking one street offer brocades, money-changing services, and clothing scraps. Around the corner are more store-fronts displaying lacquer bowls and food boxes, fans, large lacquerware, and footwear.

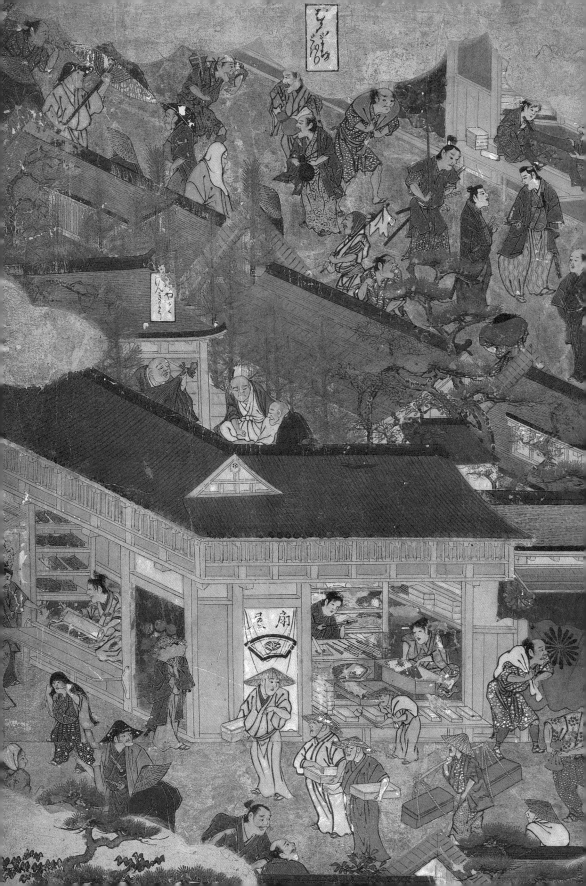

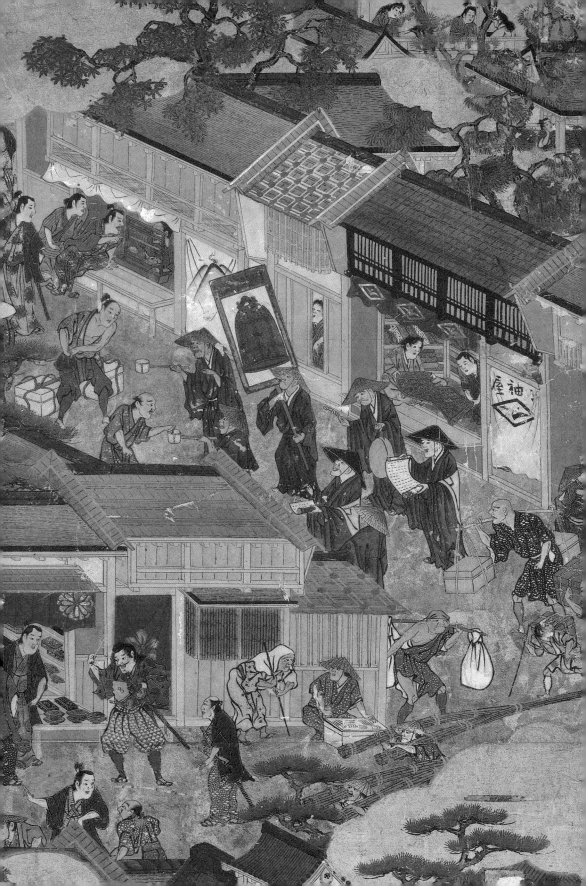

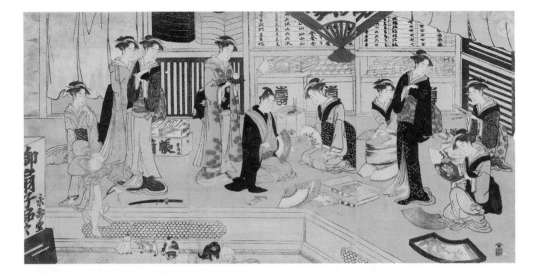

Although an eighteenth-century code of ethics exhorted artisans to live frugally, devote themselves assiduously to their craft, and leave financial matters to merchants, the distinction between these two classes was not always clear. Most craftsmen sold their own wares, but a few did have commercial agents who secured commissions, coordinated production, and ensured quality and marketability. These services were especially important in the publishing business, where the publisher orchestrated the activities of the artist-designer, woodblock-carver, and printer, as well as promoting sales of the finished book or print.

Merchants were involved in the art world on many different and often overlapping levels. Nishimura Eijudō (fl. 1780s-90s) was typical of one who made his living through the publication and sale of work by local artists (FIG. 26). Aficionados of *chanoyu* often doubled as agents and dealers in domestic and imported ceramics. Because of the high esteem for painting and calligraphy, most men and women born to wealthy merchant families received instruction in these arts from an early age. Later, failing family fortunes or personal inclination sometimes led them to use these skills in a professional capacity, as did Ogata Kōrin (1658-1716) and his brother Kenzan (1663-1743). There were also wealthy merchants, such as Kimura Kenkadō (1736-1802) of Osaka, who patronized talented painters and calligraphers, receiving in return artistic instruction. Although they too might be involved in the art world on a commercial level, these merchants saw themselves primarily as amateur artists.

The samurai or warrior class enjoyed many privileges not shared by the remaining ninety per cent of the population. They

26. UTAGAWA TOYOKUNI
(1769-1825)
View of Eijudō Fan Shop.
Triptych *ōban* woodblock
print. National Museum,
Tokyo.

The publisher Nishimura
Eijudō sits in the center of his
bustling shop examining a
fan, surrounded by beautiful
women representing sales
clerks and customers. His
name, inscribed on the giant,
fan-shaped signboard at the
top of the composition as
well as on the paper lamp in
the lower left, serves as
identification and self-
advertisement. The artist has
also cleverly incorporated his
own promotional device: the
customer on the right side of
the shop is examining a
woodblock-printed fan with
a portrait of a Kabuki actor in
Toyokuni's distinctive
pictorial style.

alone were permitted to wear two swords, and to use certain varieties of silk for their clothing, and wood for constructing their residences. They also received stipends. Samurai status was hereditary but over the course of the Edo period many samurai lost their livelihoods owing to inflation and changing economic conditions. Regardless of circumstances, however, they were expected to be paragons of virtue, rectitude, and dedication, and skilled in the arts of war and peace, ideals few actually achieved.

After the reunification of the country the samurai's ability to wield a sword, shoot with a bow and arrow, or ride horseback was demonstrated chiefly on the occasion of ceremonial games such as dog-chasing matches, or the annual archery competition held at Kyoto's Sanjūsangendō Hall. Declining mastery of the martial arts was offset by growing mastery of painting, calligraphy, poetry, and related arts. Faced with unemployment or insufficient income, many samurai took advantage of these skills, becoming professional artists or teachers of their more affluent peers or of *chōnin*. In some instances, personal pride and the ideal that a samurai should not concern himself with money prompted these men to hide or disclaim such professional involvement in the arts.

Most daimyo who ruled over the nation's two hundred or so feudal domains could boast some skill as painters or calligraphers. However, in general, they were more influential as patrons than as practitioners of the arts. Their support was the foundation for the enduring influence of the Kano school, which maintained branches in every domain, giving them a status tantamount to a nationwide painting academy. Daimyo were also prominent patrons of Kyoto's Nishijin weavers, from whose looms emanated the sumptuous brocade costumes used in Noh drama, whose performance was a requirement of formal receptions hosted by the shogun and daimyo. To increase their income and cultural prestige, some daimyo also took active roles in promoting the production of luxury crafts in their domains (FIG. 27).

Artists were also found among the ranks of the hereditary nobility and Buddhist and Shinto clergy, two groups in the same elite category as the samurai. By the start of the Edo period, the imperial family and court had already lost much of their political and economic power, but their cultural authority remained unchallenged. This led some members of the imperial family to become teachers of poetry and other arts to high-ranking warriors and wealthy merchants, thus contributing to the dissemination of many previously secret writings on calligraphy and poetry. This development also foreshadowed the "professionalization" of the

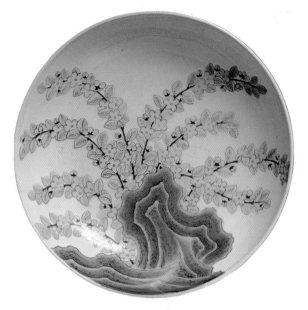

27. Plate with flower and rock motif, late seventeenth or early eighteenth century. Nabeshima ware, diameter 12″ (31 cm). Collections Baur, Geneva.

Nabeshima ware gets its name from the daimyo under whose official auspices it was made.

ideal of amateurism that would become central to many artists' sense of self-identity.

Calligraphy was an area in which the imperial family and court had traditionally excelled, since it was held that fine handwriting was a sign of character, and many Edo-period calligraphic lineages claimed aristocratic founders. Mastery of calligraphy often went hand in hand with literary scholarship, especially in the classical thirty-one-syllable *waka* poem and prose classics such as the *Tale of Genji* and the *Tales of Ise*, which had been composed by members of the nobility during the Heian period (794-1185). Many of the great poets and poetesses of that distant era were as admired for their calligraphic hand as for their verse, and the Kyoto courtiers who saw themselves as the heirs to that tradition often emulated their writing styles (FIG. 28).

As artists, the Buddhist clergy were less influential in the Edo period than they had been earlier. Monk-artists attached to large temples in Kyoto and Kamakura, who had traditionally served as painters and cultural advisers to the ruling elite, lost these roles as artistic activities of all kinds were taken over by secular professionals. The Tokugawa shogunate's adoption of Confucianism as the state ideology also led to a diminished status for monks, with the possible exception of Chinese émigrés affiliated with the newly introduced Ōbaku sect of Buddhism (see chapter two). Destined to become one of the three main sects of Zen in Edo Japan, Ōbaku had a profound cultural impact first in Nagasaki and later throughout the country.

Replaced by Confucian scholars as teachers to the ruling elite, some monks turned their attention to the education of commoners both in the city and in the provinces, thus contributing significantly to the growth of literacy. Others, dissatisfied with the worldly distractions of the urban environment, took up a life of wandering or retreated to remote mountain temples where they could devote themselves more fully to religious and artistic pursuits. Some of these monks developed new and often highly idiosyncratic forms of pictorial and sculptural expression both to serve as didactic aids and to convey their personal religious convictions and aspirations.

The Edo period witnessed the dramatic growth of towns and cities populated by large numbers of affluent and literate inhabitants. Until the late sixteenth century, patronage and practice of the arts had been limited to the elite, but urbanization fostered the flowering of many forms of artistic expression that transcended class. Participation in cultural activity became both a personal vocation and a means of demonstrating cultural authority among all social strata.

Artists shaped and responded to urban aesthetic tastes and ideals both through their own work and through artistic instruction. Like their clientele, they came from all classes of society and were involved in a wide range of personal and professional relationships. Despite the importance attributed to individual artistic expression, many belonged to associations based on kinship or affinity that provided training, friendship, patronage, and financial security. Such affiliations were essential to artistic identity and to survival in the highly competitive urban environment. The dynamics of artistic life within and among the four major cities examined in the following chapters was shaped by the proliferation of such schools, factions, or artistic lineages.

28. KONOE NOBUTADA (1565-1614)
Page from *Poems of the Thirty-six Immortals of Poetry (Sanjūrokkasen)*, early seventeenth century. Album, ink on paper decorated with gold and silver, 8^1/$_2$ x 7^1/$_2$" (21 x 19 cm). National Museum, Tokyo.

The courtier Nobutada was among the most distinguished calligraphers of his day. This classical thirty-one-syllable *waka* poem inscribed on decorated paper is typical of his style.

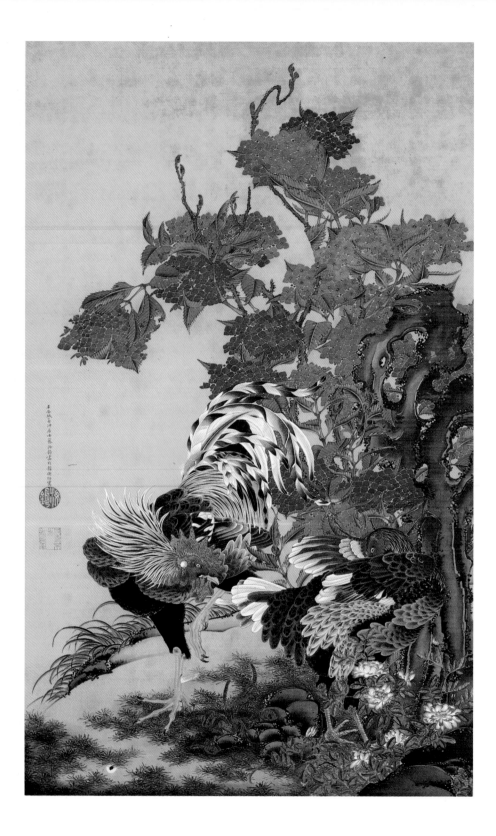

TWO

Kyoto Artists

A s a city of cultivated nobles, scholars, monks, and artists, Kyoto had a more diverse population than other major urban centers. The limited presence of shogunal officials gave its artists comparatively more cultural freedom than their counterparts in Edo, enabling them to explore and internalize diverse styles and techniques, which they creatively transformed, often in highly individualistic ways. It also made Kyoto a haven for talented and eccentric artists from other regions, some of them "drop-outs" from government officialdom, who, through their art, skillfully played the imperial court against the shogunate. Drawing on cultural traditions of both native and foreign origins, these artists developed forms and styles that both shaped and mirrored residents' sense of themselves as sophisticated and refined to a degree not found in other cities.

Kyoto's cultural identity was inextricably entwined with the production of luxury arts and crafts, and its artists were skilled and ingenious in adapting their work to ever-changing tastes. Nonetheless, by the mid-eighteenth century visitors from Edo and Osaka often disparaged Kyoto as old-fashioned, claiming that, though it had once reigned as the flower among cities, it was now little more than a provincial center, sustained by the lingering fragrance of the past. The burden of tradition was undoubtedly stronger in Kyoto than in Edo, but it did not weigh as heavily as many visitors believed. Indeed, many of the artistic developments popularized in Edo had their beginnings in Kyoto.

The sense that Kyoto was different from other cities reflected its unique place in the nation's history. Since 794 Kyoto had been home to the emperor and court nobility and, with the exception

30. Map of Kyoto with
major landmarks mentioned
in the text.

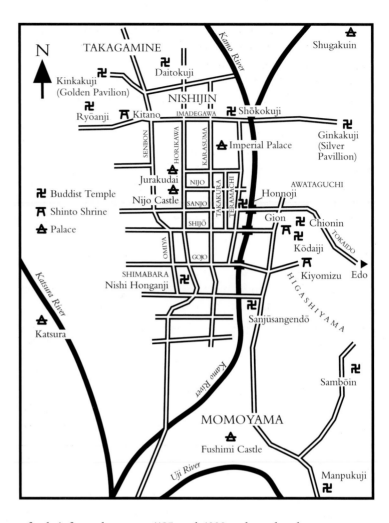

of a brief gap between 1185 and 1333, when the shogunate was
transferred to Kamakura, had served continuously as Japan's
administrative, religious, and cultural heart. This imperial legacy
is apparent from the city's layout. When Kyoto, or Heiankyō
("Capital of Peace and Tranquillity"), as it was then known, was
designated the capital in 794, Japanese culture was very much
under Chinese influence. The site was chosen following Chinese
geomantic principles (divination by means of figures, lines, or
geographical features); and the city, laid out between the Kamo
River on the east and the Katsura River on the west, followed
the symmetrical grid pattern and north-south orientation cus-
tomary in Chinese capitals (FIG. 30). A broad avenue called
Sujaku-ōji running from north to south bisected the city into left
or Eastern (Sakyō) and right or Western (Ukyō) parts, and nine
consecutively numbered avenues extended across the city from

east to west. The Great Enclosure within which stood the imperial palace and other ceremonial halls was at the northern end of Sujaku-ōji. Its presence defined the city.

The vicissitudes of the imperial palace are typical of those of Kyoto as a whole. Among the countless buildings laid waste during the Ōnin Wars of 1467-77, the palace was reconstructed and refurbished when the warlords Nobunaga and Hideyoshi assumed control of Kyoto. The palace was destroyed and rebuilt again several times over the course of the seventeenth and eighteenth centuries, following the fires that periodically swept the city. The reconstruction of 1789 was so badly damaged, first by earthquake in 1830, then by fire in 1854, that the palace had to be renovated yet again in 1855. This last reconstruction is still intact today.

If the presence of the emperor and court conferred unique prestige, by the opening years of the Edo period it could no longer guarantee the city either cultural or economic pre-eminence. The imperial family was largely dependent on the shogunate for financial support, and its patronage of the arts would not have been possible without the shogunate's calculated benevolence, especially when tensions with the court were high. The flowering of many art forms in mid-seventeenth-century Kyoto can be directly attributed to the political stability and financial benefits that accrued from the marriage in 1620 between Emperor GoMizunoo (1596-1680; r. 1611-29) and Tokugawa Hidetada's daughter, Tōfukumon'in (1607-78).

Nijō Castle, so named because of its location on Nijō ("Second Avenue"), served as an ever-present reminder of shogunal power over the city and its inhabitants. It was designed as a military garrison, having at its center a multi-storied tower, since destroyed, but it came to serve primarily as a temporary residence for the shogun during his rare visits to the imperial city. Ninomaru Palace was constructed in the grounds of Nijō Castle at the orders of Iemitsu (1604-51) for the visit of Emperor GoMizunoo in 1626 (FIG. 31).

Katsura and Shūgakuin Imperial Villas, two of the finest surviving monuments to seventeenth-century aristocratic taste, also owe their existence to shogunal largesse. Both are situated

31. Exterior view of Ninomaru Palace, Nijō Castle, Kyoto, c. 1626.

Comprising a series of vast audience halls and private chambers in the *shoin* style, this palace, with its imposing scale, hierarchical layout, and opulent decor, illustrates the way the built environment was adapted for purposes of social control, a guiding practice in official architectural design throughout the Edo period.

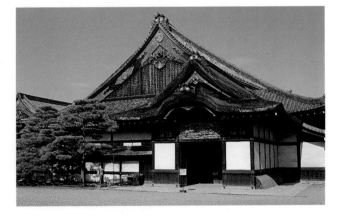

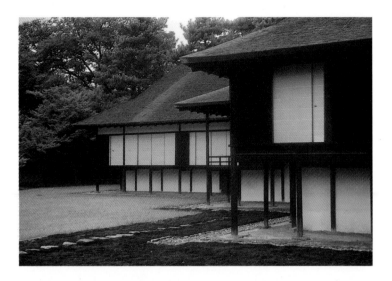

32. *Shoin* of Katsura Imperial Villa, Kyoto, c. 1640s-1650s.

Built in *shoin* style, this villa consists of a suite of three modest buildings arranged in zigzag fashion alongside a pond and a number of subsidiary structures, including four tea-houses, picturesquely situated in a beautifully landscaped garden.

on the outskirts of the city: Katsura along the river of the same name in the western suburbs and Shūgakuin in the foothills of Mount Hiei to the northeast. Prince Toshihito (1579-1629), the younger brother of Emperor GoYōzei (1572-1617; r. 1586-1611), first designed Katsura (FIG. 32) as a rustic retreat for *chanoyu* and poetry gatherings, but it was expanded by his son Noritada (1619-62). Shūgakuin was built in the 1660s and 1670s by Tokugawa Ietsuna (1641-80) as a retirement villa for Emperor Go-Mizunoo. The scenic splendor of its gardens, which were designed to take advantage of the multiple vistas offered by the hills and the mountains beyond, made it an ideal setting for the many cultural activities hosted by the emperor during his retirement. GoMizunoo was a patron of the art of flower arranging, of which he hosted many displays, as well as a practitioner of *chanoyu*.

Kyoto's estimated two thousand temples and shrines constituted the largest concentration of religious institutions in the country. Monks, especially those of the Zen sect, had traditionally formed the core of the educated elite in Kyoto, serving as scribes, advisers, poets, and painters to the ruling establishment. Although Buddhist influence waned somewhat in the Edo period owing to the shogunate's espousal of Confucianism, Kyoto's Zen temples remained influential in the cultural sphere. In the 1620s and 1630s, Daitokuji's cultivated monks attracted a lively group of painters, poets, and tea aficionados from a wide range of social backgrounds. Nanzenji and Shōkokuji were also prominent, but in the eighteenth and nineteenth centuries Manpukuji was by far the most influential institution (FIG. 33).

A temple of the Chinese Huangbo (Jap.: Ōbaku) sect of Zen, Manpukuji was built south of Kyoto at Uji on land donated by the shogunate. The shogunate permitted its establishment in 1662 not for its religious teachings (which centered on the possibility of sudden enlightenment and the practice of invoking the name of Amida, the Buddha of the Western Paradise), but because its émigré monks were well versed in Confucian writings whose values helped to buttress state ideology. For Kyoto artists, the succession of Chinese abbots and monks at Manpukuji, many of them gifted painters and calligraphers, offered tantalizing glimpses of the latest cultural developments in China and beyond.

The Kano and Tosa Schools

Kano Tan'yū's appointment as painter-in-residence to the Tokugawa shogun in 1621, and the subsequent division of the Kano and the Tosa schools into two branches, one in Kyoto and the other in Edo, set the stage for the cultural dynamics that would characterize relations between the two cities throughout the Edo period. This physical separation also reinforced and institutionalized the long-standing creative tension between Chinese and Japanese aesthetic values.

The Kano were a hereditary line of artists who rose to prominence in the fifteenth century with the patronage of the Ashikaga shoguns and provincial warlords. They achieved this through their skillful adaptation of Chinese landscape, bird-and-flower, and figural themes and ink-painting styles to the requirements of interior decoration, principally sliding and folding screens. In the

late sixteenth century, Eitoku further developed the Kano style in keeping with the growing taste for opulence and monumentality, securing commissions for both Nobunaga's and Hideyoshi's castles. By devising a repertory of themes and styles with symbolic overtones that reflected both his patrons' aspirations and the social function of each room, Eitoku laid the foundations for the use of art as an adjunct to rulership. This legacy is evident in his grandson Tan'yū's decorative program for the main audience hall of Ninomaru Palace as well as in the work of Kano Sansetsu (1590–1651; FIG. 34). However, while Eitoku's designs had promoted the display of personal power and glory, his Edo-period heirs emphasized designs that gave expression to their feudal patrons' use of Chinese ideology to buttress their political legitimacy and national social stability.

Kano painters who remained in Kyoto continued to receive some local commissions, but over the course of the Edo period they faced growing competition from other local artists espousing more innovative styles that were not associated with the shogunate. As a result many turned to writing and teaching. The

first history of Japanese painting, *Honchō gashi*, was written by Sansetsu's son Einō (1631-97), and many of the city's leading amateur and professional painters, including Ogata Kōrin and Maruyama Ōkyo, received their formative training in the Kyoto Kano studios. The Kano studios were also the training-ground for a large number of talented artists collectively known as *machi Kano* ("town Kano"), whose unsigned work often focused on the kinds of contemporary genre themes, especially dancers and courtesans, that later became popular in paintings and prints in Edo (FIG. 35).

The Tosa was also a hereditary school of painters whose members had enjoyed the patronage of both the Ashikaga shogunate and the imperial family. They were more closely identified with the latter, however, since their pictorial idioms had originated among Heian-period artists employed in the imperial painting atelier. Tosa painters were considered the leading practitioners of Yamatoe, literally "pictures of Japan" (Yamato being the name of the ancient center of Japanese culture), characterized by Japanese figural and landscape themes painted

34. KANO SANSETSU (1590-1651)
The Old Plum Tree,
c. 1647. Four-panel *fusuma*, ink, colors and gold on paper, 5'7" x 15'9½" (1.7 x 4.8 m). Metropolitan Museum of Art, New York.

These *fusuma* were once in the abbot's quarters of Tenshōin, a subtemple of Myōshinji in Kyoto. The massive, gnarled plum tree and multi-faceted rocks painted in vigorous brushstrokes against a solid gold-foil ground reflect Eitoku's influence. The willful geometric distortion of form, however, is a hallmark of Sansetsu's personal style.

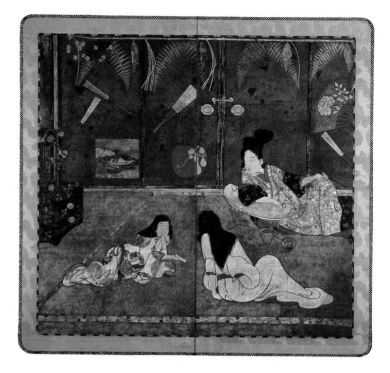

in a highly stylized manner using mineral pigments and gold. The Tosa were especially noted for their illustrations of the *Tale of Genji* and other courtly classics in the intimate handscroll and album formats (FIG. 36). The Edo branch of the Tosa school, whose members adopted the name Sumiyoshi, after a line of painters that had served the imperial family in the Kamakura period, continued to paint works in this traditional idiom (see FIG. 18).

Since Chinese themes and styles buttressed Tokugawa ideology, official Kano painters were generally commissioned to paint the screens and hanging scrolls displayed in official audience halls and other public spaces in shogunal and daimyo residences where men congregated. The courtly aesthetic of the Tosa and Sumiyoshi artists, on the other hand, was generally deemed more appropriate for the decor of the private chambers occupied by women and children and for the albums and scrolls that were often included in wedding dowries. However, there was considerable stylistic pluralism among members of the two schools.

Tosa artists who remained in Kyoto after 1683, when the shogunate appointed members of its Sumiyoshi branch as its official painters, were primarily influential as antiquarians, connoisseurs, and teachers. Kano Einō and Tosa Mitsusuke (1675-

36. TOSA MITSUNORI (1583-1638) Illustration of Chapter Twenty from the *Tale of Genji*. Album, ink and gold on paper, 5$\frac{1}{3}$ x 6" (13.7 x 15 cm). Mary and Jackson Burke Collection, New York.

By adopting an aerial perspective and figuratively removing the roof, the artist has enabled the viewer to see directly into the box-like room where four court ladies are engaged in reading and writing. This album is painted in an exacting ink-outline technique called *hakubyō* ("white drawing"), against a gold background.

1710), for instance, taught Nishikawa Sukenobu, a painter and book illustrator noted for his portrayals of Kyoto beauties (see FIG. 1). Tosa themes and styles, however, provided the inspiration for other, more creative Kyoto artists who designed works to the taste of the city's increasingly affluent and often highly discriminating bourgeoisie.

Kōetsu, Sōtatsu, and Rinpa Design

Turbulent conditions had led many artists to flee Kyoto for Nara and Sakai in the sixteenth century. Their return, following Hideyoshi's stabilization and promotion of craft production in the city, signaled the onset of an artistic revitalization of which ripple effects were felt throughout the country for over a century. At a time when other cities were still recovering from decades of warfare, Kyoto was uniquely able to meet the demand for luxury goods. It was during this era that the word *kamigata*, denoting the Kyoto-Osaka region, became synonymous with articles of unparalleled quality and expressive of a refined courtly aesthetic, to which the artists of Kyoto believed themselves to be the sole heirs.

Kyoto's renaissance was not led by official painters of the Kano and Tosa lineages but rather by a coalition of artists who specialized in the production of articles such as fans, lacquer, textiles, and ceramics that appealed to Kyoto's affluent inhabitants. These artists drew inspiration from the court tradition of poetry, calligraphy, and painting that had come to be identified as part of the shared legacy of all Kyoto residents. Access to this tradition came about through their association with impoverished courtiers who were willing to share their previously secret cultural knowledge.

Hon'ami Kōetsu (1558-1637) and Tawaraya Sōtatsu (d. 1643) were pivotal figures in this process of cultural democratization. While they were indebted to the idioms employed by Tosa artists, they also drew inspiration from painting and calligraphy of the Heian period to which they had access through their religious affiliations and through their court patrons. Kōetsu and his associates had especially close ties to Nishi Honganji, one of the head temples of the Jōdo Shinshū (True Pure Land) sect of Buddhism. Located on Sixth Avenue in the lower part of the city, this temple had a powerful religious and cultural influence in seventeenth-century Kyoto.

Printed-book design and calligraphy was the first area in which these two artists left their imprint. Their collaborative work is thought to date from before 1615, when Kōetsu, along with many fellow artists, moved to Mount Takagamine, northwest of the city. One of their most influential joint ventures was a series of publications named after the village of Saga, northwest of Kyoto, where their printing press was located. With the

37. TAWARAYA SŌTATSU
(d. 1643)
Double page from Noh text
Michinori, before 1615.
Book, ink and mica printed
on colored paper, 7 x 9½″
(18 x 24 cm). New York
Public Library.

financial backing and scholarly guidance of a member of a wealthy Kyoto mercantile family, the Saga press turned out limited editions of prose and poetry, Noh texts, as well as Chinese historical and literary works that helped to satisfy the craving for once-secret cultural knowledge. Kōetsu is thought to have provided the models for the calligraphy, and Sōtatsu and his studio the mica-printed designs on the covers (FIG. 37). The poetry scrolls on which Kōetsu and Sōtatsu also collaborated during this period feature similar randomly printed, overall patterns of flying cranes, ivy leaves, deer, and silhouetted pines. Both the books and the scrolls preserved an aura of individuality while at the same time capitalizing on the potential of replication.

Kōetsu belonged to a family of sword connoisseurs, a hereditary profession that authenticated and repaired swords. His familiarity with the techniques of repairing lacquer, metal, and mother-of-pearl, all of which were employed on sword scabbards

38. HON'AMI KŌETSU (1558-1637) Inkstone box, early seventeenth century. Lacquer, overlaid with lead and silver, $9^1/_2$ x 9 x $4^1/_2$" (24 x 23 x 12 cm). National Museum, Tokyo.

This writing-box features a domed lid spanned by a bridge made of lead, over which are the words of a poem formed in silver. It epitomizes the sensitivity to materials and the union of word and image central to Rinpa design.

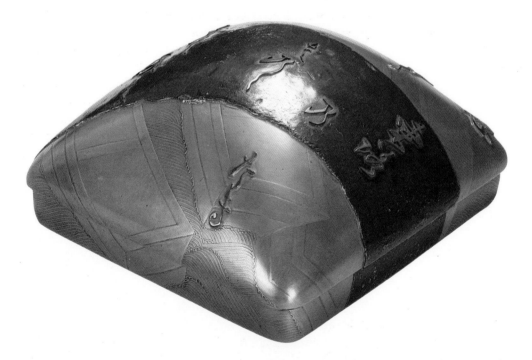

and hilts, may have led him to venture into the realm of lacquer design to which he brought daring new shapes, materials, and pictorial motifs. His technical innovations were applied primarily to writing-boxes, treasured emblems of personal cultivation because they held the implements for painting and calligraphy (FIG. 38).

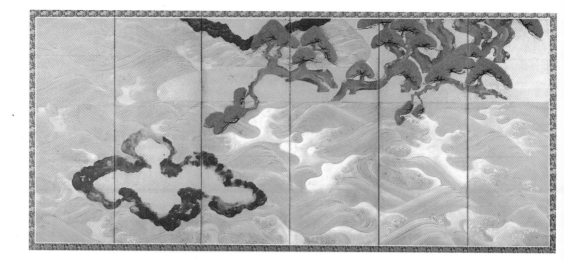

39. TAWARAYA SŌTATSU
(d. 1643)
Pine Islands at Matsushima.
Pair of six-panel folding
screens, ink, colors, and
gold on paper, each screen
5′ x 11′8″ (1.6 x 3.7 m).
Freer Gallery of Art,
Smithsonian Institution,
Washington, D.C.

This panoramic
composition represents
northern Japan's most
scenic spot, long celebrated
in poetry. The arrangement
of stylized rocks, sand bars,
and pine-covered islands,
all shown from varying
aerial perspectives, forms a
continuous sweep across all
twelve panels of the paired
screens.

Sōtatsu remains a shadowy figure, but there is little doubt that he began his career as a fan painter in the Tawaraya shop between Nijō and Sanjō Avenues. So famous were his designs that the name Tawaraya became synonymous with fine Kyoto fans. His success stemmed from his selective borrowing and recombination of familiar literary motifs from horizontal picture scrolls for use first in fans and later in hanging scrolls and screens. These same themes were also treated by artists of the Tosa school, but Sōtatsu rejected their hard-edged, miniaturistic style in favor of the more evocatively softened contours and expansive forms evident in *Pine Islands at Matsushima* (FIG. 39).

Sōtatsu's treatment of this theme may have been influenced by a scene in the fourteenth-century pictorial biography of Kakunyo (1270-1351), a priest of Nishi Honganji who journeyed to this remote region as part of his proselytizing activities. However, the screen's primary appeal to seventeenth-century viewers rested on Matsushima's reputation as one of Japan's most scenic spots. Although few artists had actually seen it, Matsushima had long been celebrated as a *meisho*, a place with poetic and imagistic associations, so much so that, when the poet Matsuo Bashō visited it in 1689, he deemed it beyond his powers of poetic description.

The work of Sōtatsu and Kōetsu laid the foundations for a heterogeneous group of artists that came to be known as Rinpa after Ogata Kōrin, a later follower. (The name was formed by combining the "rin" of Kōrin with "pa," meaning "faction" or "school.") Unlike the Kano school, whose members were bound to one another by family ties, Rinpa was a loose coalition of

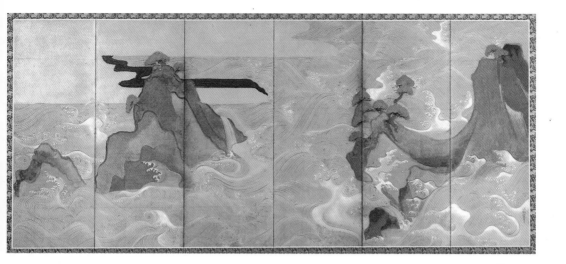

artists who identified with each other on the basis of self-chosen artistic orientation. Also unlike the Kano school, Rinpa artists freely adapted and reinterpreted the themes and styles of their predecessors for use in various media. In addition to painting and calligraphy, Kōrin and his brother Kenzan were involved in lacquer, textiles, and ceramics. Their designs influenced generations of artists of all schools.

Ogata Kōrin and Kenzan belonged to a distinguished Kyoto family whose drapery shop, the Kariganeya ("Wild Goose"), had supplied luxury textiles to warriors and courtiers since the sixteenth century. The Ogata family was related through marriage to Kōetsu, and Kenzan inherited a house on Mount Takagamine from his grandfather Sōhaku. As heirs to a flourishing business, they had since their youth dabbled in cultural pursuits, such as *chanoyu*, calligraphy, painting, and Noh, all popular among the city's merchant elite. Following the death in 1678 of its chief patroness, Empress Tōfukumon'in, however, the family business began to decline. Its total collapse in 1703, caused by the failure of daimyo to repay loans, eventually led the Ogata brothers to become professional artists and to travel to Edo in search of patronage. Their stays, though brief, laid the foundations for the Rinpa movement that would flower in the shogunal city in the nineteenth century.

Fashion was central to Kyoto's self-identity during the Genroku era (1688-1704), and clothing became one of the city's most conspicuous forms of cultural expression. In *The Eternal Japanese Storehouse (Nihon Eitaigura)* the Osaka novelist Ihara Saikaku (1643-93) observed that:

Fashions have changed from those of the past and have become increasingly ostentatious. In everything people have a liking for finery above their station. Women's clothes in particular go to extremes... But in recent years certain shrewd Kyoto people have started to lavish every manner of magnificence on men's and women's clothes and to put out design books in color. With modish fine-figured patterns, palace-style hundred-color prints, and bled dapple tie-dye, they go to the limit for unusual designs to suit any taste.

(Translation by D. Shively)

Many Kyoto painters both designed and hand-painted elegant garments, but because of his family profession Kōrin was unusually active and influential in this form of artistic expression. On one occasion he even choreographed a spectacle in which the wife of one of his merchant patrons promenaded in public while

wearing an unassuming white garment with a servant dressed in more opulent attire. This clever and sophisticated inversion of the norm through fashion exhibited a playful aesthetic sense much admired by Kōrin's contemporaries.

The *kosode* provided a large, flat surface that could be readily decorated using the same compositional principles as a hanging scroll or screen. Over the course of the seventeenth century, technical advances in weaving, dyeing, embroidery, the application of gold leaf, and painting made it possible to create garment designs of striking technical sophistication and originality. Consequently, Kyoto artists were often engaged to supply designs for the weavers and dyers in the city's Nishijin district. Kōrin's distinctive approach to composition, most notably his division of the pictorial surface into contrasting design fields and use of flattened, dramatically cropped, and simplified pictorial elements, was readily adapted to other media (FIG. 40 and see FIG. 14).

40. OGATA KŌRIN
(1658-1716)
Red and White Plums, early eighteenth century. Pair of two-panel folding screens, ink, colors, and gold on paper, each screen 5'2" x 5'8" (1.6 x 1.7 m). MOA Museum of Art, Atami.

The plum trees' angular contours serve as a foil for the broadly undulating pattern of the river. The novel device of using flowing water as a unifying element inspired generations of artists.

Just as Kōrin transcended the boundary between painting and textiles, so too Kenzan wedded painting to ceramics, bringing to the latter a new emphasis on self-expression. Many of the wares Kenzan produced in kilns in and around Kyoto featured the brightly colored overglaze enamels developed by Nonomura Ninsei (c. 1574-1660), a Kyoto potter active in the 1640s. However, while Ninsei had fashioned complex ceramic forms to the specifications of a *chanoyu* master, Kenzan made wares to his personal taste. In so doing, he came to be regarded as Japan's first "artist potter." At a time when pottery production was for the most part a corporate enterprise carried out by anonymous artisans, the signatures Kenzan brushed on the underside of his pots offer evidence of a growing awareness of artistic individuality.

Kenzan was less interested in the technical aspects of ceramics production than in the vessel's potential as a vehicle for novel decoration. By relying primarily on molded rather than hand-thrown forms, he streamlined production so as to meet the expanding market, yet by decorating them in his free and expressive style he gave them an aura of individuality. By employing pictorial motifs inspired by classical literature, Kenzan completed the process by which Rinpa artists incorporated the courtly aesthetic into all the dominant art forms practiced in Kyoto (FIGS 41 and 42).

41. OGATA KŌRIN (1658-1716) Fan with scene from the *Tales of Ise*. Ink, colors, and gold on paper, 14¹/₂ x 9″ (35.6 x 23 cm). Freer Gallery of Art, Smithsonian Institution, Washington, D.C.

Both Kōrin and Kenzan (see below) were exceptionally skillful in adapting classical literary motifs to the requirements of various media. The decoration on both the fan painting and the incense container illustrate the same episode from the *Tales of Ise*, a popular source of inspiration for Rinpa artists.

42. OGATA KENZAN (1663-1743) Incense container with scene from the *Tales of Ise*, 1699-1712. Stoneware with overglaze enamels, height 1″ (2.5 cm), depth 4″ (10 cm). Freer Gallery of Art, Smithsonian Institution, Washington, D.C.

Kōrin and Kenzan personify two contrasting ideals important in the development of Kyoto's cultural identity. Well versed in the traditional arts yet equally knowledgeable in the fashionable mores of the city's Shimabara pleasure district, Kōrin came to represent the quintessential urban dandy (*sui*) of Genroku-era Kyoto. At a time when the city's affluent merchants were noted for extravagant displays of conspicuous consumption, this *joie de vivre* alone, however, was not sufficient to distinguish Kōrin from his peers. Kōrin captivated the public for the playful wit he demonstrated in art as in life.

Kenzan, whose aesthetic sense was more subdued, identified closely with Kyoto's tradition of cultivated recluses. Shūseido ("Hall for Learning Tranquillity"), his name for the modest retreat he built for himself in northwest Kyoto, testifies to his long-standing desire for a life of quiet reflection and scholarship. His pursuit of personal cultivation through reading, writing, and painting was a model that would be followed by other artists active in Kyoto when the crest of the city's prosperity had passed.

Taiga, Buson, and the Literati Movement

The literati movement did not originate in Kyoto, but the city's time-honored tradition of Chinese scholarship and intellectual freedom provided the fertile soil where it took root and flourished. Two of its pioneers, Gion Nankai (1677-1751) and Yanagisawa Kien (1706-58), were government officials in Kii Province (modern Wakayama Prefecture) and Yamato Province (modern Nara Prefecture). Although Sakaki Hyakusen (1697-1752), the third and most artistically gifted pioneer, worked primarily in Kyoto, he was originally from Nagoya. Literati artists identified with Chinese scholar-amateur painters of the Yuan, Ming, and Qing dynasties (the fourteenth-nineteenth centuries), and adopted many of the themes and styles favored by them. They also drew inspiration from other artistic sources, not all of Chinese origin. Their painting came to be known as Bunjinga ("literati painting") or Nanga ("Southern school painting"), both terms of Chinese derivation.

Despite their artistic eclecticism, Japanese literati shared a dedication to Confucian learning and to Chinese poetry, calligraphy, and painting, a posture that both fed on and served as a counterpoint to the cultural values promoted by the shogunal government. Many were also gifted practitioners of arts, such as *haikai* poetry, not associated with China. Literati also maintained

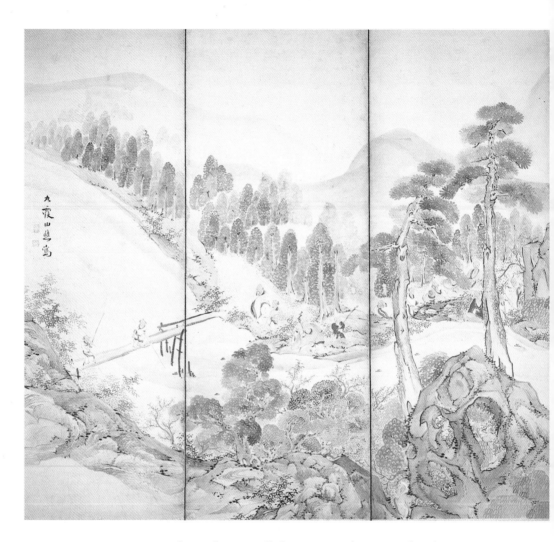

43. IKE TAIGA (1723-76)
The Gathering at the Orchid Pavilion, 1750s. One of a pair of six-panel folding screens, ink and colors on paper, 5'3" x 11'8" (1.6 x 3.5 m). Mary and Jackson Burke Foundation, New York.

Inspired by a legendary gathering of scholars and poets on the banks of a winding stream, this theme was emblematic of the refined world of Chinese culture to which literati aspired.

that as "amateurs" they possessed a personal and artistic integrity lacking among "professional" Kano and Tosa painters. This self-image was manifested in the high premium they placed on individual creativity.

The attractions of a life devoted to self-cultivation cut across class lines. Nankai and Kien were well-educated clan officials who resigned from their posts because of an unwillingness to conform. Hyakusen came from a family of pharmacists. For these men, painting was initially an avocation that only later became a means of livelihood. Ike Taiga and Yosa Buson (1716-83) came from more humble backgrounds. Their adoption of the literati mode reflected a yearning for the cultural cachet of the Chinese tradition that was shared by many commoners in and around Kyoto. It also gave them a freedom to experiment not available

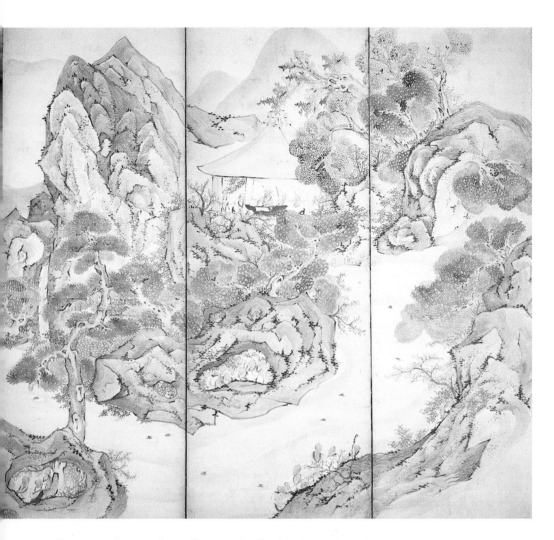

to adherents of more formally organized schools. Both artists were openly professional and often carried out commissions for large-scale sliding- and folding-screen compositions, genres of painting that were in theory disdained by literati.

Taiga was a self-educated painter who was born and lived much of his life in and around Kyoto. His many talents and unconventional lifestyle made him a celebrity even during his lifetime. Like other early literati painters, Taiga developed as an artist in a relatively haphazard way, through contacts with other artists, through the study of newly imported Ming and Qing paintings, and by borrowing from the Japanese pictorial tradition, most notably the Rinpa school, a pervasive influence in Kyoto artistic circles. Woodblock-printed books such as the *Mustard Seed Garden Painting Manual* (Jap.: *Kaishien gaden;* 1748-53)

44. Ike Taiga (1723-76)
The Gathering at the Orchid Pavilion, 1750s (detail).
Mary and Jackson Burke Foundation, New York.

The genial gentleman seated with brush in hand before the red lacquer table may represent Wang Xizhi, the fourth-century Chinese poet and calligrapher whose verses immortalized the gathering at the Orchid Pavilion.

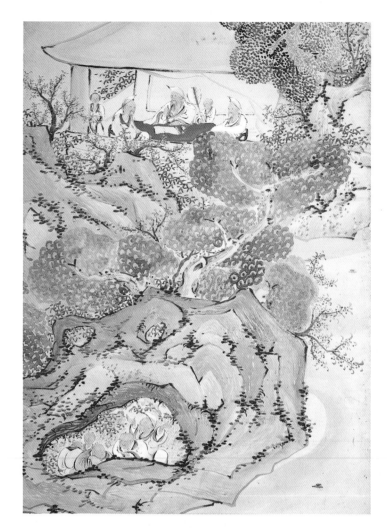

and the *Painting Manual of Eight Styles* (Jap.: *Hasshū gafū*; 1672) also exerted a profound influence on his work (see FIG. 21). Taiga's internalization and synthesis of these influences are evident in the spatial structure and richly coloristic patterns of dots and texture strokes characteristic of many of his paintings (FIGS 43 and 44).

As discussed more fully in chapter five, Taiga also educated himself through travel, which afforded him the opportunity to observe and record the topography of famous places throughout the country, infusing his work with a new visual realism. To support himself on the road, he offered demonstrations of finger-painting, a Chinese technique practiced earlier by Kien that was emblematic of the kind of eccentricity espoused by many literati; at the same time this revealed Taiga's recognition of the promotional value of public spectacles (see FIG. 19).

Buson was also a multi-talented artist of humble origins. Born in a suburb of Osaka to a farming family, he traveled as a youth to Edo to study poetry with a disciple of the great *haikai* master Matsuo Bashō (1644-94). Later, in homage to Bashō, Buson retraced his travels to the northern regions of the country, establishing in the process a network of rural patrons for his poetry and his painting. Buson first became familiar with literati painting through Hyakusen, whom he met in Kyoto during the last years of his life. After settling permanently in Kyoto in 1757, Buson became prominent in the city's cultural life, and used the membership fees and personal connections from the *haikai* poetry society he founded to help support himself and other artists in his circle.

Buson's painting defies easy categorization. Above all, he was a master of the genre known as *haiga* ("*haikai* picture") an often spontaneous pictorial style that employed only a few strokes of the brush to create a pictorial effect analogous, in its economy and its representation of a moment frozen in time, to that of a seventeen-syllable *haikai*. His work in this genre is discussed more fully in chapter five. He painted airy, light-filled, seasonal landscapes evoking the countryside around Kyoto that reveal his unusual sensitivity to the nuances of color and texture. He also created large-scale figural compositions inspired by the work of professional painters of the Ming dynasty, whose work had been introduced to Japan by Ōbaku monks and Chinese traders.

Taiga died in 1776 and Buson in 1783, leaving the literati movement without strong leadership in Kyoto and giving rival schools of painting an opportunity to build a strong patronage base. Kyoto regained its pre-eminence as a center for literati artists only after Rai San'yō (1781-1832) settled there in 1811. A charismatic historian, poet, painter, and calligrapher originally from Aki, a feudal domain in modern Hiroshima Prefecture, San'yō founded a private school in Kyoto that attracted students from all over the country. As the author of an influential history of Japan that voiced support for the imperial institution, he became a leading figure in the critique of the shogunal government. The artists who gathered around San'yō came from as far away as Osaka, Nagoya, and even Kyushu.

The artists in San'yō's circle recoiled from shogunal authoritarianism even as they sought to create their own dynastic lineages, thus transforming Bunjinga into one of the recognized schools of Kyoto painting. Participation in the literati movement initially had been based on elective affinity, but its nineteenth-century adherents tended to be more doctrinaire, with the result

that both artistically and intellectually the movement lost something of its early exuberance and diversity. While some artists painted in an individualistic manner, others stressed the importance of fidelity to the themes and brush techniques of Ming and Qing painting. This development, which went hand in hand with efforts to ensure preservation of their personal styles by training their sons as their artistic heirs, was symptomatic of increasing competition among Kyoto artists.

The practice of literati painting, which since its onset involved a special consciousness of the power of the individual imagination and a detachment from the mundane, challenged the pragmatic Confucian values espoused by the government. This dissident undercurrent intensified in nineteenth-century Kyoto, as more and more samurai, who had either resigned from or lost posts within the feudal government, identified themselves as *bunjin*, and sought to earn a living by teaching and selling their painting in the city and surrounding provinces. Literati painters in the Kansai region expressed their political and social disaffection by adopting a self-consciously bohemian lifestyle and by glorifying in their painting the life of the Chinese scholar-recluse and the pristine beauties of the natural world.

The life and accomplishments of the versatile Uragami Gyokudō (1745-1820) are characteristic of the generation of literati artists following Taiga and Buson. An official in the service of the feudal lord in Bizen (modern Okayama Prefecture), he quit his post at the age of fifty to devote himself to calligraphy and painting, and especially to poetry and music. He was so devoted to the Chinese zither (*qin*) that he named his sons Shunkin (Spring Zither) and Shūkin (Autumn Zither). After seventeen years of wandering throughout Japan, he finally settled in Kyoto with his sons, gifted painters in their own right. Most of his paintings date from this period (FIG. 45).

Aoki Mokubei (1767-1833) was another member of San'yō's circle with wide-ranging interests and talents. The son of a Kyoto restaurateur and brothel-keeper, he studied under Kō Fuyō (1722-84), a painter, seal-carver, and connoisseur, and close friend of Taiga. Although Mokubei was an accomplished painter of landscapes, he also helped to reinvigorate ceramics production in Kyoto, which had been in decline since Kenzan's death, by developing wares for *sencha* (steeped tea), the drinking of which was popular among San'yō's literati friends. After studying with Okuda Eisen (1753-1811), a local potter specializing in porcelain, he produced porcelains and stonewares decorated with overglaze enamels in imitation of those imported from China. Both his

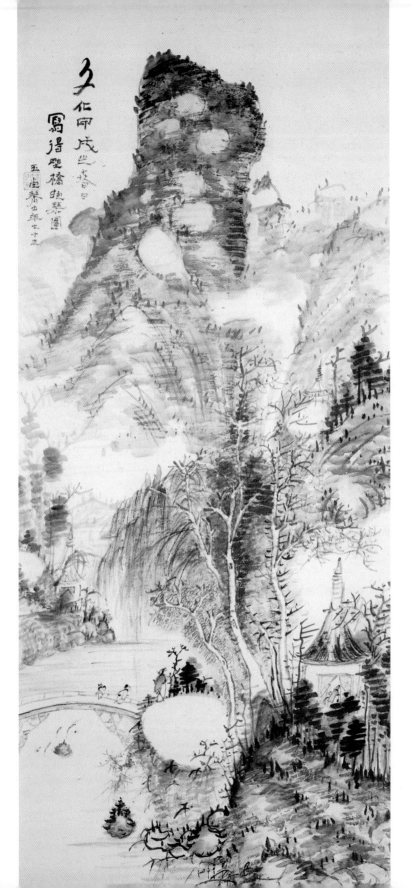

45. Uragami Gyokudō
(1745-1820)
*Crossing a Bridge
Carrying a Qin*, 1814.
Hanging scroll, ink on
paper, 4'2" x 20½"
(127 x 52 cm). Mary and
Jackson Burke Collection,
New York.

Stylistically, Gyokudō was
something of a maverick,
painting landscapes in
broad, ink-saturated
strokes and dots, a style
only remotely derived
from Chinese models.
He was especially fond
of painting views of mist-
covered mountains.

Above 46. AOKI MOKUBEI (1767-1833), attr.
Tiered food box, early nineteenth century. Porcelain
with decoration in overglaze enamels, width 5¾"
(14.9 cm). Victoria and Albert Museum, London.

This tiered box for use in *sencha* is decorated with
colors and auspicious motifs that reflect the artist's
fascination with Chinese culture.

Right 47. MIKUMA KATEN
Ike Taiga and Gyokuran in their Studio, from
Biographies of Eccentrics of Recent Times (*Kinsei kijin
den*), 1790. Woodblock-printed book, 10½ x 6½"
(26 x 16.5 cm). Ravitz Collection, Santa Monica.

The two painters play music in their crowded studio
surrounded by paintings, calligraphy, books, brushes,
and other paraphernalia associated with the literati
ideal. This fanciful image was inspired by anecdotes
about Taiga and Gyokuran's eccentricity.

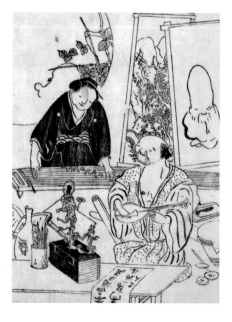

painting and his pottery feature imaginative motifs painted in strong, saturated colors (FIG. 46).

The practice of Bunjinga implied not only a certain artistic stance but also more egalitarian personal relationships than were the norm among other artistic groups. This more democratic outlook extended to relations between the sexes. While women of all classes studied painting and participated in family-run workshops, they were generally denied the personal recognition accorded their male counterparts. Literati circles, by contrast, welcomed women of literary and artistic talent, regardless of social backgrounds. Taiga's pupil and wife, Gyokuran (1727-84), for instance, was recognized as a gifted poet and painter of orchids (FIG. 47).

By 1830, the number and stature of Kyoto's women artists were such that they were accorded their own listing among the 160 painters identified in *Who's Who in Kyoto* (*Heian jinbutsu shi*). The recognition of female literati artists was one of many signs of the nineteenth-century linkage of unconventional behavior and artistic creativity.

The Maruyama-Shijō School

In 1720, as part of its Kyōhō era (1716-36) reforms, the shogunal government lifted the ban on imported books, a development with profound artistic consequences throughout the country. Although Japanese artists had been exposed to Western chiaroscuro

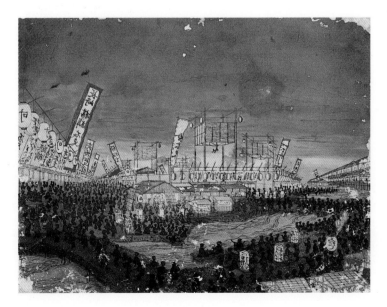

48. MARUYAMA ŌKYO (1733-95)
The Riverbed at Shijō, 1760s. Hand-colored woodblock print, 8¹/₈ x 10¹/₂" (20.8 x 27 cm). Nagasaki Prefectural Art Museum.

In this bustling nocturnal scene designed for viewing in a stereoscopic device, figures are silhouetted against the lantern-lit restaurants and theaters. An acrobatic performance dominates the background.

and vanishing-point perspective in the late sixteenth century, the
use of Western pictorial techniques soon fell victim to the Toku-
gawa's xenophobic policies and died out. Renewed access to
Western themes and styles, often by way of Chinese books, to-
gether with the public's taste for novelty, spurred interest in illu-
sionistic techniques among Edo printmakers in the 1730s. In
Kyoto, the impact of these developments was manifested twenty
years later in the art of Maruyama Ōkyo.

The founder of an enormously influential school of painting,
Ōkyo was among the first artists to recognize these new modes
of representing volume and space as more than amusing novel-
ties. He learned one-point perspective and chiaroscuro chiefly
from hand-tinted topographic prints produced in the Chinese
city of Suzhou that reached Kyoto via Nagasaki. Initially, he
adopted these techniques to create pictures of local and foreign
scenes for use in stereoscopic devices that were a popular form of
entertainment at fairs and carnivals. His celebration of scenic
spots in Kyoto in this novel manner no doubt contributed to his
initial success (FIG. 48). Later, he skillfully applied many of these
European principles to large-scale figure and landscape painting
(FIG. 49).

During the last decade of his life Ōkyo and his studio
received a number of commissions that would have once been
awarded as a matter of course to artists of the Kano school. These
included cycles of painting for the sliding screens in temples and
shrines in and around Kyoto, and even for institutions as far
away as the island of Shikoku. Moreover, in 1789-90, Ōkyo and
his students took charge of the renovation of the sliding-screen
paintings in one of the palaces of the imperial compound dam-
aged by fire in 1788. Ōkyo may have been awarded this presti-
gious commission through his friendship with the elder brother
of Emperor Kōkaku (r. 1780-1817).

Ōkyo's carefully observed sketches of flora and fauna brought
a new empiricism to this traditional genre. His understanding of
human anatomy, the result of sketching from life and attending
dissections of cadavers, an unusual activity for an artist at the
time, also influenced the development of figural painting in
Kyoto. His pictures of beautiful women (*bijinga*) have a sense of
corporeality unique among works of his era. However, while
sketching after nature remained an important part of their artis-
tic training, his followers tempered the scientific objectivity that
was Ōkyo's personal hallmark with a more delicate and, some-
times, sentimental quality that found great favor in Kyoto and
Osaka, although it was less congenial to audiences in Edo.

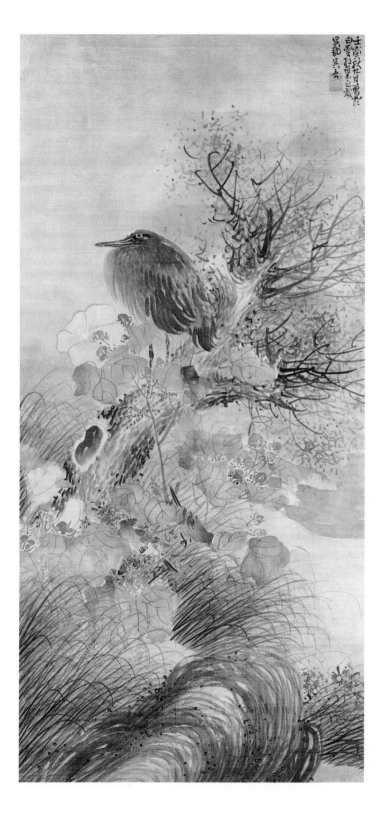

50. MATSUMURA GOSHUN (1752-1811)
Hibiscus and Blue Heron on a Tree Stump, 1782. Hanging scroll, ink and colors on silk, 50 x 23½" (126 x 60 cm). Kurokawa Kobunkan Kenkyūsho, Hyōgo.

Both in poetic quality and in brushwork, this work is more indebted to Buson than to Ōkyo. The long fibrous and short feathery brushstrokes used in rendering the foliage are particularly reminiscent of Buson's style.

This aesthetic shift was led by Matsumura Goshun (1752-1811), a talented painter who became the founder of the Shijō branch of the Maruyama school, named after the avenue in Kyoto where he and many of his disciples lived. Goshun belonged to a distinguished Kyoto family that had been employed for generations by the Office of the Mint. Like the Ogata brothers, he took up painting and poetry as an avocation and became a professional only because of financial problems following the death of his father. In his youth he studied under Buson, developing as a skillful painter of *haiga*, and also absorbing elements of the literati style. After the latter's death, however, he was increasingly drawn to the style of Ōkyo, who had become the leading artistic personality in Kyoto. Goshun retained the shading techniques developed by Ōkyo, but de-emphasized the use of perspective in favor of translucent colors and a more decorative handling of space (FIG. 50). Ōkyo and Goshun trained many talented artists in their studios. While most remained in Kyoto, others established their own studios in Osaka and Edo, adapting Maruyama-Shijō themes and styles to local tastes.

Artists of the Maruyama-Shijō and literati schools had much in common. Both drew artistic and intellectual inspiration from sources outside the official pictorial tradition, shared an interest in the natural sciences, and adopted to varying degrees an empirical approach inspired by careful observation of their surroundings. Initially a cordial relationship prevailed between the two schools, many of whose members lived in the vicinity of Shijō Avenue and moved in the same cultural circles. The nineteenth-century transformation of the literati movement into a more formal lineage guided by Chinese artistic theory and practice, however, created a growing distance between them. This schism was exacerbated by the favor Maruyama-Shijō painting enjoyed among Kyoto audiences, and the resulting expansion of its studios.

The Maruyama-Shijō's prominence in the Kyoto art world is evident in the evolution of the Higashiyama art exhibition, one of Kyoto's major cultural events. Minagawa Kien (1734-1807), a noted Kyoto Confucian scholar and amateur literati painter and calligrapher, organized the first exhibition in the city's Higashiyama or Eastern Hills District in 1792. It was such a resounding success that it attracted contributors and art collectors from all over the country and continued to be held each spring and autumn until 1864. Initially, submissions came from all schools of Kyoto painting, offering viewers a unique opportunity to appreciate the range of artistic activity in the city. In 1794, the roster of participants included Gyokudō and his two sons, who exhib-

ited a series of jointly brushed fan paintings. In 1796, there were ninety-seven participants from all over the country, among them Kyoto artists of the Maruyama-Shijō, Tosa, and Kano schools, as well as independents such as Itō Jakuchū (1716-1800). Tani Bunchō (1763-1840), a prominent Edo artist, and several painters from Osaka also contributed works. However, artists of the Maruyama-Shijō and their affiliated studios monopolized later exhibitions, confirming their status as the dominant school of painting in Kyoto.

Individualists: Jakuchū, Shōhaku, and Rosetsu

The growing popularity of the Higashiyama and other public exhibitions changed the artistic climate in Kyoto. While town painters (*machi eshi*) had been selling their work in shops since the beginning of the period, established painters were more dependent on commissioned work. In such a climate, artists belonging to a school with a well-developed network of patrons were at a distinct advantage. The rise of public exhibitions contributed to the weakening of the atelier system by offering enterprising independent artists new venues for display and personal recognition. As commercial competition intensified, many Kyoto painters, as well as their friends and disciples, became adept in manipulating the social mechanisms of artistic celebrity through the creation of biographies that accentuated those personal qualities thought to be desirable in an artist.

The publication of *Biographies of Eccentrics of Recent Times* (*Kinsei kijin-den*) and *Who's Who in Kyoto* (*Heian jinbutsu shi*) was symptomatic of this trend. First issued in Kyoto in the last decades of the eighteenth century, they proved so popular that updated and expanded editions appeared regularly until the Meiji era (after 1868). Both contain biographical sketches of cultural figures thought to possess that mysterious "otherness" associated with creative genius. The imaginative illustrations were often as influential as the text in shaping popular perceptions of many artists (see FIG. 47).

Although Itō Jakuchū, Soga Shōhaku (1730-81), and Nagasawa Rosetsu (1754-99) had radically different artistic visions, all three are generally classified as eccentrics (*kijin*), individuals whose personalities and activities transcend the boundaries of normal behavior. The link between eccentricity and artistic creativity had deep roots in both Zen Buddhism and Daoist philosophy, but from the late eighteenth century onwards it became emblematic

of resistance to Confucian rationality and the state's control of the individual. Their biographies are replete with anecdotes extolling their unconventional behavior and divine skills.

Reclusiveness, deeply felt religious convictions, and an uncanny ability to imbue even the most mundane subjects with a mysterious, supernatural quality all contributed to the popular image of Jakuchū as an artist outside the norm. His painting runs the gamut from meticulously rendered, luminously colored compositions on silk to ink monochromes brushed in a highly expressive manner on paper. Little is known of his training, but in all likelihood he studied under Ōoka Shunboku (1680-1763), an Osaka artist of Kano affiliation known for his printed compendia of Chinese and Japanese paintings.

Like the sons of many prosperous Kyoto merchant families, Jakuchū seems to have first taken up painting as a hobby. He turned to it on a full-time basis only when he was forty, after ceding management of the family greengrocer business to his younger brother. Initially he enjoyed relative financial security, but this changed after the great Kyoto fire of 1788 destroyed the family business, its many properties, and Jakuchū's studio, which is thought to have been situated on the banks of the Kamo River between Shijō and Gojō Avenues. For Jakuchū, as for many of his peers, the years following the fire were marked by more overtly commercial activities.

Daiten Kenjō (1719-1801), the abbot of Shōkokuji, one of Kyoto's leading Zen temples, was influential in Jakuchū's religious and artistic development, enabling him to study and copy at his leisure rare Chinese and Japanese paintings in Shōkokuji and other temple collections. Friendships with monks of Manpukuji gave him still further access to works imported from China, as well as to Japanese paintings in the realistic Nagasaki style discussed in chapter four. For Jakuchū, who appended the epithet *koji* (Buddhist layman) to many of his works, painting became a form of religious discipline and spiritual expression. Buddhist faith was so entwined with his personality that many works that appear to be of a secular nature were in fact religiously motivated.

His *magnum opus*, a series of thirty large, intricately painted scrolls representing an encyclopedic array of flora and fauna of land and sea, was designed to be displayed around paintings of the historical Buddha, Shakyamuni (Jap.: Shaka), and two attendant Bodhisattvas (Jap.: Bosatsu). They were painted expressly for Shōkokuji and the temple's annual display of this profoundly moving and intensely personal vision of the unity of all living

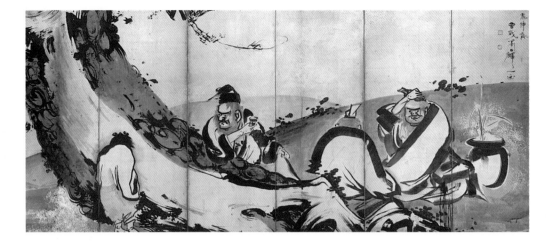

beings no doubt contributed to legends of Jakuchū's divinely inspired artistic gifts. Jakuchū returned to these themes, developing them in a number of ways in many of his later works (see FIG. 29, page 51).

Biographies of Soga Shōhaku often include references to his painting while intoxicated, an artistic practice with precedents among Chinese artists. This tradition was no doubt inspired by his strong, idiosyncratic brushwork, striking contrasts between dark and light, and predilection for off-beat subject-matter (FIG. 51). Shōhaku studied briefly under a minor Kano master but eschewed formal ties to any workshop, choosing instead to identify himself with the Soga, a line of monk-painters active at Daitokuji during the Muromachi period (1333-1573). While themes from Chinese lore and the Zen pictorial repertory figure prominently in his work, stylistically he is indebted to Japanese artists such as Kano Sansetsu and heterodox Chinese painters of the late Ming period.

Breaking away from an established studio was not uncommon, but artistic survival was more precarious without the backing of such an organization. That Nagasawa Rosetsu was able to thrive testifies both to his talent and to exaggerated accounts of his rupture with his mentor, Maruyama Ōkyo. Rosetsu belonged to a low-ranking samurai family and had served feudal lords in regions just outside Kyoto before entering Ōkyo's studio. However, his personal and artistic idiosyncrasies were apparently incompatible with the routine of the workshop system, and he soon set off on his own. By 1782, when his name first appeared in *Who's Who in Kyoto*, he was recognized as one of the leading talents in the city.

51. SOGA SHŌHAKU
(1730-81)
Four Sages of Mount Shang,
second half of the eighteenth century. One of a pair of six-panel folding screens, ink and gold on paper, 5'1½" x 12' (1.5 x 3.6 m). Museum of Fine Arts, Boston.

The four sages of Mount Shang are legendary Chinese figures who retreated to the mountains after refusing to serve an immoral minister. The broad, powerful brush-strokes that delineate both the contorted pine and the figures are characteristic of this artist's individualistic style.

An artist of boundless energy and versatility, he carried out, over several months in 1787, a major painting commission for three temples, Sōdōji, Muryōji, and Jōjuji in the southern part of Kii Province (modern Wakayama Prefecture). This monumental project consisting of a hundred and eighty sliding screens is a compendium of Rosetsu's novel and often witty interpretations of motifs drawn from Ōkyo's repertory. Although his fascination with scientific perspective and his use of the "boneless" style (*mokkotsu*) reveal Ōkyo's influence, he often used these strategies to very different ends. Whereas Ōkyo took pride in his scientific detachment, Rosetsu took a childlike delight in startling and amusing the observer. The whimsical interplay of distance and identification characteristic of many of his works was achieved by unexpected juxtapositions of the familiar and the exotic, large and small (FIG. 52). Rosetsu had a wide following among Kyoto townspeople.

The Yamatoe Revival

The fire of 1788, which destroyed the imperial palace as well as the residences and studios of many of Kyoto's artistic luminaries, marked a dramatic turning-point in the city's cultural life. The rebuilding and redecoration of the palace was carried out between 1789-90, at a time when several years of poor rice harvests and inflationary prices had led to riots and unrest throughout the country. To improve conditions, the shogunate's senior councillor Matsudaira Sadanobu (1758-1829) promulgated a series of economic and social reforms, which came to be known as the

Kansei Reforms, after the era when they were enacted. However these did little to quell the pervasive sense that the shogunate had become corrupt and ineffectual, or to stem the conviction that only by reviving the pristine values of the past could the nation regain its proper moral compass.

Local artists participated to an unprecedented extent in the decoration of the palace, underscoring changes in Kyoto's relationship to Edo. Since the opening years of the Edo period, the task of painting the sliding screens in the three main palaces on the imperial compound had been entrusted to artists of the Edo branch of the Kano school, with local Kano and Tosa artists assisting them. In 1789 however, Sadanobu, under whose auspices the work was carried out, agreed to Emperor Kōkaku's request that the palace be rebuilt in its original Heian-period style. The two main ceremonial buildings were accordingly decorated by Kano and Tosa artists following ancient models. At Kōkaku's request also, Maruyama-Shijō painters were entrusted with the decoration of a third palace. (The entire palace complex was destroyed in 1854.)

The Heian style of decor chosen for the two main palace buildings reflected a growing antiquarianism and nativism, centering on glorifiication of the imperial institution and its cultural legacy. This movement was led by scholars of "National Learning" (Kokugaku), whose study of works associated with the Heian nobility, such as the *Tale of Genji,* contributed to a surge of interest in Japanese history and literature. These scholars' efforts to identify peculiarly Japanese cultural elements in native literary works also prompted painters to investigate and copy

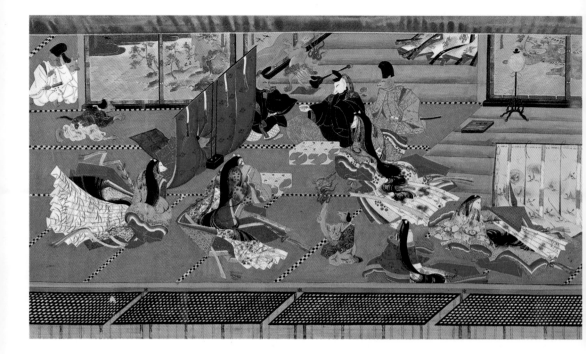

53. UKITA IKKEI (1795-1859)
*Tales of a Strange Marriage
(Konkai zoshi)* 1850s
(detail). Handscroll, ink and
mineral pigments on paper,
12″ x 25′7″ (30 cm x 7.8 m).
Metropolitan Museum of
Art, New York.

This narrative handscroll
depicts the preparations for
and betrothal of a fox and a
vixen. The brilliant mineral
pigments and pictorial style
make visual reference to the
*Miracles of the Kasuga
Shrine,* a handscroll painted
by a fourteenth-century
court painter.

ancient Yamatoe narrative handscrolls, and other paintings believed to have been produced by artists of the imperial painting atelier.

These developments were the impulse for the revivalist movement dominated by Tanaka Totsugen (1760-1823) and his pupils Ukita Ukkei (1795-1859) and Reizei Tamechika (1823-64). Totsugen, who had studied under masters of both the Kano and Tosa schools, had been among the Kyoto painters engaged to work on the palace in 1789-90. Ikkei and Tamechika participated in the decoration of the palace after the 1854 fire. In preparation for these projects, all had had the opportunity to study and copy Heian- and Kamakura-period paintings, adapting what they learned to create original works. Yamatoe Revival (Fukko Yamatoe), the name by which this movement is known today, acknowledges its debt to classical Japanese themes, styles, and color schemes.

Ikkei's blend of reverent antiquarianism and satirical reinterpretation of time-honored themes reveals a social and artistic ambivalence widespread among artists active during the last quarter century of Tokugawa rule. It is this quality that gives his *Tales of a Strange Marriage (Konkai zoshi)* its edge (FIG. 53). Since the pictures are not accompanied by an explanatory text, it is not clear whether this scroll is merely whimsical or bitingly satirical.

Representations of animals, insects, and imaginary creatures engaged in human activities were common in the arts of the nineteenth century, and many had hidden political meanings. It was once thought that Ikkei painted this scroll as a comment on the betrothal in 1858 of Princess Kazu, sister of Emperor Kōmei (r. 1846-67), and the fourteenth shogun Iemochi (1846-66). The marriage was part of the shogunate's efforts to smooth relations with followers of the increasingly powerful and vocal imperialist movement. Although recent scholarship has questioned this interpretation, there is no doubt that many of Ikkei's works have political overtones. Indeed his involvement with the imperialist faction in Kyoto eventually led to his arrest and execution.

By the opening decade of the nineteenth century, the art-historical consciousness stimulated by the reconstruction of the imperial palace in 1789 had spread from Kyoto to other cities, embracing artists of widely disparate backgrounds. While artists of the Fukko Yamatoe movement sought through their study of classical painting to understand and recapture ancient Japanese life and values, others directed their attention to Japanese painters of later periods, such as Kōrin, and still others combined the study of Japanese and Chinese antiquity. These developments contributed to a growing sense of national artistic identity that would crystallize in the Meiji era.

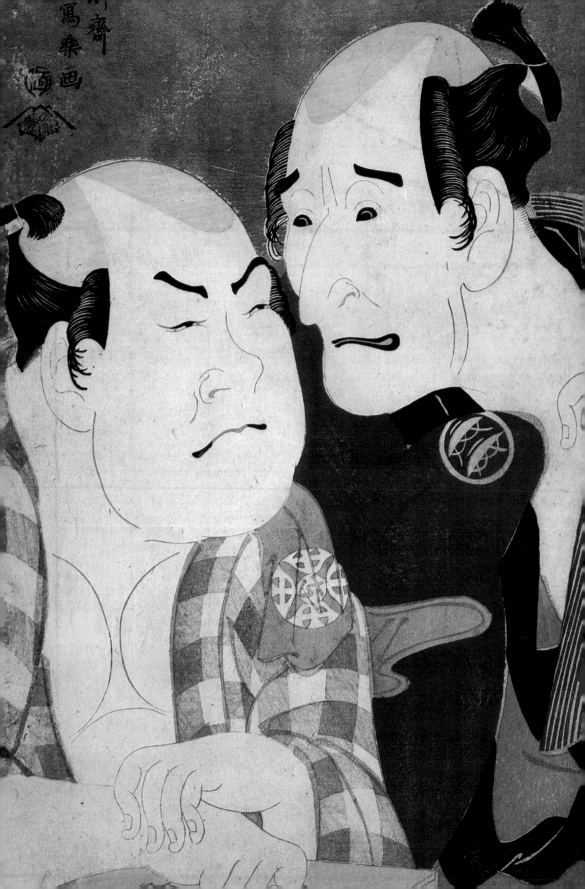

THREE

Edo Artists

Artistic developments in Edo, as in Kyoto, were inseparable from the shared experiences of urban life. The shogunate, which had made this city its administrative and political headquarters, sought to enforce cultural control over its vast and heterogeneous population by endorsing and promoting art forms that supported its ideology. However, these efforts met with only limited success. Art is by nature a bridging activity that allows individuals to construct identities for themselves through elective affinity, and in Edo, as in other cities, activity across classes flourished despite the official compartmentalization of society. The creative energies unleashed by this social mix were given their most eloquent expression in the woodblock print.

When Ieyasu made it the nation's administrative headquarters in 1603, Edo was little more than a swampy village. Within a hundred years it had become the largest city in the world, boasting a concentration of political, military, and economic might unmatched by any other city in Japan (FIG. 55). Despite its explosive growth, initially the city lacked the accoutrements of culture, and in the seventeenth and early eighteenth centuries, luxury goods such as silk, lacquer, ceramics, and paintings had to be imported from Kyoto, usually by sea via Osaka. This cultural backwardness was reflected in the contemporary pejorative *kudaranai*, used to describe a product so shoddy that it could not be sold even in Edo.

Edo first sought to challenge the prestige of Kyoto and Osaka in the cultural realm by appropriating the Kano and Tosa schools, but their officially sanctioned forms of artistic expression were

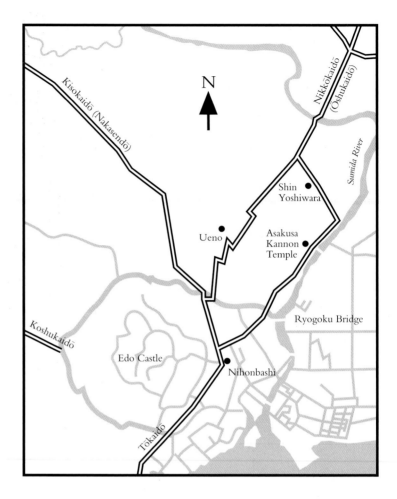

55. Map of Edo with major landmarks mentioned in the text.

soon challenged by newer ones created and supported by the merchants, artisans, and lower-level samurai who constituted the bulk of the population. Whereas painting, ceramics, lacquer, and textiles were all central to the artistic life of Kyoto, woodblock prints and illustrated books were the cornerstones of Edo art, overshadowing all other media in number, variety, popularity, and socio-economic importance. So closely were such prints identified with this city that they were commonly referred to as *Edoe*, "Edo pictures," or *Azuma nishikie*, "Eastern brocade pictures" (Edo being in the Kantō or eastern part of the country). Prints capture better than any other medium Edo's distinguishing cultural traits – a love of bravura, novelty, and wit; pride in local landmarks; and, especially in the final years of Tokugawa rule, imaginative and cynical social and political satire.

Artistic production in Edo was by no means limited to prints. Most designers of woodblock prints were also skilled painters,

but painting tended to appeal to a more affluent clientele and its market was more limited than that for prints, a successful run of which might number in the thousands. While painters of the Kano and Tosa, and to a lesser extent, Rinpa and literati styles flourished in Edo, they did not capture the public's hopes and dreams as did their *ukiyoe* counterparts. As a witty eighteenth-century epigram had it, "Neither the Kano nor the Tosa can paint it: Main Street, Yoshiwara."

When Edo was laid out, it was conceived as a spiral with a castle in the center and all major roads and waterways emanating from it like the spokes of a wheel. The cool, hilly areas surrounding and to the west of the castle, which were known as the High City or Yamanote, were reserved for the daimyo and their retainers, and the less salubrious, low-lying areas to the east, the Low City or Shitamachi, were for the merchants and artisans (FIG. 56). Despite legislation to ensure segregation according to class or occupation, as well as sumptuary laws designed to maintain distinctions between dwellings of different classes, increasing affluence among artisans and merchants led to less clearly defined residential patterns as well as to some blurring of social distinctions. The practical requirements of daily life in the city – especially the need for easy access to services and goods – also fostered the development of self-contained, mixed neighborhoods where residents could conveniently acquire all their supplies.

The segregation of samurai and townsmen began to break down after the fire of 1657 destroyed two-thirds of the city and more than 100,000 of its inhabitants lost their lives. In keeping with the shogunate's more pragmatic approach to urban planning, daimyo and their retainers were encouraged to build residences in various parts of the city, and shrines, temples, and even the new official brothel district were moved beyond its outskirts. *Chōnin*, however, continued to live in Shitamachi, tightly packed into single-storey, wooden terraced houses. This area, much of it reclaimed land criss-crossed by canals and bridges, was the heart of the city's vigorous commercial and artistic life.

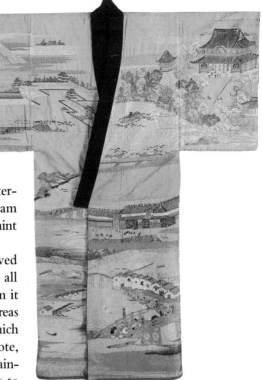

56. Robe (*juban*) with scenes of the city of Edo, mid-nineteenth century. Cotton thread embroidery of grey, plain-weave cotton, 4'9" x 3'11½" (1.4 x 1.2 m). National Museum of Japanese History, Nomura Collection.

The design of this man's under-robe incorporates Edo's major landmarks. A view of Edo Castle with Mount Fuji in the distance and a daimyo procession extend across the shoulder and sleeves. In the middle is Nihonbashi ('Japan Bridge'), starting point for all roads out of the city. The Sumida River, the city's main waterway, dominates the lower front. A detail of the back of the robe is reproduced in the frontispiece.

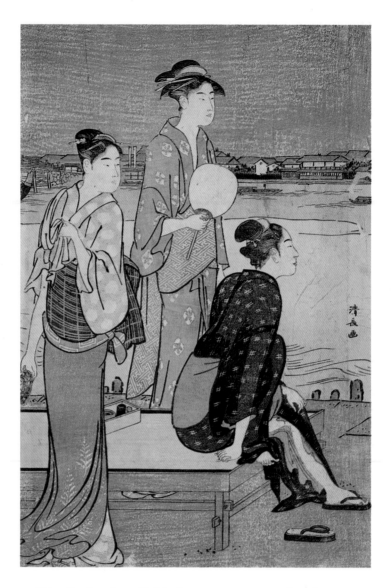

Edo Castle, the official city center, was a colossal structure whose central grounds alone covered some 181 acres, an area deemed large enough to house 260 daimyo and 50,000 soldiers in case of attack. Because of their scale and cost, Ieyasu's expansion and redecoration of the existing castle required thirty years to complete. Until it was destroyed by the fire of 1657, its five-storey donjon, 192 feet (58.4 m) from ground-level to top and towering 275 feet (84 m) above Tokyo Bay, was rivalled only by Mount Fuji, one hundred miles (62 km) southwest of the city. The spiral-shaped moat surrounding the castle merged into the estuary of the Sumida River, one of the city's three major waterways.

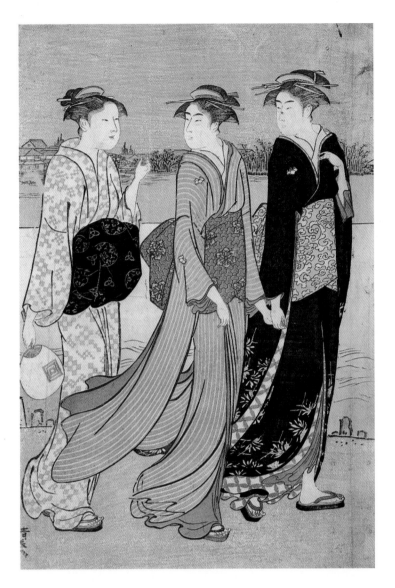

57. TORII KIYONAGA
(1752-1815)
*Cooling off by the Sumida
River,* c. 1784-85. Diptych
ōban woodblock print.
British Museum, London.

Kiyonaga specialized in
diptychs and triptychs
featuring fashionably
dressed beauties against
scenic views of Edo. The
backdrop here is the
Sumida River, along whose
distant banks may be seen
restaurants and warehouses.

 The Sumida River was both the physical and symbolic link
between the two poles of cultural life in the city: Edo Castle
(Edojō), where the shogun and his entourage resided, and the
"Nightless Castle" (Fuyajō), where the city's much-vaunted court-
esans lived (FIG. 57). The first government-sanctioned pleasure
quarter was located in the town center, in a swampy area called
Yoshiwara to the east of Nihonbashi, the bridge in the center of
Edo that was the starting point for the Tōkaidō and all other main
roads out of the city (FIG. 58). After the 1657 fire it was relocated
on the northeastern outskirts, roughly three miles (5 km) from
Nihonbashi, and designated Shin Yoshiwara (New Yoshiwara).

58. Hishikawa Moronobu *Edo Castle and the Tōkaidō Road*, from *A Measured Pictorial Map of the Tōkaidō* (*Tōkaidō bunken ezu*) 1690 (detail). Woodblock-printed book, 10¼ x 5" (26 x 13 cm). Ravitz Collection, Santa Monica.

Moronobu's guidebook is in the form of a folding book, a format well suited to the traveler's needs. This section shows the first three stages of the Tōkaidō Road: Nihonbashi, the traditional starting point, followed by Kyōbashi, and Shinbashi. Edo Castle is on the upper right.

The boundaries of this new licenced quarter were clearly marked by walls and a moat, and entry was through a single gate that made it easy to monitor the comings and going of both visitors and inhabitants. Because of its distance from the city center, visits to Shin Yoshiwara became pleasure outings in their own right. Tea-houses and restaurants were opened along the banks of the Sumida River, the customary route being by boat.

Although the government discouraged frivolity and idleness, warriors frequently sought the distractions and sensual pleasures of the pleasure quarters as relief from the responsibilities and oppressive routines of official life. Activities in the castle and mansions of the feudal lords were dominated by ceremony and ritual in which every detail was laid out and fixed according to precedent and minute social distinctions. Those centered in the Shin Yoshiwara, on the other hand, while not without their traditions and hierarchies, defied class and rewarded inventiveness. It was in this setting, where money and taste mattered more than social status, that the government's efforts to enforce a linear culture were most seriously compromised.

Edo's licenced Kabuki theaters were conveniently situated in the central business districts near Nihonbashi, where they too were readily accessible by boat. However, in 1841, after this area was destroyed by fire, the theaters were relocated to the vicinity of Asakusa temple, one of the city's liveliest recreational centers. The shogunate closely monitored activities in and around the theaters. The size, arrangement, and number of theaters were prescribed, the subject-matter of plays was censored, and actors were forbidden to dress ostentatiously off-stage lest they attract the amorous attentions of their many female fans. In 1714, the Yamamuraza, one of the city's four major theaters, was permanently closed following the discovery of a love affair between a leading actor and a lady-in-waiting in the service of the shogun's mother.

Most of the city's artists, including official painters of the Kano school, lived in Shitamachi. The designers, writers, and publishers of prints and illustrated books lived predominantly in and around Nihonbashi, so as to be near the clientele of the theater and amusement districts. Many of the albums, books, and

broadsheets featuring actors in their starring roles were published by arrangement with these theaters. In the nineteenth century, however, publishers catering to travellers buying prints as souvenirs from the capital moved to the outlying districts, along roads that connected to the Tōkaidō and Kisokaidō, the two main highways linking Edo with Kyoto.

The Kano School and the Realm of the Official Artist

Patronage of selected artists and institutionalization of the expressive and symbolic content of their work in keeping with a rigidly hierarchical canon of taste was central to the Tokugawa strategy of rule. While many artists received shogunal or daimyo commissions at one time or another, those who enjoyed hereditary status as official artists were relatively few in number. In keeping with the Tokugawa's efforts to strengthen its credentials through association with rulers of the past, these artists were predominantly from distinguished lineages earlier patronized by the Ashikaga shoguns. They included painters of the Kano and Sumiyoshi schools, who decorated castles, palaces, and temples, provided instruction in painting, and served as official connoisseurs; metalworkers of the Gotō family, who supplied swords and fittings; and lacquerers from the Igarashi and Kōami families. The latter were entrusted with projects ranging from the lacquer decor inside feudal mansions and Tokugawa mausolea to the creation of ornate lacquer furniture for bridal trousseaux (FIG. 59).

Official artists tended to stress tradition over innovation, a quality that appealed to the ruling elite, but their profession required continual fine-tuning to adjust to changing tastes and conditions. Relations with their patrons were not always smooth, since the bureaucrats who oversaw their activities were not necessarily sensitive in aesthetic matters. This was dramatically highlighted by the suicide of

59. KŌAMI NAGASHIGE (1599-1651)
Hatsune dowry set, c. 1637-39. Lacquer on wood, with gold, silver, and coral. Tokugawa Art Museum, Nagoya.

This set of shelves holding ornate boxes for combs and cosmetics equipment forms part of the luxurious household furnishings included in the bridal trousseau of the eldest daughter of the third Tokugawa, Iemitsu. The decoration, inspired by the *Tale of Genji*, incorporates the triple paulownia leaf, family crest of the groom, who was also a member of the Tokugawa family.

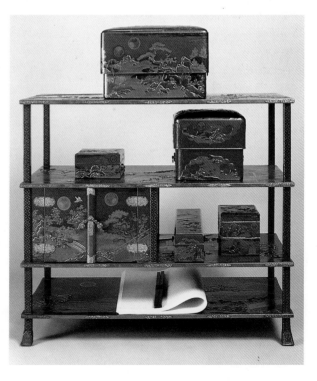

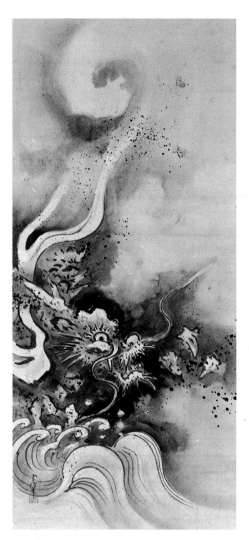

Kano Yūsen (1778-1815) after he had been falsely accused of having cheated the government by scrimping in the use of gold on the background of his paintings. His symbolic protest against shogunal officialdom was, however, an exceptional case.

The Kano school offers a paradigm of the organizational structure, training methods, and aesthetic outlook of the official artist. The Edo Kano was dominated by four schools, known after their locations as Kajibashi, Nakabashi, Kobikichō, and Hamachō. These were founded in the early years of Tokugawa rule by Tan'yū, his brothers Naonobu (1607-50) and Yasunobu (1613-95), and by the latter's grandson Minenobu (1682-1709). The successive heads of these schools were designated "inner artists" (*oku eshi*), entitling them to samurai status and its attendant hereditary stipend. "Inner artists" were expected to display their work to the shogun on an appointed day once a month.

"Official artists" (*omote eshi*), consisting of sixteen studios founded by cadet sons, and other branch members of the Kano followed the "inner artists" in status. The leaders of these studios were also awarded shogunal commissions but did not enjoy the same rights or hereditary stipends. Next in the hierarchy were the various branches of the Kano school supported by the daimyo both in Edo and in their domains. In Edo, as in Kyoto, there were also many "town Kano" painters, trained in the Kano studios but lacking the authority to sign and seal their works with the Kano name. Some of these unofficial painters compiled books of Kano pictorial models, thus contributing to the nationwide diffusion of the school's normative themes and styles.

The Kano school's hierarchical structure ensured artistic authority and stability and, by emphasizing the supremacy of diligent practice, was able to maintain the house tradition from one generation to the next. Tan'yū's youngest brother, Yasunobu, made the Kano view quite clear in his *Secrets of the Art of Painting* (*Gadō yōketsu*), in which he declared painters who achieve mastery through dedicated practice to be superior to those with innate talent. While dissenting voices among Kano-

school adherents were rare, literati painters, who stressed the importance of personal expression, were vehement critics of this academic approach.

During the intense building activities of the early years of Tokugawa rule, Kano Tan'yū, the first official shogunal painter, supervised the decoration of Osaka Castle, Nijō Castle, Nagoya Castle (see FIG. 5), the Tokugawa mausoleum at Nikkō, and the keep and palaces at Edo Castle. For his services, he received a mansion at Kajibashi, adjacent to the castle, and two hundred *koku* annually. (A *koku* was a measure of rice, equivalent to 5.12 bushels, thought sufficient to feed one person for a year.) After the mid-seventeenth century, when the burst of construction and decoration had passed, the focus of Edo Kano activity shifted increasingly to the creation of folding screens and hanging scrolls, often diptychs and triptychs featuring flora and fauna, which could be displayed in the large *tokonoma* of audience halls or used for official gift-giving (FIG. 60). The Kano artists' rigid adherence to models, which were jealously guarded as part of the studio's artistic capital, ensured the transmission of such themes and styles from generation to generation (see FIG. 24). Although parts of Edo Castle were destroyed in the periodic fires that swept the city, surviving preparatory sketches made by Kano Seisen'in (1796-1846) are thought to be faithful to the compositional schemes developed by Tan'yū two centuries earlier.

Gifted painters who sought guidance and training in the Kano ateliers but refused to sacrifice their personal style often broke away and founded their own studios. Of these, Kusumi Morikage (fl. 1634-97) and Hanabusa Itchō (1652-1724) were among the most successful. Morikage was one of Tan'yū's leading disciples, favoring landscapes and genre scenes painted in ink and light colors with a delicacy of touch rare in works of the Kano school. Itchō's warm and often humorous scenes of humble activities reflect a sensibility that has much in common with the *haikai* poetry of which he was also an accomplished author (FIG. 61). Itchō also had the distinction of being one of the first

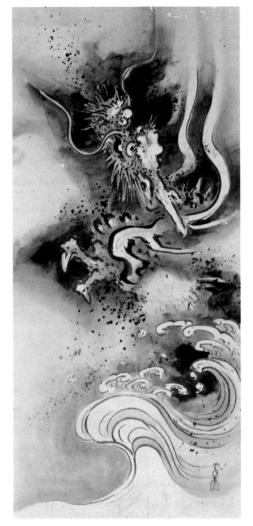

60. KANO TSUNENOBU (1636-1713)
Ascending and Descending Dragons. Two of a set of three hanging scrolls, ink and light colors on paper, each 44½ x 20" (113 x 51 cm). Tokugawa Art Museum, Nagoya.

Painted in the muscular brushwork characteristic of the Kano school, these paintings were designed for display in the *tokonoma* of the *shoin* during official receptions.

Edo artists to be sent into exile by the shogunate. Both Itchō and the print designer Kaigetsudō Ando were punished for their presumed involvement in the 1714 love affair between a shogunal lady-in-waiting and a Kabuki actor of the Yamamuraza theater.

Not all painters who served the Tokugawa shogunate and daimyo belonged to the Kano or Sumiyoshi schools. In the early seventeenth century, the grandson of Tokugawa Ieyasu, Matsudaira Tadanao, lord of Echizen Province (modern Fukui Prefecture), summoned from Kyoto the painter Iwasa Katsumochi (1578-1650). Better known as Matabei, Katsumochi was the son of a feudal lord whose family had been destroyed by Oda Nobunaga in 1579. Matabei was called to Edo to paint articles for the trousseau of the daughter of Tokugawa Iemitsu.

Although trained in Kano and Tosa painting, Matabei was a versatile artist who treated a wide range of Chinese and Japanese subjects in varying styles. Since he was popularly known after his death as "Ukiyo Matabei," it was once held that he was the founder of *ukiyoe*. Questions of attribution abound, but his name is closely associated with many narrative picture scrolls featuring figures with oblong faces and puffy cheeks, including the *Story of Yamanaka Tokiwa* illustrated here (FIG. 62). The blend of nobility and cruelty, the glorification of battle, and the oppression of women in this scroll foreshadow trends in nineteenth-century woodblock prints.

61. HANABUSA ITCHŌ (1652-1724) *Leading a Horse in the Morning Light,* early eighteenth century. Hanging scroll, ink and colors on paper, 12 x 20" (31 x 52 cm). Seikadō Bunko Art Museum, Tokyo.

Developments in Woodblock Prints: 1660-1760

In the aftermath of the 1657 fire, just as Edo's inhabitants reconstructed their physical surroundings in a manner suited to the practical requirements of daily life, so too artists reconstructed the city of their imagination. Woodblock-printed books and single-sheet prints became the chief tools in this process. The artistic vision of the publishers, designers, and writers who collaborated in their creation both stimulated and responded to the growing sense of Edo cultural identity.

Unlike paintings, prints could be produced rapidly, relatively inexpensively, and in large numbers, making them exceptionally responsive to the latest fashion or politics. Prices varied, depending on size and quality, but in the mid-nineteenth century the cost of a single print was roughly the same as a bowl of noodles, a full meal for most commoners. Prints could be purchased from itinerant street vendors or directly from publishers' shops, such as that of Nishimura Eijudō (see FIG. 26). Their owners sometimes pasted them on walls or sliding screens to enhance interior decor. Those issued in large series, an increasingly common practice from the late eighteenth century on, were generally kept in boxes or mounted in albums to be enjoyed at leisure.

The earliest prints were black-and-white illustrations for the new genres of books that emerged in response to a growing demand from an increasingly literate public. These included romances, tales of the supernatural, and humorous stories written in easy-to-read syllabic script, *kana*, rather than the more difficult Chinese characters, *kanji*; guides to famous places in

62. IWASA MATABEI
(c. 1578-1650)
Story of Yamanaka Tokiwa
(detail). Handscroll, ink, colors, and gold on paper, height 13½" (34 cm). MOA Museum of Art, Atami.

This narrative picture scroll, painted in dazzling mineral pigments and gold highlights, is based on the tale of Lady Tokiwa's murder at Yamanaka in Mino Province and her son Yoshitsune's revenge.

Kyoto, Osaka, and Edo; and critiques of courtesans and actors. Hishikawa Moronobu (?1618-94) is thought to be the first print designer to sign his work and, in freeing prints from their secondary role as book illustrations, is often considered the father of *ukiyoe*.

Like most of Edo's great seventeenth-century artists, Moronobu was not a native son. He left his provincial home and family profession of embroiderer to seek fame and fortune in the great city around 1660, at some point receiving training in Kano- and Tosa-style painting. His skill in handling complex figural groupings and spatial relationships is evident in a pair of screens showing the backstage of a Kabuki theater (see FIG. 7). In addition to painting, Moronobu illustrated over one hundred and fifty books on many subjects, including guides to the Yoshiwara and to the Tōkaidō Road (see FIG. 58). Also figuring in his repertory are a large number of erotic prints, in which suggestive sexual activities are presented against the backdrop of the emotional-seasonal allusions associated with classical literature (FIG. 63).

Moronobu's influence extended beyond his own studio to the schools of Torii Kiyonobu (1664-1729) and Kaigetsudō Ando (fl. 1704-14). This indebtedness is especially evident in the linear clarity of their designs. Unlike Moronobu, however, both Kiyonobu and Ando focused their talents as painters and print designers on single-figure compositions featuring the two embodiments of Edo culture: Kabuki actors and courtesans.

Born in Osaka, the son of an actor and painter of billboards, Torii Kiyonobu moved to Edo in 1687, where he began producing prints of beautiful women, and, in greater numbers, of actors in their dramatic roles. His success was due not only to his artistic skill but to his association with the rising Kabuki star Ichikawa Danjūrō I who popularized the dynamic *aragoto* ("rough stuff") acting style that Edo audiences found so appealing (FIG. 64). Later Torii artists specializing in actor prints adopted the stereotyped figural style developed by Kiyonobu, with legs shaped like inverted gourds and wriggling-worm contours. Because of the fickleness of the Edo public, few schools of print designers lasted for more than

63. HISHIKAWA MORONOBU (? 1618-94)
Lovers under a Mosquito Net, c. 1680. Monochrome woodblock print, 12 x 13¾" (30 x 35 cm). Honolulu Academy of Art, Hawaii.

This monochromatic print is a leaf from an album of erotica (*shunga*), a genre practiced by many Edo print designers.

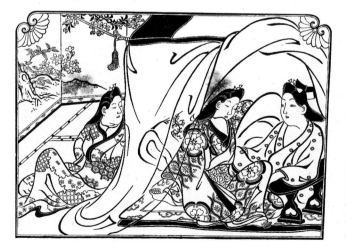

64. Torii Kiyonobu II
(fl. 1720s–c. 1760)
The Actor Ichikawa Danjūrō II as Soga Gorō, c. 1735.
Woodblock print, 12¹/₂ x 6″
(32 x 15 cm). Geyger
Collection, Germany.

Danjūrō II performs a
celebrated *aragoto* role in a
play about the revenge of
the Soga brothers, a favorite
in the Kabuki repertory. The
actor's distorted facial
expression, symbolically
painted in alternating lines,
and the scale of the arrow
he sharpens vividly convey
the young Soga Gorō's fury
and determination to avenge
his father's murder.

65. KAIGETSUDŌ DŌHAN
(fl. 1710s)
Beauty Reading a Poem Slip, c. 1714. Monochrome woodblock print, 23$\frac{1}{2}$ x 12$\frac{1}{2}$" (59 x 32 cm). National Museum, Tokyo.

The mannered pose of this robust beauty was used in many paintings and prints by members of the Kaigetsudō school to highlight the elaborate and imaginative decoration of the garments.

two or three generations. The Torii lineage is exceptional in that its members are still active today.

About the time that Torii Kiyonobu was popularizing portrayals of actors in *aragoto* roles, his contemporary Kaigetsudō Ando and his followers Anchi, Dōhan, and Doshin developed an equally influential vision of feminine beauty. Skilled both as painters and print designers, they specialized in seductively posed, robust beauties dressed in sumptuous garments (FIG. 65). The majestic allure of these idealized women is enhanced by the unusually large size of the prints, which may cover one-and-a-half sheets of paper. The publication of such oversize prints may have been cut short by the government edicts of the Kyōhō era (1716-36) that sought to limit luxurious excesses of all kinds.

The Kyōhō Reforms were the first of the government's periodic efforts to quell social unrest brought on by poor economic conditions. Like the Kansei Reforms of the 1790s and the Tenpō Reforms of the 1840s, these programs included regulations directed at the publishing industry. Their application was capricious, but the government often targeted books and prints dealing with current events, especially those that presented the shogunate in an unfavorable light, erotic works deemed detrimental to public morality, and excessively luxurious prints. Enforcement was strongest in Edo, although publishers in Osaka also curtailed their activities for fear of punishment, ranging from jail terms and exile to confiscation of their property.

A lifting of the ban on the importation of foreign books, providing they contained no material pertaining to Christianity, was also part of the Kyōhō Reforms. Intended to promote scholarship, this policy resulted in the diffusion of illustrated books from China and Europe, especially those dealing with the natural sciences and technology. Avidly studied by both scholars and artists, they spurred new ways of seeing and recording the physical world.

Ever eager to cater to the public's love of novelty, Edo print artists responded to these new sources of influence by incorporating European illusionistic techniques into their designs. Okumura Masanobu (1686-1764) was the first to exploit Western perspective, inaugurating a genre of print

called *ukie*, "floating picture." His *ukie* focus on familiar Edo locales such as the interiors of theaters, tea-houses, and brothels, but, by employing in their representation complex arrangements of vertical, horizontal, and, especially, receding diagonal lines that give the illusion of deep space, he invested them with an exotic aura that captivated the public (FIG. 66).

Print designers had no pretensions about their status as commercial artists. Their unabashed commercialism is evident in the self-promotional signatures and inscriptions figuring on many prints. Masanobu, who, exceptionally, was both an artist and publisher, claimed in his signature that he was the originator of one school of Edo *ukiyoe*. As seen in the right margin of the print illustrated here, he also included the location and trademark of his shop so that potential customers would know where to purchase his works.

Developments in Polychrome Prints: 1765-1801

The publication of sumptuous books privately printed by and for affluent aficionados of Noh and classical literature had been a catalyst for the revival of the courtly aesthetic that became a hallmark of Kyoto art. Similarly, a century and a half later, the publication of commemorative prints by and for poetry aficionados in Edo paved the way for the rise of the fully developed multicolor (known in the Japanese context as polychrome) print that became one of the city's most famous products. These prints came to be known as *Azuma nishikie* ("Eastern brocade pictures"), a name that suggests that they were the Kantō region's counterparts to the colorful silks for which Kyoto was renowned.

With their appearance, the techniques of woodblock printing reached full maturity. Prints in a limited palette had been issued in the 1740s. These were followed by three- and four-color prints in the 1750s, but it was not until the second half of the eighteenth century that prints of a dozen colors or more appeared. These required the use of one block for each color. Their high technical quality followed from the perfection of a system of color registration involving simple notches carved on every block. Production was a collaborative effort requiring the participation of an artist, and often a calligrapher, a block-carver, a printer, and a publisher. The publisher played an essential role in conceiving, financing, and coordinating production. He also arranged for sale or distribution.

The publisher's first task was choosing, on the basis of a line drawing provided by the artist, the number of thick cherry-

Following pages
66. OKUMURA MASANOBU (1686-1764)
Interior of a Brothel, c. 1740. Woodblock print, 12 x 17½" (31 x 45 cm). Geyger Collection, Germany.

This *ukie* was inspired by a play about Umegae, a famous Osaka courtesan. By beating a bronze brazier, she was said to have produced a shower of gold coins to help her penniless lover.

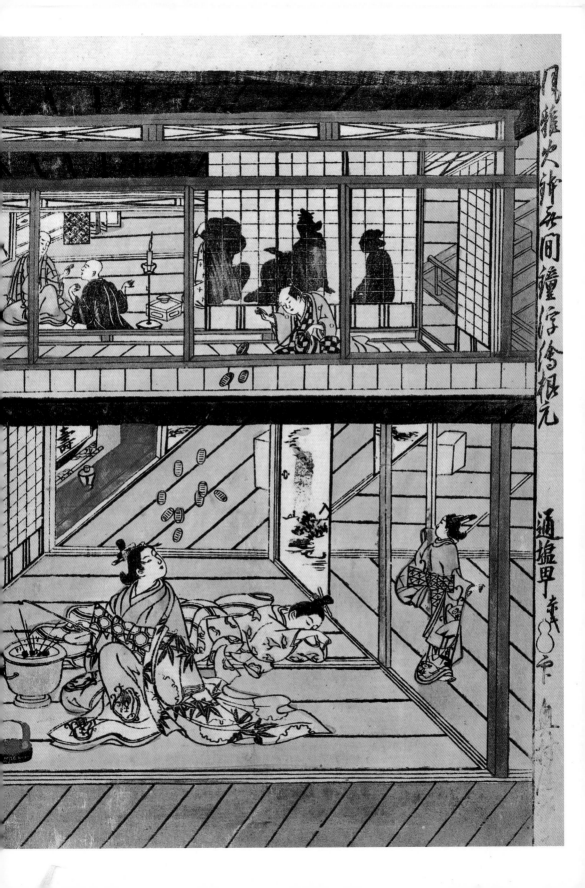

wood blocks to purchase. To cut costs, blocks were often carved on both sides, so that a ten-color print (a typical number of colors in a *nishikie),* would require only five blocks. Next the carver produced the keyblock by pressing the artist's design face down on the wood and carving along the lines on the paper. Each subsequent color required the carving of another block, using the keyblock print as guide. Pigments were then applied to each block, and paper pressed to each in turn, and rubbed down firmly to transfer the design. For an especially luxurious glistening effect, a thin coating of glue might be applied to the finished print and mica dust sprinkled over it. Using this technique, eighteenth-century publishers usually obtained two hundred impressions per run, but in the nineteenth century, one thousand or more was not uncommon. These prints were generally in one of two standard sizes, the *ōban,* approximately 15 x 10″ (39 x 26 cm), or the *chūban,* approximately 10¹/₂ x 8″ (27 x 20 cm).

The first full-color prints were published privately under the auspices of amateur *haikai* poetry societies for presentation as gifts, chiefly at New Year. Since production costs were not a consideration, they were printed on thick, high-quality paper, using excellent pigments, and featured imaginative designs that often incorporated subtle poetic allusions. Many were pictorial calendars that cleverly concealed within their designs the number of days in each month, which varied from year to year in the Edo-period calendrical system. In this way, publishers cleverly circumvented the government monopoly in calendar production.

Although the reason is unknown, the year 1765 saw the publication of an unusually large number of calendar prints, many of them designed by Suzuki Harunobu (1725-70), an artist with close ties to one of the leading *haikai* clubs in Edo. His exploitation of the full-color print made him one of the most successful commercial designers in Edo – so successful that other artists made forgeries of his work even during Harunobu's lifetime. Between 1765 and his death five years later he is thought to have produced at least a thousand designs, many of them featuring one or two young beauties set against delicately colored or patterned backgrounds that took full advantage of the technical advances in printing. While Moronobu and artists of the Kaigetsudō school had favored a relatively robust woman, Harunobu adopted a frailer, more innocent type, indebted to but more androgynous than the type popularized by the Kyoto artist

67. NISHIKAWA SUKENOBU (1671-1750)
Beauty at her Toilette (detail of FIG. 1, page 9), first half of the eighteenth century. Hanging scroll, ink and colors on silk, 33¹/₂ x 17¹/₂″ (85 x 44.5 cm). MOA Museum of Art, Atami.

Nishikawa Sukenobu (1671-1751; FIG. 67). Harunobu, who may have studied under Sukenobu, was the last Edo print designer to follow the lead of a Kyoto artist in representing beautiful women.

Harunobu had four favorite female subjects, Osen, Ofuji, Onami and Onatsu, all local beauties, not professional courtesans. Osen was a waitress at Kagiya teahouse; Ofuji (FIG. 68) sold cosmetics at a stand near the temple at Asakusa, and Onami and Onatsu were sacred dancers at Yushima Tenjin Shrine. However, all are represented in much the same way, so that without identifying labels or context it is difficult to distinguish one from the other. Gender distinctions are equally ambiguous. Were he not carrying two swords, the sex of Ofuji's samurai admirer would be uncertain. This androgyny may have been intentional since male prostitution was widespread and male prostitutes often adopted feminine mannerisms and dress.

68. Suzuki Harunobu (1724-70)
Clearing Weather at Asakusa, c. 1764-70. *Chūban* woodblock print. British Museum, London.

The inscription above Ofuji and her lover identifies this picture as *Clearing Weather at Asakusa*, one of the *Eight Fashionable Views of Edo*. Edo cognoscenti would have immediately recognized this as a modern adaptation of one of the *Eight Views of the Xiao and Xiang Rivers*, a Chinese theme popular in Japan since the fourteenth century. As noted above, allusions to classical art were from the outset important components in woodblock prints. In Kyoto, continuities with the past could be seen and felt, but in Edo artists needed to remind their viewers of that continuity. They did so using a playful device called *mitate* (parody), in which a contemporary "equivalent" was substituted for classical subject-matter, giving the resulting work multiple layers of meaning. *Mitate* lent legitimacy to representations of contemporary subjects, and as the people of Edo increasingly took pride in their urban culture, local artists' reinterpretations of time-honored secular and even religious themes became more and more satirical.

69. Torii Kiyonaga (1752-1815)
Cooling off by the Sumida River, c. 1784-85 (detail of FIG. 57, page 92). Diptych *ōban* woodblock print. British Museum, London.

The feminine ideal promoted by Harunobu influenced the work of other artists, but by the 1780s it gave way to a more mature, taller, full-bodied woman. These changes in physique were accompanied by the dramatic changes in hair and dress styles evident in the designs of Torii Kiyonaga and his rival Kitagawa Utamaro (?1753-1806). To enhance the illusion of height, these artists featured beauties dressed in garments with vertical stripes or with designs concentrated around the lower hem. This was offset by increasingly elaborate, winged hairstyles embellished with radiating decorative combs and pins (FIG. 69).

While Harunobu had depicted idealized women engaged in mundane activities such as tending children, washing, or lighting a lantern, Utamaro presented them in a more convincing setting, investing them also with a more overt eroticism. Although his thematic range was wide, his forte was the exploration of feminine diversity, as revealed through subtle nuances of pose, gesture, costume, and above all, physiognomy (FIG. 70). Utamaro, however, was less interested in individuality than in typology, an approach to portraiture that was inspired by a Chinese pseudo-science similar to phrenology. Nonetheless, his half-length physiognomical studies brought new expressiveness to the representation of women.

Utamaro was among the stable of artistic and literary luminaries managed by Tsutaya Jūzaburō (1748-97), popularly known as Tsutajū, the reigning publisher in Edo during the 1780s and 1790s. His bookshop was rivalled only by that of Nishimura

Eijudō, Kiyonaga's publisher. Tsutajū's circle included men of both samurai and *chōnin* background who laid the foundations for many of the new literary and artistic genres of the 1780s. Among them were two shogunal officials, Ōta Nanpo (1749-1823), an influential *kyōka* poet, and Takizawa Bakin (1767-1848), the author of historical novels; Santō Kyōden (1761-1816), the author of numerous popular novels and, under the *nom de plume* Kitao Masanobu, designer of prints and book illustrations; and Hiraga Gennai (1728-80), a pioneer in "Dutch studies" (Jap.: Rangaku), as well as the author of satirical novels and essays. The impact of these intellectual and artistic crosscurrents is evident in the subjects and naturalism of Utamaro's compositions.

Tsutajū enjoyed a close personal relationship with many of his protégés. Both Bakin and Utamaro lived in his house for a time. As an active member in one of the leading poetry circles in the Yoshiwara, Tsutajū also helped them cultivate the network of patrons necessary to underwrite the publication of their work. Utamaro's *Picture-book of Selected Insects, (Ehon mushi erabi)*, one of the most luxurious illustrated anthologies of *kyōka* verse to appear in the 1780s, was the result of such efforts (FIG. 71).

Kyōka ("crazy verse") is a form of poetry that parodies and updates classical *waka*, through witty topical allusions and puns. The genre originated in the Kyoto-Osaka area, gaining only a limited number of practitioners until it spread to Edo, where it became immensely popular, spurring interrelated developments in the performing, visual, and literary arts. *Kyōka* societies, whose membership often overlapped with that of Kabuki fan clubs, contributed to the growth of a distinctive urban aesthetic sensibility in Edo, much as *chanoyu* and literati gatherings did in Kyoto. Membership often included famous actors. (Danjūrō V, the fifth head of the Ichikawa line, not only dazzled the public with his versatility on stage, but also with his skill as a poet.) *Kyōka* was practiced by many of the urban sophisticates (*tsū*)

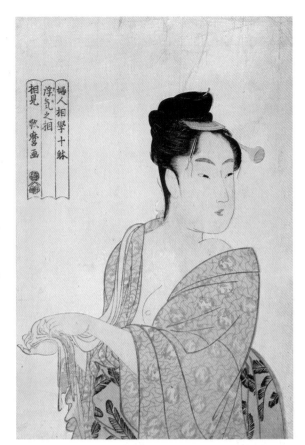

70. KITAGAWA UTAMARO (?1753-1806)
The Flirt from the series *Ten Examples of Female Physiognomy*, c. 1792-93. *Ōban* woodblock print. British Museum, London.

As suggested by the inscription in the title box, this young woman who has just emerged from the bath, with her cotton garment only partially covering her body, personifies flirtatiousness.

71. KITAGAWA UTAMARO (?1753-1806)
Illustration from *Picture-book of Selected Insects* (*Ehon mushi erabi*), 1788. Woodblock-printed book, 10½ x 7" (27 x 18 cm). British Museum, London.

The naturalism of Utamaro's representation of birds, flowers, and insects underscores the growing empiricism in the arts in the last quarter of the eighteenth century.

who gathered in the tea-houses of the Yoshiwara and other lively locales to eat, drink, and enjoy the company of the leading courtesans of the day. Indeed, the preface to Utamaro's book reveals that the idea for a poetic anthology combining the unusual themes of love and insects came to the authors when they were gathered at a restaurant along the Sumida River and heard the sounds of crickets and cicadas. Since the subject-matter of such verse was often quite scurrilous, their authors were generally identified only by humorous pseudonyms. Thus, for example, the *kyōka* that likens a bee's quest for honey to a man's quest for sexual pleasure, accompanying the picture of a wasp's nest in Utamaro's *Picture-book of Selected Insects*, is signed "Burnt-assed Monkey Man" (Shiriyake Sarundo), the pseudonym of Sakai Hōitsu, the second son of the daimyo of Himeji.

The 1770s and 1780s, when *kyōka* societies were the rage, were also a golden age for theater fans. The dramatic growth in the number, variety, and quality of actor prints issued during these decades testifies to this efflorescence. Artists of the Katsukawa school, founded by Shunshō (1726-92), dominated the genre, pioneering the portrayal of individual actors, not only in their stage roles but, increasingly, backstage or even in private

life. Shunshō popularized a more realistic mode of representation that enabled viewers to identify his subjects without recourse to labels. Many of these were half-length portraits of actors represented within the confines of a fan-shaped composition that could be cut out and mounted on a paper fan. He also produced portraits of sumo wrestlers, another new genre of prints. But prints were only one facet of his work. A set of paintings of beauties of the twelve months thought to have been commissioned by Matsuura Seizan, daimyo of Hizen, reveals him to have been a gifted painter as well. Shunshō trained many artists including his son Shunkō (1743-1812), Katsukawa Shun'ei (c. 1762-1819), and even the young Hokusai.

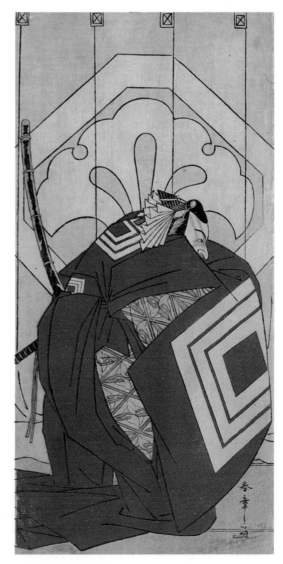

72. KATSUKAWA SHUNSHŌ (1726-92)
The Actor Ichikawa Danjūrō in Shibaraku Role, c. 1777. Woodblock print, 11½ x 5″ (29 x 13 cm). Grunwald Center for the Graphic Arts, University of California, Los Angeles.

Many of Shunshō's outstanding prints represent the charismatic Danjūrō V performing the archetypal *aragoto* role in *Wait a Minute* (*Shibaraku*). In the highlight of this play, a favorite of Edo audiences, the glowering hero enters dramatically calling "Wait a minute!," just as the villain is about to attack. The tension is palpable in Shunshō's profile view of the actor, dressed in a voluminous, persimmon colored robe, striking the stereotyped pose signaling this moment in the drama (FIG. 72). Shunshō has captured in this design the bombast and exaggeration that made the Kabuki theater so appealing to the Edo public.

Tōshūsai Sharaku brought to actor prints a more pronounced and often disconcerting form of realism. Unlike earlier masters of this genre, he did not idealize his subjects but instead deliberately exaggerated their personal physical traits (see FIG. 54, page 88). In so doing, he highlighted as never before the gap between the actor and his role. Sharaku's designs, numbering approximately 160, were all published by Tsutajū during a ten-month period between 1794 and 1795, when the artist mysteriously disappeared from view. Although it was once claimed that the brevity of Sharaku's career was due to negative reaction to his unflattering portrayals

73. UTAGAWA KUNIYOSHI
(1797-1861)
Rorihakuto Chōjun, from
the series *A Hundred and
Eight Heroes of the
Suikōden*, C. 1827-30
(detail of FIG. 78, page 118).
Ōban woodblock print.
British Museum, London.

A circular censor's seal
appears to the left of
Kuniyoshi's signature and
above the publisher's mark.

of popular stars, his enormous output makes this unlikely. Sharaku remains one of the most enigmatic personalities in the Edo print world.

The reforms of the Kansei era (1789-1801) dealt a temporary blow to the publishing world while at the same time stiffening popular resistance to shogunal authority. Intended primarily to curb samurai and *chōnin* extravagance and to stabilize rice prices following a series of famines and other natural disasters, they included measures that had a direct impact on artists and publishers. To enforce the ban on the representation of current events, erotica, and other unsuitable subjects, commercial prints published after 1790 were required to pass the inspection of a censor, whose seal of approval had to be cut into the finished design (FIG. 73). As part of this campaign, many of those active in the lively literary, artistic, and theatrical circles that gathered in the Yoshiwara were targeted for punishment. Santō Kyōden was manacled and placed under house arrest for fifty days; Tsutajū had to close his shop and lost half of his estate to fines; Utamaro was imprisoned following the publication of a series of irreverent prints that featured Hideyoshi and other sixteenth-century historical figures. While some artists and writers withdrew from the publishing world, others responded by devising increasingly ingenious means of circumventing government ordinances. Still others charted out new and less dangerous artistic and literary territory.

Further Developments in Woodblock Prints: 1801-68

By the opening decade of the nineteenth century, nationwide travel for both business and pleasure was common among all classes. Pilgrimages to temples, shrines, and scenic sites in the countryside were popular, but the great Eastern Capital, as Edo was often known, was also a favorite destination. To enhance sales to tourists, many publishers opened branches or even relocated their shops from Nihonbashi to the outskirts of the city, usually near the intersection of major thoroughfares. During this era, woodblock prints, long considered to be among Edo's distinctive products, were increasingly marketed as inexpensive souvenirs of a visit to the capital.

Publishers catered to this changing audience by issuing prints that required less arcane knowledge of the theater and Yoshiwara. Tapping into the rich literary and visual vein of *meishoe*, previously exploited primarily in painting and guidebooks, they

began publishing single-sheet prints featuring landmarks in the nation's major urban centers as well as those in more remote rural locales. Colorful designs of birds and flowers and heroes from Chinese and Japanese history also entered the repertory. While prints of courtesans and actors still attracted a large audience, they were overshadowed by these newer genres.

The growing audience for prints is evident from the explosion in the number of artists and prints issued in the nineteenth century. The Utagawa school alone comprised hundreds of artists, and the output of its pre-eminent members, Hiroshige (1797-1858), Kunisada (1786-1865), and Kuniyoshi (1797-1861) was prodigious. Earlier prints had been issued in sets of ten or twelve, but now sets ranging from thirty-six to over one hundred became the norm. When a design was particularly successful, it was often recarved and reissued many times.

With an output numbering in the thousands, Katsushika Hokusai (1760-1849) was one of the most prolific, versatile, and influential of all print designers. Over the course of his long career, in addition to producing single-sheet prints, he illustrated novels, design books for craftsmen, and instructional manuals for amateur artists. He was also a great performer who on several occasions gave public demonstrations of his artistic skill by painting Brobdingnagian half-length portraits of Bodhidharma (Jap.: Daruma), the Indian monk who reputedly took Zen Buddhism (Chinese: Chan) to China in the 6th century AD. Unfortunately these colossal paintings are not among the huge corpus of this artist's painting that has been preserved.

It is difficult to get a clear sense of the full scope of Hokusai's activity since he changed his name and his style every few years. He began his career designing actor prints under the name Katsukawa Shunrō. Next he produced prints of beautiful women and book illustrations. His use of the name Hokusai first occurs in a book celebrating the amusements of Edo, published in 1799. Hokusai maintained a long relationship with the writer Takizawa Bakin (1767-1848), and his imaginative illustrations for the latter's historical novels reveal a penchant for the bizarre and grotesque that would remain a distinguishing feature of his art (see FIG. 17).

Although he was not as widely traveled as his younger contemporary Hiroshige, in 1812 he visited Nagoya, where he met Eirakuya, the city's leading publisher. At his suggestion, Hokusai began preparing a series of sketchbooks, *Manga*, containing perceptive and often droll illustrations of every possible subject. Hokusai intended his *Manga* to serve as a source-book for amateur

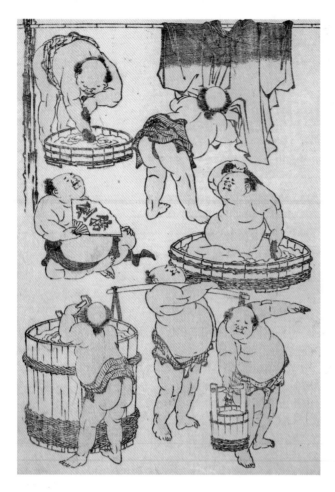

74. KATSUSHIKA HOKUSAI
(1760-1849)
Illustration from *Manga*,
vol. 11, c. 1812.
Woodblock-printed book,
8¾ x 10½" (22.5 x 27 cm).
British Museum, London.

painters and artisans, but its visual delights gained it a much wider audience (FIG. 79).

While Hokusai's *Manga* enjoyed great success, his *Thirty-six Views of Mount Fuji* made the artist a legend in his lifetime. This series, which actually comprises forty-six views, further stimulated the flourishing tradition of landscape prints. Artists in both Kyoto and Edo, including Masanobu and Ōkyo, had experimented with European techniques of spatial illusion, but none had done so with Hokusai's uncanny choice of locale, dramatic light or atmospheric conditions, and compositional ingenuity (FIG. 75).

Hokusai's vision, widely diffused through prints and books, reflected and heightened public consciousness of Mount Fuji as a noble yet dangerous peak. Although it was a hundred miles (62 km) away from Edo and had not erupted since 1707, city residents were keenly aware that it was an active volcano and held it in veneration. Hokusai's personal obsession with Mount Fuji was rooted in the ancient and still vital belief that it was sacred and a source of the secret of immortality. Indeed, throughout the summer months, when there was little risk of avalanches, male pilgrims traveled from all over the country to climb its peaks (women were prohibited from doing so). By depicting Mount Fuji time and again and by employing its conical peak as a distant yet central element in many of his views of Edo, Hokusai contributed to the popular perception that this sacred mountain was integral to Edo's identity.

The enthusiastic response to Hokusai's Fuji series prompted other artists to develop the landscape genre still further. Utagawa (Andō) Hiroshige was by far its most gifted practitioner. A low-ranking samurai whose family held a hereditary position in the Edo fire brigade, Hiroshige studied Kano painting but was also conversant with other painting styles. His work reveals the influ-

ence of literati, Maruyama-Shijō, and Western pictorial techniques. Hiroshige's compositions, like those of Hokusai, are characterized by a personal, often highly contrived sense of order. Unlike Hokusai's works, however, Hiroshige's reveal an emotional response to the poetry of place that found resonance both among city dwellers, who increasingly viewed the countryside with nostalgia, and among visitors from the provinces, who were delighted to see landmarks from their regions celebrated in prints.

Hiroshige began issuing his celebrated *Fifty-three Stages on the Tōkaidō* in 1833, a year after he himself had traveled along this route as a member of a daimyo retinue. Their subject-matter capitalized on the phenomenal success of *Footing it along the Tōkaidō*, a picaresque novel issued in annual installments between 1802 and 1822, and of a Kabuki play also set on the Tōkaidō that was first staged in 1825. Hiroshige's series was so successful that the artist reissued it in three versions, including one made jointly with Kunisada. He also designed another extended series devoted to the *Sixty-nine Stages of the Kisokaidō Road*, the inland route between Edo and Kyoto, as well as many smaller series highlighting provincial landmarks.

75. KATSUSHIKA HOKUSAI (1760-1849) *Mount Fuji in Clear Weather,* from the series *Thirty-six Views of Mount Fuji,* 1830-32. Ōban woodblock print. Musées Royaux d'Art et d'Histoire, Brussels.

Hiroshige capped his long and illustrious career as a designer of topographic prints with the ambitious *One Hundred Famous Views of Edo* (*Meisho Edo hyakkei*; FIG. 76). Issued serially between 1856 and 1859, just as Japan was opening to foreign trade, their striking compositional effects and colors exerted a powerful influence on artists both in Japan and abroad. In this extraordinary series, Hiroshige capitalized on the tradition of *meishoe*, pictures of famous places with seasonal and poetic associations, to immortalize shrines and temples, tea-houses and restaurants, theaters and shops, rivers and canals, all bustling with activity. While accurately presenting topographic detail, the artist adopted unusual vantage-points, seasonal allusions, and striking colors to invest each scene with freshness and lyricism. The cumulative effect on both inhabitants and visitors of Hiroshige's celebration of Edo's scenic beauty and prosperity was analogous to that of Hokusai's *Fuji* series.

The Utagawa school, where Hiroshige was trained, was the foremost print atelier in the nineteenth century. Although its members were especially noted for actor and historical prints, most were adept in all the popular genres. Toyokuni's triptych showing the shop of his publisher Eijudō, combining a perspective view, the portrayal of fashionable beauties, and fan-shaped actor prints, is emblematic of this range (see FIG. 26). The success of the Utagawa school can be attributed primarily to the artists Toyokuni trained, among whom Kunisada and Kuniyoshi were especially talented.

Opposite
76. ANDŌ HIROSHIGE (1797-1858)
Fireworks over Ryōgoku Bridge, from the series *One Hundred Famous Views of Edo* (*Meisho Edo hyakkei*), c. 1857. Ōban woodblock print. British Museum, London.

Watching the annual display of fireworks from boats on the Sumida River was a highlight of the summer in Edo.

77. UTAGAWA KUNISADA (1786-1865)
A Tipsy Courtesan from Fukagawa, c. 1829-30. *Uchiwae* (fan-shaped woodblock print). Russell Family Foundation.

The long face and sharply pointed chin of this courtesan are hallmarks of the Utagawa-school figural style.

Kunisada, like Utamaro, was an active participant in the lively cultural life of Edo. A skilled *haikai* and *kyōka* poet, he was a drinking companion of many of the literary luminaries of the day. He was also conversant with the latest Edo fashions and used this knowledge in many of his prints (FIG. 77). The fan-shaped design illustrated portrays a courtesan from one of the new, unofficial brothel districts that emerged after Yoshiwara was destroyed by fire in 1812. Her plaid costume reflects the new taste in dress during the 1820s while the exotic European goblet she holds in her hand and deep-blue landscape in the background are evidence of the growing availability of imports from the West. The use of Prussian blue, a synthetic dye introduced from Europe, was in vogue among many printmakers in the 1830s and 1840s.

Kuniyoshi began his professional career in 1814 but remained overshadowed by Kunisada until 1827, when he began publication of a series of one hundred and eight prints featuring the heroes of *Tales of the Water Margin* (*Suikōden*), Takizawa Bakin's immensely popular adaptation of a Chinese novel about a band of outlaws who form a community on a mountain surrounded by a vast marsh. The publication of this novel in 1805 had ushered in a vogue for historical and legendary themes. Although Hokusai and Kunisada both produced illustrations, Kuniyoshi's compositions pulsated with action of an intensity and ferocity more extreme than that of earlier designs (FIG. 78). His exploitation of an aesthetic of depravity – embodied in scenes of gory, erotic, and sadistic brilliance – developed against a backdrop of increasing social and political instability in Edo.

The publication of prints featuring heroes of Chinese and Japanese history was given a boost in 1842 when the government banned the portrayal of actors and courtesans, urging artists instead to focus attention on more morally uplifting subject-matter. Kuniyoshi took advantage of this mandate by issuing prints devoted to heroes of the twelfth-century wars between the rival Taira and Minamoto clans. However, in the eyes of a public accustomed to looking for secret meanings, his portrayals of these paragons of feudal loyalty and self-sacrifice were often interpreted as censorious references to the existing political order. Such mixed messages – whether intentional or not – were but one of many signs of the fraying of the Tokugawa social fabric. In giving artistic expression to the gap between official and perceived reality, woodblock-print artists were reflecting the growing political disaffection that marked the final decades of Tokugawa rule.

78. UTAGAWA KUNIYOSHI (1797-1861)
Rorihakuto Chōjun, from the series *A Hundred and Eight Heroes of the Suikōden*, c. 1827-30. *Ōban* woodblock print. British Museum, London.

Kuniyoshi's glorification of the muscular, richly tattooed bodies of these counter-culture heroes lent new legitimacy to elaborate body decoration associated with Edo gangsters.

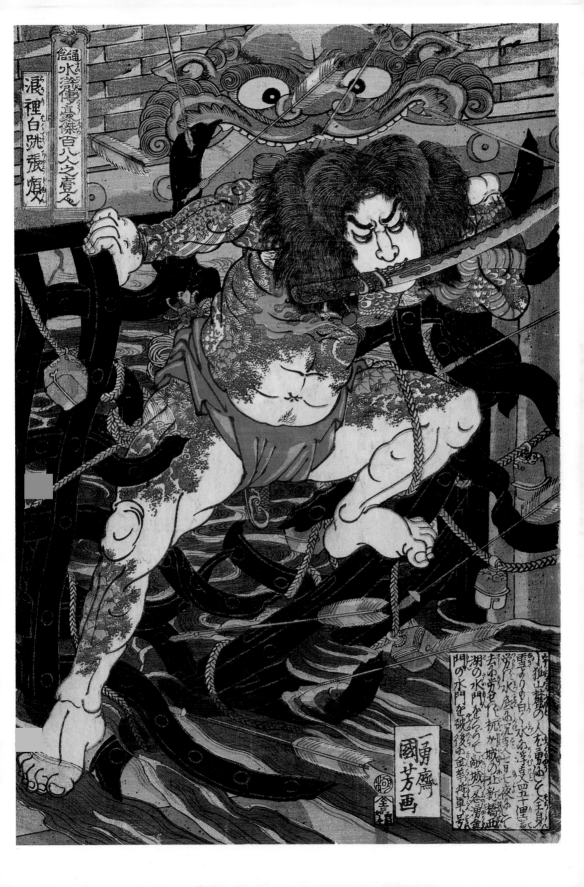

79. SAKAI HŌITSU
(1761-1828)
*Thirty-six Immortals of
Poetry*, early nineteenth
century. Two-panel
folding screen, ink and
colors on silk, 4'11½" x
5'4" (1.5 x 1.6 m). Freer
Gallery of Art,
Smithsonian Institution,
Washington, D.C.

These *waka* poets were
traditionally portrayed in
a dignified manner
befitting their aristocratic
status, but in Hoitsu's
interpretation they are
unceremoniuosly packed
together in a confining
space.

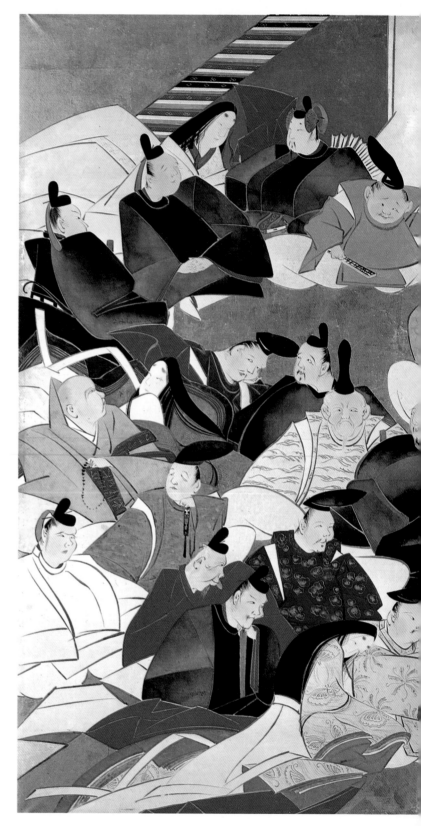

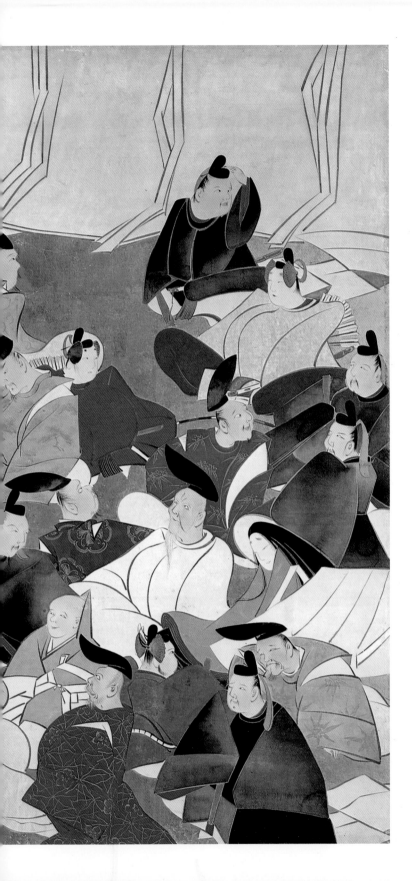

Sakai Hōitsu and Tani Bunchō: Edo Rinpa and Bunjinga

The nineteenth century was marked by a breakdown of lineal affiliations among painters in Edo. While members of the Kano school continued to receive official commissions, the perception that their work was stale and that training in their studios was of little value was widespread. Dissatisfaction with the status quo led many painters to experiment with newly introduced themes, styles, and techniques from China and the West, as well as to seek inspiration from the study of indigenous styles of earlier eras. As respect for individual creativity and freedom of expression grew, many painters saw the adoption of a particular style as a personal aesthetic choice. This phenomenon underlies the eclectic nature of the Rinpa and literati movements as they developed in Edo.

Rinpa had been a dynamic aesthetic force in Kyoto in the seventeenth and early eighteenth centuries, but, despite both Kōrin's and Kenzan's sojourns in Edo, did not immediately find a following in the shogunal city. Why this is so is not altogether clear, but it may be attributed at least in part to the fact that sumptuary regulations were more rigorously enforced there than in Kyoto. Observance of such edicts was inimical to the luxury-loving Rinpa aesthetic.

Sakai Hōitsu (1761-1828) led the movement that promoted the revitalization of the themes and style of Kyoto's Rinpa artists. Personal access to Kōrin's paintings was probably the initial catalyst for his interest in Rinpa, but his friend Tani Bunchō may have furthered it. Hōitsu's aesthetic orientation was informed by the spirit of nativism and antiquarianism common among artists of his generation.

The second son of the Lord of Sakai, Hōitsu had been steeped since childhood in a rich cultural environment that included training in Kano painting, study of *chanoyu*, and, most importantly, the opportunity to study works by Kōrin, of whom his family had been an important patron. Initially, Hōitsu painted as an avocation, but in 1797, after giving up the right to succession on the pretext of poor health, he took Buddhist vows. Later, he established a studio in Edo where he dedicated himself to painting, calligraphy, and poetry. Hōitsu participated enthusiastically in cultural activities in the Yoshiwara, associating with many of the leading scholarly, literary, theatrical, and artistic personalities of the day. His *haikai* and *kyōka* verses appear in many anthologies, including Utamaro's *Picture-book of Selected Insects* (FIG. 80).

80. KITAGAWA UTAMARO (?1753-1806)
Illustration from *Picture-book of Selected Insects* (*Ehon mushi erabi*), 1788 (detail of FIG. 71, page 110). Woodblock-printed book, 10½ x 7" (27 x 18 cm). British Museum, London.

A two-panel folding screen of the *Thirty-six Immortals of Poetry* is emblematic of many of the qualities that inform Edo Rinpa (see FIG. 79, pages 120-21). Although Kōrin had a penchant for playfulness and may have painted this theme, Hōitsu's humor is more pointed than that of the Kyoto master and his colors more intense. The assembled poets look inebriated, bored, or simply bewildered. For Kyoto Rinpa artists, the courtly heritage represented an unquestioned cultural ideal but for their Edo counterparts the value of this heritage was more ambiguous.

Hōitsu's admiration for Kōrin led him on a search for Kōrin's extant works, which culminated in his compilation of *One Hundred Paintings by Kōrin* (*Kōrin hyakuzu*). First published in 1815, this compendium would be instrumental in rekindling interest in Rinpa among painters, lacquerers and potters, and textile designers both in Edo and in other parts of the country. The preface to this book was written by Hōitsu's friend and neighbor, Kameda Bōsai (1752-1826), a distinguished Confucian scholar, poet, and calligrapher (FIG. 81). Bōsai described Kōrin as an artist possessed of a "divinely untrammeled style," a phrase of Chinese origin implying exceptional artistic genius. That this characterization was applied to Kōrin testifies to the intellectual and artistic crosscurrents of nineteenth-century Edo.

81. KUWAGATA KEISAI *Five Friends at a Restaurant,* from *Food Connoisseurship* (*Ryōri tsū*), c. 1822. Woodblock-printed book, 6 x 8½" (15.2 x 21.4 cm). Ravitz Collection, Santa Monica.

Friendly gatherings at Edo's many restaurants and teahouses often brought together artists and intellectuals of diverse backgrounds. Pictured here are Kameda Bōsai (with his hand raised), Sakai Hōitsu (with his back to the viewer), the *kyōka* poet Ōta Nanpō (with wine cup in hand), and Shibutsu.

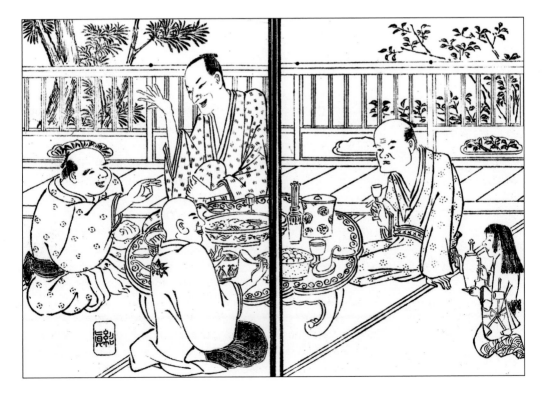

Tani Bunchō (1763-1840) is generally considered to be the founder of the Edo literati movement but, in fact, literati painting was only one thread in the activities of this intellectually and artistically sophisticated man. Born to a samurai family, he was in the service of Matsudaira Sadanobu, the powerful chief adviser to the shogunate from 1787 to 1793 and architect of the Kansei Reforms. Sadanobu's own antiquarian interests and involvement in the rebuilding of the imperial palace in Kyoto led him to dispatch Bunchō on a nationwide survey of antiquities. These travels gave Bunchō a wide-ranging familiarity with traditional Japanese themes and styles as well as the opportunity to study Chinese and European painting techniques employed by artists in Nagasaki. It was during these peregrinations that he visited Osaka and enjoyed the hospitality and intellectual stimulation of the lively salon that gathered around Kimura Kenkadō, a sake brewer, literati painter, and seal-carver whose residence attracted many of the artistic luminaries of the age.

Bunchō himself was a central figure in an equally lively salon in Edo whose members met in the convivial surroundings of popular downtown restaurants and tea-houses. There they could savor fine cuisine while discussing the latest social, political, and cultural trends. Many of these relationships were of a symbiotic nature: friends shared rare books, helped to find publishers and buyers for each others' work, and organized exhibitions to promote fellow artists' careers. Indeed, Bunchō is thought to have popularized the Edo vogue for painting and calligraphy gatherings in 1792, when he and several of his students gathered at a popular restaurant to demonstrate their painting and calligraphic skills before a paying audience. This practice continued to be popular in the city throughout the nineteenth century (see FIG. 20).

Although Bunchō was a gifted and versatile painter, he was perhaps more influential as a teacher and advocate of the study and practice of various pictorial styles of past and present, especially literati and Western-style painting. This two-fold legacy is reflected in the work of his associate and student Watanabe Kazan (1793-1841). The chief retainer of the small fief of Tawara (in modern Aichi Prefecture), Kazan was attracted to the *bunjin* philosophy and produced some paintings in the literati manner. However, "Dutch studies" (Rangaku) were the true center of his intellectual and artistic interests. His association with a group of scholars who shared his dedication to Western learning, along with his forthright criticism of shogunal policy, led to his imprisonment on charges of sedition and his eventual suicide.

Kazan's large corpus of paintings and sketches includes many portraits that reveal his scientific curiosity, keen powers of observation, and mastery of Western pictorial techniques (FIG. 82). In addition to painting and teaching to supplement his meager income, at Bunchō's suggestion Kazan hosted commercial painting and calligraphy gatherings. However, his writings and sketchbooks leave no doubt that such events, while necessary, were wholly incompatible with his vision of himself as a literatus.

Bunchō, Kazan, and their followers called themselves *bunjin* on social, not on stylistic grounds. Unlike their contemporaries in Kyoto, they did not lay much store by strict adherence to pictorial models associated with the Chinese Southern or Nanga school of painting. Unlike them also, Edo *bunjin* did not resign their government posts and live as bohemians, but used painting instruction and sales to supplement their incomes. Their repudiation of the academic styles supported by the shogunate and experimentation with nativist, literati, and Western styles were less subversive than regenerative in intent. Bunchō, Kazan, and other scholar-artists working from within shogunal officialdom saw their artistic endeavors both as a means of self-expression and as part of a rational quest for historical and empirical knowledge that might contribute to national political and social reform.

FOUR

Osaka and Nagasaki Artists

O saka and Nagasaki were the nation's most important
artistic centers after Kyoto and Edo. Both were major
ports, with Osaka dominating domestic and Nagasaki
foreign shipping, and both were under the direct administrative
supervision of the shogunate. Beyond this, the two cities had lit-
tle in common. Osaka, with close to half a million inhabitants,
was one of the nation's three largest metropolises, while
Nagasaki, with about 65,000, was much smaller. Their cultural
influence derived not from their size, however, but rather from
their location and from the social and ethnic composition of
their populations. Osaka was nominally a castle city, but because
its castle was not the residence of a feudal lord, the warrior pop-
ulation remained relatively small and was vastly outnumbered by
townsmen engaged in commerce, banking, and crafts. The latter
were not of the luxurious variety produced in Kyoto but con-
sisted predominantly of practical articles such as cooking pots,
rice bowls, and chopsticks for the urban consumer. The prepon-
derance of *chōnin* in Osaka fostered the growth of a culture with
a distinctly mercantile character. In Nagasaki, by contrast, the
presence of Dutch and Chinese traders, though numerically
small, made the city a mecca for inquisitive and innovative artists
from all over the country. Until the opening of the port of
Yokohama in 1859, Nagasaki was Japan's window on the world
(FIG. 84).

Osaka lies in a fertile and prosperous region 250 miles (400
km) southwest of Edo and 30 miles (50 km) south of Kyoto.
Because of its advantageous location at the head of Osaka Bay
and at the mouth of the Yodo River, it became the hub for the

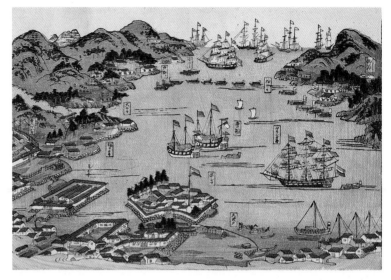

84. ANONYMOUS
Bird's-eye View of the Port of Nagasaki, c. 1854-64. *Ōban* woodblock print. British Museum, London.

The small, fan-shaped island in the foreground of this souvenir print is Deshima, where after 1641 Dutch traders were confined. In the harbor beyond are Chinese and Dutch ships.

85. GIGADŌ ASHIYUKI (fl. 1814-33)
Ten Actors on Tenjin Bridge, 1825. Triptych *ōban* woodblock print. British Museum, London.

This triptych combines a panoramic view of one of Osaka's scenic spots, the Tenjin Bridge spanning the Yodo River, with nine of the city's most celebrated actors of male and female roles. It was issued to commemorate the Osaka performances of the Edo actor Onoe Kikugorō III, the tenth figure in the group.

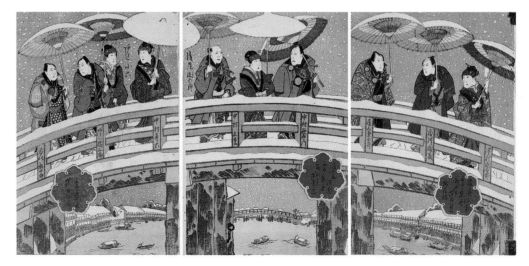

collection and distribution of the rice tax from domains in western Japan (FIG. 85). It also led the nation in manufacturing industries such as shipbuilding, oil production, copper refining, and cotton processing.

As Osaka prospered, its dynamic community of merchants, bankers, and manufacturers began to support cultural activities of all kinds. Proximity to Kyoto – only a day's journey away by boat up the Yodo River – fostered close ties among artists of the two major cities in the Kamigata. But Kyoto culture, as recreated by and for free-spending Osaka townsmen, was less concerned with aristocratic refinement than with material splendor. The materialistic orientation of Osaka culture served as a bridge between the cultures of Kyoto and of Edo.

Engelbert Kaempfer (1651-1716), a German physician serving the Dutch East India Company, was afforded the rare opportunity of visiting Osaka in 1691 and 1692, during one of the journeys to Edo made by the company's directors to offer presents to the shogun. In his *History of Japan* Kaempfer noted that the city, "well inhabited with rich merchants, artificers and manufacturers," had a reputation for free spending:

> Even what tends to promote luxury, and to gratify all sensual pleasures, may be had at as easy a rate here as anywhere. For this reason the Japanese call Oasacca the universal theater of pleasures and diversions... Hence it is no wonder, that numbers of strangers and travelers daily resort thither, chiefly rich people, as a place where they can spend their time and money with much greater satisfaction, than perhaps anywhere else in the Empire.

The beginnings of Osaka's cultural flowering can be traced to the construction of its castle in 1583. One of the most ambitious and lavish architectural projects undertaken by Hideyoshi, its outer courtyard was 8 miles (13 km) in circumference, requiring tens of thousands of workmen for its construction. Its interior decor, painted by Kano Eitoku and his workshop, was equally impressive. The castle was badly damaged during the siege and battle of Osaka in 1614-15 that wiped out all the heirs to the Toyotomi family. After assuming control of the city in 1615, the shogunal government repaired the castle and undertook massive public works projects that transformed Osaka into a city of canals and bridges. Osaka's theater district developed along the Dōtonburi canal with the licensed quarter directly across from it. As in Edo, activities there were strictly controlled by the government.

Osaka first achieved cultural autonomy during the Genroku era (1688-1704), a golden age throughout the Kansai region. The racy fiction of the Osaka writers Asai Ryōi (d. 1691) and Ihara Saikaku (1642-93) popularized the word *ukiyo* in its new and fashionably hedonistic sense of living for the moment. Saikaku's writings also portrayed the Osaka merchant as a hard-working pragmatist who found satisfaction in the pleasures of the material world. Osaka's cultural identity was further defined by the play-wright Chikamatsu Monzaemon (1653-1725). Although he wrote primarily for the puppet theater, which was the rage in seventeenth-century Osaka, many of his domestic tragedies, built around unsuitable love affairs and culminating in double suicides, were subsequently adapted for the kabuki stage. The emotional orientation of these dramas fostered the development of the *wagoto* or "soft" style of acting for which Osaka was renowned.

Kimura Kenkadō and his Circle

The Kyōhō era Reforms curbed the unrestrained pursuit of pleasure and brazen display of merchant wealth that the shogunal authorities deemed injurious to public morals and threatening to the stability of the city. The desire to promote a more intellectual ambience in Osaka also led to the founding in 1724 of the Kaitokudō, a school of Chinese studies for commoners, comparable to the Shoheikō, the government-run Confucian academy in Edo. The instructors at the Kaitokudō, however, advocated a more egalitarian and pragmatic form of Confucianism than their Edo counterparts.

With the institution of the Kaitokudō, both formal and informal cultural clubs sprang up, comparable to those in Kyoto and Edo, where cultivated men could gather to compose poetry, paint, and enjoy related activities associated with the life of the Chinese literatus. The sake merchant Kimura Kenkadō (1736-1802), one of Osaka's most enlightened personalities, was at the center of a particularly noteworthy and influential group. Kenkadō's reputation as a man of wide-ranging intellectual curiosity, learning, and artistic talent, not to mention as a generous host, made his residence a magnet for artists and scholars from as far away as Edo and Nagasaki. Shiba Kōkan (1747-1818), a pioneer in European oil painting and copperplate engraving, visited him both on his way to and on his return from Nagasaki in 1788-89. Tani Bunchō also visited Kenkadō in 1796, and on this occasion made preliminary sketches for the commemorative portrait he painted after Kenkadō's death (FIG. 86).

Kenkadō's diary and other writings reveal Osaka to have been a close-knit yet cosmopolitan city whose leading artists were unusually receptive to new artistic trends. The Kano school provided the educational matrix for many Osaka painters, such as Ōoka Shunboku (1680-1763), under whom Kenkadō himself studied for a time. However, exponents of the Maruyama-Shijō and literati styles enjoyed the greatest favor among local patrons. While there was no doubt some professional rivalry between them, members of both schools frequented Kenkadō's salon.

Kenkadō himself had a special predilection for literati painting and maintained close ties with many of its leading exponents. He studied informally with both Yanagisawa Kien and Ike Taiga and was so impressed with the latter's talent that he helped to promote his work through exhibitions in Osaka and Kyoto. He also received instruction from the Ōbaku priest Kakukei and from the Nagasaki painter Kumashiro Yūhi (1713-72). For Kenkadō himself, however, painting remained an avocation, not a profession, even after the loss of his brewing business in 1789 when he was accused by the authorities of illegally producing excessive quantities of sake.

Although many literati painters passed through Osaka, Okada Beisanjin (1744-1820) seems to have been the first major exponent of the literati style native to the city. A local rice merchant, Beisanjin was apparently self-taught, although some of his work reveals the influence of Taiga, with whose painting he may have become acquainted through Kenkadō. Like most literati, he had a penchant for idealistic landscapes and gardens with Chinese literary associations, often representing them with a quirky and humorous touch. The *Poetry Gathering at the Orchid Pavilion* was a special favorite, probably because it allowed such latitude of interpretation (FIG. 87). In the version reproduced here, the small figures seated along the banks of the winding stream that extends the length of the composition are dwarfed by fantastic, pretzel-

86. TANI BUNCHŌ (1763-1840) *Portrait of Kimura Kenkadō,* c. 1802. Hanging scroll, ink and colors on paper, 27 x 16½" (69 x 42 cm). Osaka Prefecture, Board of Education.

Though fairly conventionalized, this painting was based on sketches Bunchō made during his visit to Kenkadō's residence in 1796.

87. Okada Beisanjin
(1744-1820)
*Poetry Gathering at the
Orchid Pavilion*, 1816.
Hanging scroll, ink and
light colors on paper, 55½
x 19″ (141 x 48.4 cm).
Idemitsu Museum, Tokyo.

shaped rocks. Beisanjin's fascination with grotesquely perforated rockery, a key component in Chinese garden design, may have come about from his study of books or even actual rocks in Kenkadō's celebrated collection of curiosities.

After Kenkadō's death, Osaka lost something of its cultural prominence among literati artists, and Beisanjin's son Hankō (1782-1846), also an accomplished painter, gravitated to the Kyoto circle of Rai San'yō. Like other literati artists of his generation, he became familiar with Chinese literati theory and practice and adhered more closely to Chinese models and brush techniques.

Mori Sōsen (1747-1813), the founder of the Osaka branch of the Maruyama-Shijō school, was another local artist who visited Kenkadō's residence. Like Ōkyo, Sōsen claimed to take nature as his model, gaining a reputation as a painter of monkeys, which he is said to have studied in their natural habitat so as to represent them accurately (FIG. 88). The Osaka workshop founded by Sōsen continued to flourish after his death, producing increasingly stereotyped paintings of monkeys and other flora and fauna rendered in a realistic manner against a decorative background.

Osaka Books and Prints

Although publishing enterprises flourished in Kyoto, Nagoya, and Nagasaki, Osaka was the only city that came close to rivalling Edo in the quality, if not in the quantity or variety, of its books and woodblock prints. Illustrated books produced in Osaka catered to the practical requirements and cultural interests of residents throughout western Japan. They included treatises on agriculture and sericulture, poetry collections, travel guides, guides to Shinmachi, Osaka's brothel district, and compendia of famous Chinese and Japanese paintings. Fueled by the burgeoning interest in natural history, artists of all affiliations published picture-books of flowers, birds, and other creatures, rendered with meticulous attention to textures, colors, and patterns of foliage, fur, and feathers. The painting manual by Mori Sōsen's pupil Shunkei (dates unknown) illustrated here exemplifies both the high technical quality and the artistic eclecticism characteristic of nineteenth-century Osaka publications (FIG. 89).

88. MORI SŌSEN (1747-1813)
Monkeys in Snow. Hanging
scroll, ink and colors on silk,
41½ x 15" (105 x 39 cm).
Itsuo Art Museum, Osaka.

Monkeys, relatively common
throughout Japan, had long
figured in Japanese myth and
folklore as messengers of the
gods and mischievous pranksters.
In Sōsen's painting they often
assumed anthropomorphic
qualities, reflecting the popular
Japanese saying, "Monkeys are
only three hairs from being
humans."

89. MORI SHUNKEI (fl. 1820s)
Illustration from *Shunkei's Painting Compendium*
(*Shunkei gafu*), c. 1820.
Woodblock-printed book.
Ravitz Collection, Santa Monica.

Shunkei's close-up view of insects on a decaying lotus may have been inspired by a design by Utamaro, but its more realistic approach reflects the influence of the Nagasaki school.

Opposite
90. GOCHŌTEI SADAMASU (KUNIMASU) (fl. 1834-52)
Ōkawa Hashizō as the Priest Saigyō, 1848. *Chūban* woodblock print. Victoria and Albert Museum, London.

The popular Onoe Kikugorō III performed this role at Osaka's Nakaza theater in August 1848. After his formal retirement in 1847, Kikugoro reappeared under the stage name Ōkawa Hashizō. However, the lotus blossoms in the title box, Buddhist symbols of the afterlife, indicate that this print was issued posthumously.

The subject-matter of Osaka prints was drawn primarily from the kabuki theater, in which local residents took great pride. The four main theaters, located in a narrow street parallel to the south bank of Dōtonburi Canal, attracted a large and affluent clientele, which in turn brought actors from Edo to perform there frequently. The Edo actor Onoe Kikugorō III, who arrived in Osaka in 1825 and remained for six months, caused a particular stir (see FIG. 85). Although he was a versatile actor he was especially celebrated for playing ghosts and lower-class characters. He was featured in many prints issued that year as well as in later ones celebrating his return to the Osaka stage after his formal retirement in Edo (FIG. 90). In the nineteenth century, several celebrated actors exiled from Edo due to their extravagant lifestyles settled in Osaka, to the delight of local publishers and theater audiences. The influx of specialists in *aragoto* roles altered patterns of taste in Osaka. While the domestic dramas traditional to the Kamigata region were not totally eclipsed, their monopoly was challenged by pseudo-historical and often fantastic dramas featuring heroic warriors.

Because the market was considerably smaller in Osaka than in Edo, and because Edo prints were also readily available, even the most successful artists did not make a living solely by designing prints but held other professions in related fields such as bookselling and book illustration. Between the late eighteenth century and the mid-nineteenth, around two hundred artists were active in the production of single-sheet prints. Most of these were issued by only four publishers, who produced both com-

mercial series and deluxe editions (*surimono*) using overprinting, costly metallic pigments, lacquer, and mica. Favorite actors in their most popular roles were depicted in the highest-quality prints, which were generally intended for and eagerly seized on by members of local kabuki fan clubs.

Edo and Kyoto also had fan clubs comprised of wealthy theater devotees – usually men who were well versed in the ways of the pleasure quarters as well – but the history of those of Osaka has been unusually well documented. Clubs developed elaborate clapping techniques to applaud their hero, especially when he made his first appearance of the season; they wore special garments in the actor's favorite colors or emblazoned with his crest; and assumed financial responsibility for the decoration and repairs to the theater where "their" actor performed. This system of private patronage was essential to the flowering of Kabuki theater in Osaka and to the development of its autonomous printmaking tradition.

The few single-sheet prints that were published in Osaka before 1800 were often made using a stencil technique in which black outlines were printed with woodblocks and colors were filled in with stencils. This stencil technique, which was less expensive and technically exacting than multi-block printing, continued to be employed in Osaka well after the appearance of full-color prints in Edo. The heyday of Osaka prints came only in the Bunka-Bunsei eras (1804-29), a period that saw the rise of two prolific and influential artistic lineages, one of them linked to Shunkōsai Hokushū (d. 1832) and the other to Asayama Ashikuni (fl. 1807-18).

Ashikuni and the artists associated with him – usually identifiable by the characters "ashi" or "kuni" in their names – benefitted from their close ties to a circle of theater enthusiasts and *kyōka* poets who began commissioning prints from them. Many of these prints were first issued for private circulation and only later to the general public. Yoshikuni (fl. c. 1803-40), the leader of the Jukōdō poetry circle, was himself an amateur print designer. Their prints often commemorated specific roles and performances, especially those of Nakamura Utaemon III, who appears in more Osaka prints than any other actor.

Little is known about Shunkōsai Hokushū's origins or training. The name Hokushū suggests ties with Hokusai, who visited Osaka in 1812 and 1817 and published works there as early as 1808, but the nature of their relationship is unclear. Some of Hokushū's designs exhibit the Edo master's clarity of design and dramatic use of atmospheric effects, as do those of his pupils, most notably Hokuei (d. 1836). Hokuei was especially fond of

eerie night scenes in which he used the contrast between light and dark to heighten the dramatic impact of his subject (FIG. 91).

The influence of the Utagawa school became pronounced in Osaka after Toyokuni's visit to the city in 1821 in the company of a Kabuki troupe. Utagawa Sadamasu (also known as Kunimasu, fl. 1834-52) was among the local artists who followed Toyokuni back to Edo for a period of study. The actor prints by Sadamasu and his students feature the long, angular faces and broad, stooped shoulders characteristic of this school, while exhibiting the Osaka predilection for rich backgrounds and decorative effects (see FIG. 90).

Print production in Osaka nearly ceased in 1842 owing to the promulgation of the new sumptuary laws of the Tenpō era, but five years later Hirosada (fl. 1820s-65) began issuing half-block-size (*chūban*) bust portraits of actors in the guise of famous figures from history and legend. Thereafter he published prolifically, becoming the most successful Osaka artist during the final years of the Edo period. His domination of the Osaka print world can be attributed both to his talent and to his continuing ties with local theaters and publishers.

91. SHUNKŌSAI HOKUEI (d. 1836)
Iwai Shijaku I as Lady Osuma and Bandō Jūtarō as Sasaya Hanbei, 1832. Diptych *ōban* woodblock print. Victoria and Albert Museum, London.

The play commemorated in this print revolves around a family conflict caused by a scheming retainer. In the dramatic scene here, Lady Osuma emerges from the cave where she has been hiding and shines a torch on Hanbei, her brother-in-law's murderer.

Nagasaki: Window on the World

For Japanese artists forbidden to travel abroad, Nagasaki, located in the northwestern corner of the island of Kyūshū, some 600 miles (960 km) from Edo, was a point of direct access to Chinese and European culture. Until 1639, when the shogunate issued the last of five edicts officially closing the country to the outside world, Nagasaki was a thriving international port that attracted traders from Southeast Asia, China, Korea, and Europe. Thereafter, among Europeans, only Dutch traders were permitted entry. However, they were confined to Deshima, a small, man-made island in the harbor, where Japanese were forbidden access except on official business. Trade with China, though closely monitored by the shogunal authorities, also continued, giving birth in Nagasaki to a small Chinese settlement. Although Japan maintained diplomatic relations with Korea, most trade passed through the small island of Tsushima between Korea and northwest Kyūshū. Nonetheless, there were some Korean traders in Nagasaki as well.

While the government embraced Chinese and Korean culture, its attitude towards European culture was more ambivalent. Christianity was deemed a threat, and books treating religious matters were proscribed, but scientific and medical materials were eagerly sought after and studied. Contact with European culture and values, however ill understood, forced scholars and artists to confront the question of Japan's place in the world. The complex and often alarming ramifications of this inquiry had a direct impact both on the lives of individual artists and on changing attitudes towards art from the late eighteenth century on.

Many of the arts created during the last seventy-five years of Tokugawa rule show evidence of growing interest in the world beyond Japan, often accompanied by a new spirit of empirical inquiry. The introduction of European maps stimulated a new interest in, if not necessarily an understanding of, Japanese and world geography that is reflected in prints, paintings, and even ceramic decoration. Chinese and European books on anatomy, botany, and astronomy, and instruments such as microscopes, camera obscura, and telescopes also offered new means of investigating, recording, and classifying the physical world.

Newly encountered Chinese and European artistic techniques altered the artist's apprehension and interpretation of even the most time-honored subjects. Some artists, such as Okumura Masanobu (1686-1764; FIG. 92), embraced these innovations mainly to capitalize on the public's zest for the exotic, but others sought

thereby to transform the visual language of their day. Although all were influenced either directly or indirectly by artistic developments flowing through Nagasaki, it is difficult to determine whether their sources were Chinese or European. Most Japanese artists drew inspiration from an amalgam of sources.

The Nagasaki art world was broadly divided into two groups, one influenced primarily by painting, calligraphy, and other art forms introduced and practiced by Chinese monks and émigré artists and the other by books and engravings brought to Japan by the Dutch. For the most part Nagasaki artists belonged to readily identifiable professional lineages, each with its own stock of imported models. Since these models were relatively scarce, they were copied time and again, making it possible to trace the lines of artistic transmission from one generation to the next and from Nagasaki to other cities.

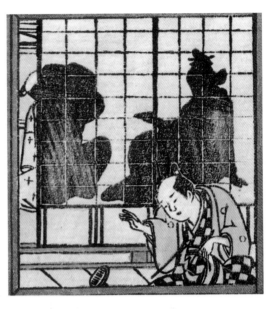

92. OKUMURA MASANOBU (1686-1764)
Interior of a Brothel, c. 1740 (detail of FIG. 66, page 103). Woodblock print, 12 x 17½" (31 x 45 cm). Geyger Collection, Germany.

Monk-Artists of the Ōbaku Sect

In the seventeenth century Kōfukuji, Fukusaiji, and Sōfukuji, three temples constructed in Nagasaki under the patronage of Chinese merchants, and with the approval of the shogunate, were the most important sources of knowledge about intellectual and artistic developments in China. All three belonged to the Ōbaku sect of Zen Buddhism, which by the eighteenth century had over four hundred temples throughout Japan. The steady stream of émigrés fleeing China after the fall of the Ming dynasty in 1644 ensured that, for much of the Edo period, the abbots of the leading Ōbaku temples – the three in Nagasaki, Manpukuji in Uji, and Rakanji in Edo – were Chinese. These émigré monks brought to Japan a fresh infusion of Chinese beliefs and practices that included the drinking of steeped tea (*sencha*), which became a popular alternative to *chanoyu*. They were also accompanied by architects, sculptors, professional painters, and other artisans, so that their temples could be constructed and filled with devotional imagery conforming to Chinese norms. The exotic appearance of Ōbaku temples, with their ornate, two-part roofs, dramatically upturned eaves, elaborate bracketing, arched gateways, and tiled floors, made a strong impression on Japanese

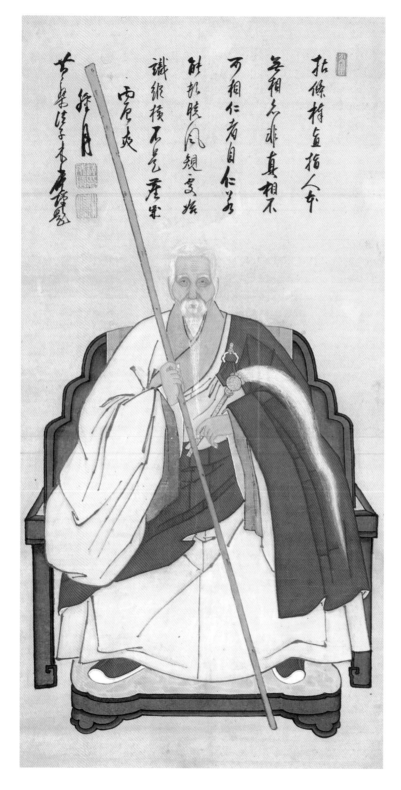

拈條柱杖指人不
無相无非真相不
可相仁者自仁若
鮮振睫風規變焰
識絲橫石毛尾塵巢
宗唐炎

93. ANONYMOUS
*Portrait of Ōbaku Monk
Ingen* with an inscription
by Mokuan (1611-84),
1676. Hanging scroll,
ink and colors on paper,
47 x 23″ (119 x 58 cm).
Shōka Collection.

Ōbaku portraits are
distinguished by their
vivid colors and a strong
sense of volumetric form,
achieved by shading the
areas just inside the
contour lines.

both curious about and respectful of all aspects of Chinese culture (see FIG. 33).

Many Ōbaku monks possessed a deep knowledge of Chinese history and literature and were accomplished painters and calligraphers as well. The abbot of Kōfukuji, Yiran Xingyong (Jap.: Itsunen Shōyū; 1601–68), helped to found a school of painting that included Watanabe Shūseki (1639–1707), whose disciple taught the pioneer of literati painting, Yanagisawa Kien. Shūseki himself was the first Nagasaki painter to assume the post of inspector of foreign art (*karae mekiki*). The occupants of this hereditary post, who enjoyed an official status comparable to that conferred on the members of the Kano school, were responsible for authenticating and establishing the monetary value of paintings imported from China. Their duties also included making exact copies of paintings and other imported articles. Although these inspectors were not among Nagasaki's most accomplished painters, they were instrumental in the diffusion of foreign models.

Ōbaku influence, though pervasive in the arts, was especially influential in the realms of portraiture and calligraphy. Likenesses of prelates (*chinsō*) had traditionally served in the Zen sect as graduation certificates for disciples and as objects of devotion at memorial services. Both practices continued in Ōbaku temples. The monk Yinyuan (Jap.: Ingen; 1592–1673), the patriarch of the Ōbaku sect in Japan and the first abbot of Manpukuji, is known from at least a dozen portraits, not all of them painted on the basis of direct observation (FIG. 93).

Despite its strong evocation of Yinyuan's physical and spiritual authority, the anonymous work reproduced here is in all likelihood a faithful copy of an earlier work. The poetic inscription was added two years after Yinyuan's death by his successor Muan Xingtao (Jap.: Mokuan Shōtō; 1611–84), who was admired for his robust and fluent calligraphy. The verses pay tribute to the state of enlightenment achieved by the subject:

> Holding his staff, he points out
> That humans were originally without form,
> If not, true form could not be formed.
> Benevolent people are naturally human,
> For if you suddenly understand
> And abide in the teachings,
> You begin to understand
> That discriminations are empty.

> *(Translation by Stephen Addiss)*

Visiting Chinese Artists and their Pupils

Many Chinese artists visited Nagasaki during the eighteenth and nineteenth centuries, but not all were of equal artistic stature. Because of the Japanese respect for Chinese culture, even mediocre talents could find pupils and a market for their painting. Shen Quan (Jap.: Shen or Chin Nanpin; 1682–?1760), an artist little known in his native land, who was in Nagasaki between 1731 and 1733, was among the most accomplished and influential. Shen Quan specialized in brilliantly colored, realistic depictions of birds, flowers, fish, insects, and other exotic creatures. His works revealed his indebtedness to both Song academic and Ming realistic painting. Few survive, and many of those traditionally attributed to him are now believed to be the work of other Chinese artists whose names have been forgotten, or of his Japanese followers Kumashiro Yūhi, Sō Shiseki (1715–86), and their numerous disciples. The designation Nagasaki school is generally employed to describe the realistic genre of bird-and-flower painting (*kachōga*) they popularized.

Birds and flowers had long figured in Japanese painting but until the seventeenth century had functioned primarily as seasonal metaphors rather than as subjects of interest in their own right. Fresh influences from China and the West revitalized this tradition, long dominated by painters of the Kano and Tosa schools, infusing it with qualities that simultaneously satisfied the new fascination with empirical values and the deep-rooted appreciation of lush and sensuously colored exotica.

Shiseki's *Rooster and Hen under a Willow Tree* typifies the synthesis of representational accuracy and decorative jewel-like tones that Japanese viewers found so compelling (FIG. 94). Shiseki painted this vignette using a variety of techniques characteristic of the Nagasaki school: stippling to give volume to the tree trunk, the application of color in *mokkotsu*, the "boneless" manner, for the flowers, and the use of fine, punctilious brushstrokes for the feathers. This compositional approach and meticulous technique for rendering plumage were subsequently adopted by the Kyoto painter Jakuchū, who had close contacts with monks of the Ōbaku sect.

Shiseki was instrumental in popularizing the Nagasaki school. Little is known about his early artistic training in Edo, where he was born and lived until he went to Nagasaki in the hope of receiving instruction from a Chinese master. However, after studying in this port city with the Chinese painter Song Ziyan (Jap.: Sō Shigan), from whom he took his artistic name,

he became an enthusiastic promoter of the Nagasaki school, publishing several manuals of their themes and styles. His interest in European pictorial techniques also led to his close association with Hiraga Gennai (1728-80), the leading "Dutch studies" (Rangaku) scholar in Edo, whose influential compendium of *materia medica* he illustrated.

94. Sō Shiseki (1715-86) *Rooster and Hen under a Willow Tree*, 1770. Hanging scroll, ink and colors on silk, 26″ x 4′5¾″ (66 x 136 cm). Nagasaki Prefectural Museum.

Painters in the Western Manner

Before the proscription of Christianity, some Japanese artists had experimented with the techniques of chiaroscuro and scientific perspective. They had also helped to satisfy the curiosity about the appearance and customs of Europeans by painting large-screen compositions, known as "pictures of southern barbarians" (*Nanban-zu*) because Portuguese traders were thought to come from the south. These highlighted the arrival of huge black Portuguese ships and processions of exotic Portuguese merchants, sailors, and Jesuit monks through streets crowded with curious Japanese onlookers. For the most part, they were painted in Kyoto by Kano and Tosa artists, based on pictorial models rather than firsthand observation. The production of such screens ceased around 1639, when the country was officially closed to the Portuguese and foreign subject-matter was proscribed.

The government's seclusion policy intensified the craving for knowledge about the world beyond Japanese shores, and following the loosening of strictures on foreign imports in the eighteenth century, pictures of foreigners enjoyed renewed popularity,

95. ANONYMOUS
Dutch Woman with a Parrot,
c. 1830-44. Woodblock
print, 16¼ x 6¼" (41.6 x
15.9 cm). British Museum,
London.

especially in Nagasaki. To cater to the growing number of visitors to the port, enterprising publishers began to issue inexpensive woodblock prints showing Dutch and Chinese visitors engaged in daily activities, views of their ships, and of the curious cargo, such as elephants and camels, they brought to Japan. Foreign women, who were officially barred from residing in Deshima, were especially popular subjects (FIG. 95). The beauty represented here may be the young wife of an artist who accompanied von Siebold to Japan, but upon arrival was ordered by the government to return home. Because of their exotic subject-matter, these prints, while less sophisticated artistically and technically than their counterparts in Edo and Osaka, enjoyed wide popularity. Most were produced by Yamatoya, the most prominent Nagasaki publishing house.

The government did not view Dutch studies as inherently threatening and indeed respected European pictorial techniques for their practical rather than their aesthetic potential. Many scholar-bureaucrats saw their study of European art as part of an investigation of the nature of the physical world that was encouraged and sanctioned by Confucianism. This pragmatic outlook animated the inquiries of Rangaku scholars, such as Hiraga Gennai.

Although he was a painter of only modest talent, this writer, naturalist, and scholar was a seminal figure in the promotion of Western art. Born into a low-ranking samurai family on the island of Shikoku, he was sent in 1752 by his lord to study herbal medicine in Nagasaki. During his stay there and subsequent travels around the country he helped to establish a network of physicians and scholars who met periodically to study and discuss Chinese and Western scientific materials (see FIG. 6). Gennai also introduced members of his circle to Western pictorial techniques and materials, and experimented personally in oil painting and copperplate engraving.

He found an enthusiastic audience for these new modes of visual expression in the remote northern reaches of Honshū. Inspired by Gennai, feudal lord of Akita, Satake Shozan (1748-

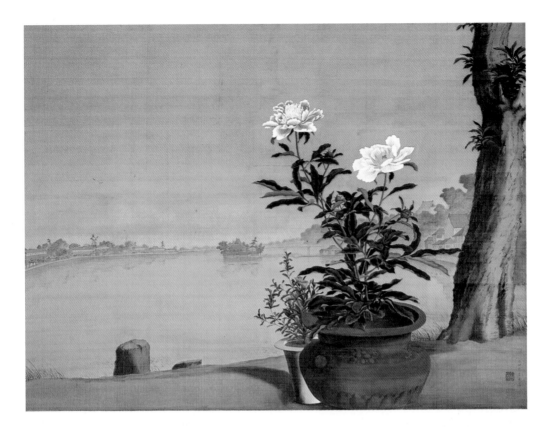

86), developed a genre of painting that combined Western techniques of linear perspective and chiaroscuro with the decorative realism of the Nagasaki school. Many compositions by members of what came to be called the Akita school feature large birds against a distant landscape similar to the work of Sō Shiseki, or themes of Dutch inspiration.

Odano Naotake (1749-80) was one of the most talented and original of the Western-style artists to emerge from the Akita circle. Born in Akita to a samurai family that served as retainers to the Satake, he was already versed in the styles of the Kano school and the bird-and-flower tradition of Shen Quan when he met Gennai. Because of his natural artistic talent, Naotake was sent to Edo to live with and receive instruction from Gennai between 1773 and 1777 and again in 1778-79. During this period he may have also studied with Sō Shiseki. Whether or not he met Shiba Kōkan, who shared his intellectual and artistic interests, is not clear. His stay in Edo, during a period of great cultural efflorescence, exposed him to a wide range of native, Chinese, and Western influences, which he assimilated and synthesized with unusual success in his work (FIG. 96).

96. ODANO NAOTAKE (1749-80) *Shinobazu Pond*, c. late eighteenth century. Hanging scroll, ink and colors on silk, 3′2″ x 4′4″ (98.5 cm x 1.3 m). Akita Museum of Modern Art.

Shinobazu Pond, in the middle of which lies an island with a shrine devoted to Benzaiten, the goddess of good fortune, was a famous Edo landmark. In this view, however, the distant shadowy shrine is subordinated to the crisply delineated and brightly colored urn of peonies in the foreground.

Though lacking the rigorous intellectual training of the Rangaku scholars with whom he associated, Shiba Kōkan (1747-1818) also saw Western empiricism as an agent of modernization. Because he was an effective self-promoter and popularizer, his views gained wide circulation among the general public. Kōkan began his career as a forger of Harunobu's painting and prints, at a time when this artist was unrivalled in popularity in Edo. Kōkan's talent and intellectual curiosity eventually led him to Gennai and Shiseki, with whom he began experimenting in the techniques of copperplate engraving and oil painting.

In 1788, after a long period of personal study and occasional meetings with Dutch traders during their annual visits to Edo, he was finally able to visit Nagasaki. He was unable, as he had hoped, to find a Western artist with whom to study, but his experiences there confirmed his conviction of the superiority of European pictorial techniques. While acknowledging the importance traditionally attributed in Sino-Japanese painting to evoking the essence or spirit of a subject rather than merely its outward form, he was deeply impressed by the potential of Western pictorial techniques to accomplish both these goals.

Kōkan financed his travels by painting demonstrations and displays of curiosities such as a magnifying glass, camera obscura, and copperplate engravings of his own manufacture. While he was in Osaka, he even executed for Kenkadō a pen-and-ink drawing (now lost) of Nagasaki harbor. His views of scenic sites in Edo and elsewhere clearly reveal his mastery of the techniques of engraving and optical illusion. His forays into the realm of oil painting ranged in subject from birds and flowers and scenes of European craftsmen to landscapes. His skill as a painter, combined with his use of a mixture of oils, wax, egg white, and chalk to emulate the glistening surface of a European oil painting and achieve other novel effects, made him wildly successful and influential among Edo artists. The prints of Hokusai, with whom he shared a fascination with Mount Fuji, are especially indebted to Kōkan's innovations (FIG. 97).

Many artists lived or traveled to Nagasaki in the hope of finding a Chinese or European master, but Kawahara Keiga (1786-1860) was among the few to enjoy a long and close relationship with an enlightened European mentor. Born into a family of professional Nagasaki painters and printmakers, Keiga was already an experienced artist when he met Dr Philipp Franz von Siebold, a physician to the Dutch on Deshima from 1823 until 1829. Recognizing his talent, von Siebold employed him to make accurate drawings of Japanese flora and fauna, people, customs,

97. SHIBA KŌKAN (1747-1818) *Seven-league Beach at Kamakura (Shichirigahama)*, c. 1800. Hanging scroll, oil painting on silk, 18½ x 29" (47 x 73.7 cm). Yamato Bunkakan Museum, Nara.

In this view of a celebrated scenic spot in Kamakura, Kōkan drew on his understanding of Western pictorial techniques to convey the spatial relationship between the broad, curvilinear beach, with waves breaking at the shoreline in the foreground, and Mount Fuji rising in the far distance. In keeping with his admiration of the West, he even inscribed his painting in Roman script.

and topography. Many of the resulting works are of great ethnographic interest since they record aspects of Japanese culture – including the lives and customs of the Ainu and other ethnic minorities – of which there are few comparable pictorial records (see FIG. 83, page 127).

Von Siebold had wide-ranging interests in the fields of medicine, natural history, language, and ethnology, and while in Japan, devoted himself to the collecting of Japanese documents and artifacts, which he planned to display to the public on his return to Europe. His museum and his monumental *Nippon*, the first major scholarly study of Japan in a Western language, were instrumental in opening European eyes to the qualities of Japanese art. To gather the requisite materials, he cultivated friendships with many scholars and artists. In 1829, von Siebold was forced to leave Japan after Keiga was accused of passing classified maps to him. Von Siebold's departure apparently also signaled the end of Keiga's artistic career since little is known of him thereafter.

Itinerant, Provincial, and Rural Artists

98. YOSA BUSON
(1716-83)
*The Narrow Road to the
Deep North*, 1779 (detail).
Folding screen, ink and
colours on paper, 4′7″
x 11′5¹/₂″ (1.4 x 3.5 m).
Yamagata Museum of Art.

The Union of painting and
poetry was integral to the
aesthetic of both *haiga* and
literati painting, two genres
in which Buson excelled.

K yoto, Edo, Osaka, and Nagasaki offered their inhabi-
tants an unparalleled wealth and variety of cultural
activities, but the nationwide network of roads and
waterways established by the Tokugawa shogunate ensured a
steady flow of culture to and from these cities. Itinerant artists
were key intermediaries in the intricate web of relations among
the major metropolises, provincial cities, and rural areas. Just as
they helped to shape perceptions of the people and places they
visited, so too their visual sensibility was shaped by the experi-
ence of travel. Provincial and rural artists also contributed to
regional and urban culture by creating works in distinctive local
styles for sale in the city.

To facilitate its political and economic hegemony, the Toku-
gawa government maintained a system of Five Highways, the
Tōkaidō, Kisokaidō or Nakasendō, Kōshūdō, Nikkōdō, and Osh-
ūdō, each punctuated by numerous official post towns. The
Tōkaidō, the 351-mile (560-km) coastal road from Edo to Kyoto
carried the heaviest traffic, but the inland Kisokaidō was also
well traveled. To promote commerce and communications in
areas where land travel was difficult, the government also devel-
oped a national marine transport system. The western shipping
route extended from Matsumae, Japan's northern outpost on the
island of Hokkaidō, down the Japan Sea coast, through the Shi-
monoseki Straits, and along the Inland Sea to Osaka. There were
also shorter routes along the eastern coast, including one for

transport and trade between Osaka and Edo. Constant travel along these and smaller roads and waterways linked the nation's metropolises to castle towns, highway post and market towns, religious centers, ports, and farming villages throughout the archipelago.

During the Edo period, it is hardly an exaggeration to say that Japan was a nation of people on the move. Feudal lords and their retinues traveled regularly between Edo and their home provinces, contributing to the flow of artistic influence among regions. Depending on the size and output of their fiefs, occasionally such a procession might number as many as twenty thousand, with artists occasionally among them. Hiroshige is thought to have accompanied such a group to make the preliminary drawings for his *Fifty-three Stages of the Tōkaidō Road*, many of which show members of daimyo retinues. In addition to such official travelers, roads were filled with merchants and peddlers, itinerant holy men, pilgrims, and tourists.

Most travelers went on foot. Travel on horseback was costly, and horses served primarily to carry baggage too heavy for human porters. Palanquins of various kinds, in which a single passenger rode within a small compartment carried by two or more bearers, were used primarily by the feudal and aristocratic elite, women and children, and the elderly and infirm. The simplest of these was like a giant bamboo basket, but extremely elaborate and ornately lacquered palanquins (*norimono*), decorated by renowned painters and lacquerers, were used for wedding processions or other ceremonial purposes (FIG. 99).

Geographically and climatically Japan varies greatly from north to south and from east to west, and these regional differ-

99. Palanquin, early nineteenth century. Lacquer and gold on wood, compartment 4'2" x 4'6" x 3'2" (1.3 m x 1.4 m x 97 cm). Sackler Gallery, Smithsonian Institution, Washington, D.C.

The workmanship, splendor, and crests woven into its lacquer decoration indicate that this palanquin was created for a bride marrying into the Tokugawa family.

ences are reflected in culture as well. The dichotomy was espe-
cially pronounced between the northeastern Kantō, dominated
by Edo, and the southwestern Kansai or Kamigata, dominated
by Kyoto and Osaka (FIG. 100). The "Osaka Pass," near Ōtsu, was
traditionally held to mark the boundary between these two
zones. The Kansai traditionally had the highest level of agricul-
tural productivity, and enjoyed economic and cultural superior-
ity over the rest of the country. Rural areas in the Kansai made a
successful transition to commercial activities early in the Edo
period. Consequently they were integrated sooner and more
fully into the urban cultural sphere than areas in the Kantō. The
resulting high standard of living enabled many farmers to
indulge in cultural pursuits and to construct handsome residences
incorporating elements of upper-class architecture. However,
even after the establishment of Edo and the expansion of arable
land in the surrounding areas, the harsh climate and often inhos-
pitable terrain discouraged development in the northern regions.
Throughout the Edo period, they remained cultural backwaters,
with only small pockets of development. For many religious and
cultural missionaries, however, this very backwardness was an
attraction rather than a deterrent.

The experience of travel altered the urban artist's perception
and representation of northern as well as other formerly unfamiliar

100. Nineteenth-century
farmhouses in Shirakawa,
Gifu Prefecture. Climate
contributed to pronounced
regional differences in rural
architecture. The farm-
houses of north-central
Japan (Kantō and Chūbu
regions) are multi-storied
and have unusually steeply
pitched roofs. The upper
stories were used for
growing silkworms.

regions. Until the Edo period, few artists had actually visited the scenic spots (*meisho*) long celebrated in poetry and painting. Evidence of the change from a predominantly poetic visualization of place to a more empirical one is evident in all the media. The differences between Sōtatsu's poetic yet topographically ambiguous panorama of the islands in Matsushima Bay (in modern Miyagi Prefecture), and Hiroshige's readily identifiable view of the treacherous whirlpools at Naruto, between Honshū and the island of Shikoku, are emblematic of this transformation (FIG. 101 and see FIG. 39).

Japanese religious beliefs had long emphasized the close ties between man and nature, but from the late eighteenth century onwards advances in technology and agriculture had begun to alter these traditional attitudes. While a sensitivity to and reverence for nature continued to inform the visual and literary arts, this outlook was tempered by a growing preoccupation with the ways in which empirical knowledge could be used to harness natural resources for human welfare. Hiraga Gennai was among

101. ANDŌ HIROSHIGE (1797-1858)
View of the Whirlpool at Naruto, 1857. *Ōban* triptych woodblock print. British Museum, London.

In this striking panorama, the turbulent waters in the foreground contrast with the serenity of the distant coastline. The artist has adapted western principles of perspective to achieve a convincing sense of pictorial depth.

the Rangaku scholars who advocated this attitude, and in so doing stimulated efforts in many regions to exploit local resources to produce cash crops, such as silk and dyes, and to develop industries such as textiles, pottery, and lacquer. Advantageous locations, such as proximity to a major roadway or port, and the presence of natural resources were key factors in the growth of such industries.

The growth of a diversified rural economy, more vigorous in the Kansai than in the Kantō, diminished the central government's ability to plan and control the economy from the center, weakening the power of cities and conversely strengthening that of the provinces. As rural economies rose, and the incomes of city dwellers, especially the samurai class, stagnated or declined, prosperous farmers began to lure artists away from the large cities to towns and villages in the hinterland. Regional production and patronage of the arts invested the provinces with new cultural authority. While this cultural authority never challenged that of the city, it did nourish it in many ways.

Itinerant Monk-Artists and Pilgrimage Art

Pilgrimages to sacred mountains, shrines and temples, or other spots associated with charismatic holy men had figured prominently in Japanese religious life since early times. Until the late sixteenth century, however, such arduous journeys were largely confined to unorthodox religious wayfarers known variously as *hijiri*, *yūgyōsha*, or *yamabushi*, or to members of the elite hoping thereby to gain religious merit or other benefits. In the Edo period better roads, increasing safety, and the availability of new accommodation contributed to a dramatic increase in religiously motivated travel among ecclesiastics and lay people of all classes. While group journeys by members of religious associations were especially popular, religious itinerancy by individuals also flourished. Among the latter group were monks, artists, and preachers, some officially ordained and others not, who supported their travels by making paintings and statuary for devotees along their route or by proselytizing with the aid of their own or other professionally painted pictures.

For the most part, itinerant holy men lacked professional training, creating works that by urban standards appear awkward and technically naive. Yet the taste for such works was by no means limited to uneducated countryfolk. The expressiveness and artlessness they embodied found an appreciative audience among sophisticated city dwellers as well. Some urban artists, such as Jakuchū in Kyoto and Kuniyoshi in Edo, even created works in which they deliberately suppressed their technical skill to achieve the apparently spontaneous, unpretentious effects of their rural counterparts.

Itinerant monks generally left their carved statuary unsigned, Enkū (1632-95) and Mokujiki (1718-1810) being rare exceptions. Modern scholars have traced Enkū's itinerary by the thousands of wooden images he (and probably his disciples or later emulators) left at sites the length and breadth of Japan. All are rough-hewn, unpainted figures, with chisel marks clearly visible, a tradition with roots in a genre of statuary created as early as the twelfth century by itinerant *yamabushi*, who, like Enkū, were members of the Shūgendō order. A religious movement that combined elements of Buddhism, Daoism, and Shinto, Shūgendō prescribed ascetic practices in the mountains in order to attain magic powers that would benefit the community. Enkū's statues include deities from the traditional Japanese Buddhist canon, popular folk figures, and deities from the Shinto tradition (FIG. 102). Some were carved under excruciatingly difficult con-

102. ENKŪ (1632-95)
Prince Shōtoku, seventeenth century. Wood, height 40" (102 cm). Naka Kannondō, Hajima City.

This seventh-century prince, considered the father of Japanese Buddhism, was the object of veneration throughout Japan. He was often portrayed as a child with his hands joined in prayer.

ditions, in small, dark caves, as part of his practice of religious austerities. Others he made at the request of devotees or in repayment for hospitality.

Born to a modest farm family in the modern city of Hajima (modern Gifu Prefecture), Enkū became such a noted figure that his biography was later included in the Kyoto publication *Biographies of Eccentrics of Recent Times.* It recounts that Enkū took Buddhist vows at an early age but fled from the temple to take up the life of a recluse on Mount Fuji, later making numerous pilgrimages to sacred mountains as far north as Hokkaidō. In ascribing miraculous powers to the images he carved along his route, using a chisel as his only tool, Enkū's biography reflects the identification of unconventional lifestyle with artistic creativity, a belief that became widespread in the late Edo period.

Mokujiki, who was also born to a peasant family, took Buddhist vows at a comparatively late age, and began sculpting only when he was in his sixties. His career as an itinerant monk-sculptor was also inextricably tied up with his religious practices. The name Mokujiki, literally "one who eats wood," suggests that he followed an extremely rigorous form of Shūgendō asceticism involving subsistence only on wild fruits and vegetables, although it might possibly refer also to his prodigious sculptural activities. Mokujiki, like Enkū before him, left a nationwide trail of carvings, some created as expressions of personal piety, others in response to commissions. Mokujiki's sculptural style is marked by a soothingly rhythmic, rounded treatment of forms and drapery that is in sharp contrast to Enkū's raw, angular style (FIG. 103).

Monks of the Rinzai school of Zen were especially active in provincial regions, and many of them used painting and calligraphy to aid their followers. For the most part, these self-trained artists painted in ink monochrome, infusing their work with a spiritual conviction and an idiosyncratic touch absent in the more conventional religious paintings of their professional lay counterparts. The unpretentious subject-matter, economy of means, and self-consciously unstudied qualities of such paintings, which are now known as Zenga ("Zen pictures") have much in common with *haiga*, the mode of painting associated with *haikai*.

Hakuin Ekaku (1686-1769) was exceptionally inventive in his use of the visual arts to explain his teachings, and in so doing was instrumental in extending the Rinzai sect's popular following. A monk of modest background, Hakuin was born in Hara, one of the post stations on the Tōkaidō Road, and remained in the Kantō until 1718, when he went for a brief and apparently unsatisfactory period of study in Kyoto. Thereafter, he led a peripatetic

103. MOKUJIKI (1718-1810) *Fudō Myōo*, 1789. Wood, height 30" (75.6 cm). Japan Folk Crafts Museum, Tokyo.

Mokujiki carved this image relatively early in his career while staying at the Hyūga Kokubunji, a temple in Kyushu. His rendering of this Buddhist deity is unconventional: iconographic tradition prescribed that Fudō should hold a noose in one hand, a sword in the other, and be surrounded by a flaming halo.

life, travelling widely throughout Japan and returning only periodically to his home temple, Shōinji, in Hara. Although he painted traditional Zen themes such as portraits of Bodhidharma (Jap.: Daruma), the founder of the Zen sect, and of Avalokiteshvara (Jap.: Kannon), the *bodhisattva* of compassion, he also created humorous pictures, caricatures, and parables to serve as visual sermons for his followers.

Typical of his work is *Blind Men Crossing a Bridge* (FIG. 104), a theme of his own invention, the power of which is rooted in its union of the specific and universal. The setting is a narrow log bridge spanning the Kanō River near the Shōinji, but the silhouetted forms of the blind travelers feeling their way across the chasm suggests the difficulty of the route to enlightenment. This theme is echoed in the poem inscribed in Hakuin's spidery script:

> Both inner life and the floating world outside us
> Are like the blind men's round log bridge –
> A mind that can cross over is the best guide.
>
> *(Translation by Stephen Addiss)*

Although the feudal government restricted travel for pleasure or sightseeing, generally it did not refuse permission to visit shrines and temples or healing hot springs. Consequently pilgrimage, or sightseeing under the pretext of pilgrimage, became so popular that the authorities in many domains issued edicts stipulating on which days, for how long, and how often people could travel. Publishers in Kyoto, Osaka, and Edo catered to pilgrims by issuing maps and illustrated guidebooks highlighting the sacred poetic and historic sites throughout the country. With the growth of pilgrimages, the areas in the vicinity of popular shrines and temples developed flourishing commercial districts offering food, lodging, and entertainment, as well as religious objects including devotional imagery. Small painting workshops also

sprang up in the towns and villages along the major routes to supply pilgrims with souvenirs.

In Ōtsu, a village on the shores of Lake Biwa that was the last station on the Tōkaidō before Kyoto, families specialized in simple paintings and hand-colored prints, which the wayfarer could easily carry home as souvenirs and protective talismans. Religious subjects predominated in the earliest examples of Ōtsue

105. ANONYMOUS *Halberd-bearer (yaro)*, c. 1685. Ōtsue ("Ōtsu picture"), ink and colors on paper, 12³/₄ x 9¹/₂" (32.5 x 23.8 cm). Geyger Collection, Germany.

("Ōtsu pictures"), but by the eighteenth century the repertory had expanded to include a wide range of secular subjects as well (FIG. 105). The unflattering portrayal of a bombastic, halberd-bearing, feudal retainer, who led the daimyo processions, reflects the unpopularity of these men, before whom commoners had to prostrate themselves as a sign of respect. The enduring popularity of and many literary references to *Ōtsue* during the Edo period suggest that urban sophisticates appreciated these inexpensive pictures as refreshing alternatives to the works available in the cities.

The most popular pilgrimage destinations drew visitors from cities, towns, and villages throughout the country. These included Mount Fuji, the temples Zenkōji (modern Nagano Prefecture) and Shinshōji (Chiba Prefecture) and above all, Ise Shrine (Mie Prefecture. Ise, a Shinto shrine devoted to Amaterasu Omikami, the ancestral god of the imperial family, was first opened to public worship in the fifteenth century when financial support from the imperial family declined. To raise funds and attract pilgrims, monks and nuns traveled about the country praising the efficacy of prayers at Ise, using paintings depicting the shrine thronged with pilgrims as visual aids in their sermons (FIG. 106). So successful were their efforts that in 1563 and 1585 the Inner and Outer Shrines were reconstructed largely through popular contributions.

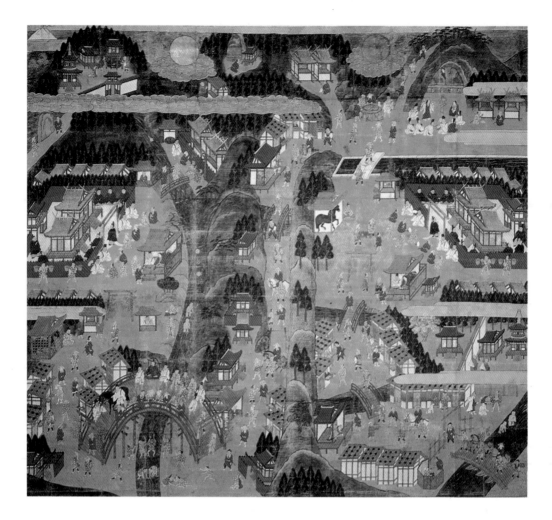

In the Edo period, popular pilgrimages to Ise to pray for abundant crops or personal well-being mushroomed as a result of expanding membership in religious confraternities organized by itinerant Ise priests. Members of such organizations paid annual dues so that every year a group, chosen by lot, could worship at Ise on their behalf. Ise pilgrimage mandalas often served as the objects of devotion of such groups, whose membership is estimated to have included between eighty and ninety per cent of the nation. Mass pilgrimages (*okage mairi*) occurred periodically over the course of the Edo period, but in 1830 the popularity of Ise was such that more than five million people were swept up in the event.

Until the Edo period, communal observances such as festivals and pilgrimages had been for the most part local and regional affairs. The Ise phenomenon, reinforced by the ideology of the

National Learning movement, and drawing participants from throughout Japan, transcended regional boundaries, signalling the beginning of a unified national cult centered on the worship of the deities associated with the imperial family.

Poet and Literati Painters

Many painters in the tradition of Yosa Buson and Ike Taiga were restless individuals with lives rooted in the city yet drawn for various reasons to life outside it. When they traveled, it was not usually with a particular destination in mind but rather because the sense of dislocation and flux thus engendered was conducive to self-discovery and enhanced creativity. Travel also offered opportunities to satisfy the yearning to learn more about Japan and to establish or expand a network of patrons. The ranks of peripatetic poet and literati painters swelled dramatically in the nineteenth century, as the number of unemployed samurai skilled in the arts increased and artistic competition in the city intensified.

Poetic consciousness was central to patterns of travel in the Edo period, and many artists of both religious and secular backgrounds followed the footsteps of literary wayfarers of earlier times. The places visited by the tenth-century courtier-in-exile Ariwara no Narihira, which were described in the prose and poems of the *Tales of Ise*, exerted a strong attraction (see FIGS 41 and 42). So too did those celebrated in the poetry of the twelfth-century monk-poet Saigyō, whose life and travels were often alluded to in Kabuki drama (see FIG. 90). The most powerful stimulus by far, however, was Matsuo Bashō's *The Narrow Road to the Deep North* (*Oku no hosomichi*), an account of his travels through northern and western Japan. Bashō's poetic diary of the first six months of this journey, which began in 1689 and lasted more than two-and-a-half years, is a rich tapestry of image and emotion, recollection and observation. Unlike his predecessors, Bashō did not employ the classical *waka* form but rather the newer *haikai*. His verses also differ in their celebration of even the most humble and unwelcome aspects of travel, such as fleas and lice.

Bashō's followers were on the whole less concerned with objective fidelity in recording the physical world than in using the seasons and places they visited to convey their own mental images and emotional states. The scenes illustrated (FIG. 107 and see FIG. 98, page 149) evoke the following passage from Bashō's poetic diary:

106. ANONYMOUS
Ise Pilgrimage Mandala, late sixteenth century. Hanging scroll, ink and colors on paper, 3'4" x 5'11" (1 x 1.8 m). Jingū Chōkokan, Ise, Mie Prefecture.

This painting helped devotees prepare for or recall their own pilgrimage by depicting with map-like precision the location of the main buildings of the Inner and Outer Shrines at Ise, the routes leading to them, and pilgrims engaged in the different ritual purifications required at various stages along the way. Similar compositions continued to be painted throughout the Edo period.

107. YOSA BUSON (1716-83)
The Narrow Road to the Deep North, 1778 (detail). Handscroll, ink and colors on paper, height 11½″ (29 cm). National Museum, Kyoto.

Handscrolls are read from right to left. In this section, the scene of three friends seeing the elderly poet (with staff in hand) and his companion off on their long journey is followed by a passage from Bashō's text.

As I was landing at a place called Senju my heart was burdened by the thought of the many miles stretching ahead, and my tears fell over such a parting on the illusory path of this world.

> With spring leaving
> The birds cry out regret, the fish
> Have tears in their eyes

That poem marked the beginning of the pilgrimage, but it was difficult to set forth. There were all my friends gathered to see me off and apparently prepared to stand there till they saw the last of my back vanish down the road.

(Translation by Earl Miner)

Buson, who studied under a Bashō disciple, was one of many who retraced Bashō's route into the north, later creating many paintings inspired by his journey. The long handscroll format is particularly well suited to this subject since it enables viewers to re-enact in their imagination the passage of time and space of the original journey. The juxtaposition of passages from Bashō's diary with the sketchy portrayal of the poet and his companion reflects the harmonious accommodation of word and image that distinguishes *haiga*.

Although Taiga was also inspired to visit places celebrated in Bashō's poetic diary, and even kept a personal diary of his own journey to the three peaks of Hakusan, Tateyama, and Mount Fuji, his sense of place differed considerably from that of the poet-painters in Buson's circle. His many views of Mount Fuji and Mount Asama, for instance, communicate the exhilaration

of exploration and discovery and a keen sense of curiosity about his physical surroundings. Although the representation of scenic landmarks (*meisho*) celebrated in literature had a long tradition in Japanese painting until Taiga's day, the multiple layers of historical and literary associations they evoked had overshadowed interest in their visible reality. Taiga's personal fusion of these two seemingly incompatible subjective and objective modes of visualizing place marked the emergence of a new and influential genre of painting called "true view pictures" (*shinkei-zu*).

Like their metropolitan counterparts, many men and women living in provincial towns and villages sought self-cultivation through forms of literary and pictorial expression associated with Chinese culture. Literati artists served this yearning by traveling about the countryside, offering instruction to merchants, farmers, and rural samurai in exchange for food, lodging, and recompense, a practise known as *bunjin bokkyaku* (literally "literati ink guest"). They made especially rapid inroads in small towns and villages in the Kansai region and along the Inland Sea, where the development of industry and artisanal activity had brought great prosperity and with it the leisure to enjoy cultural pursuits.

Uragami Gyokudō, Rai San'yō, and Tanomura Chikuden were all active in this region. All were estranged from official culture yet no doubt beneficiaries of their former status within it. Gyokudō made a living chiefly by offering instruction in the *qin*, a stringed instrument, mastery of which was considered one of the four gentlemanly accomplishments. San'yō relied on his skills as a scholar and poet as well as a painter and calligrapher. So too did Chikuden, who was often his travel companion.

Chikuden, who came from a distinguished family of hereditary physicians in northern Kyushu, resigned his position as head of the clan school in 1811, after his proposals for local administrative reforms were rejected. Thereafter he spent much of his time in the Kansai area, where he developed his artistic skills through contacts with other literati, most notably Okada Beisanjin. His scholarly interests are reflected in his treatises on painting, which include assessments of the work of fellow literati as well as pointed criticism of that of rival schools.

Many of Chikuden's paintings incorporate visual allusions to his travels along the Inland Sea. Scenes of rivers, both in stormy and calm weather, are ubiquitous. Two works painted in the intimate album format, *Scenes from a Boat Window*, a record of a trip he made in 1829, and *Yet One More Pleasure*, a record of one made in 1831-32, are unusually evocative. The tranquil, idyllic scene in a leaf from the latter reproduced here reveals the lyricism

characteristic of Chikuden's finest work (FIG. 108). Executed in ink using careful, repeated applications of a dry brush, enhanced by the application of light colors, the portrayal of a solitary figure playing the flute by moonlight embodies the eremitic ideal that he shared with his fellow literati. Like each of the thirteen paintings in the album, it bears an inscription by the artist concluding with the phrase "and this is yet one more pleasure."

The genesis of this album offers telling insights into the importance literati artists attributed to personal relationships. The album, originally containing ten leaves, was commissioned by an Osaka doctor and collector. Before turning the album over to him, however, Chikuden showed it to San'yō, who so admired it that he wanted it himself. Chikuden acquiesced, adding three more paintings for his friend as well as an account of the affair. His patron was offered another album.

By the mid-nineteenth century, the wanderings of Buson, Taiga, and their followers had gained *haiga* and Bunjinga a wide following, especially in towns and villages in western Japan but also in the Kantō. The popularity of these art forms, both of which combined verbal and visual components, served as a catalyst for the formation of countless provincial cultural coteries comparable to those in urban centers. The diffusion of the aesthetics of *haiga* and Bunjinga brought about a blurring of the cultural boundaries between city and country.

Provincial and Rural Artists

In the seventeenth century, when the Japanese population was roughly thirty million, of whom eighty per cent were peasants, rice cultivation was the backbone of the national economy. To prevent peasants from becoming corrupted by the money economy that ruled urban life, the government restricted their movement and contact with city dwellers. By the eighteenth century, however, crop diversification, increased productivity, land reclamation, and, above all, the development of cash crops and artisanal activity had profoundly altered the character of rural life.

This trend was accelerated by feudal lords who recognized the benefits of economic diversification. To promote development of regional crafts in their castle towns and surrounding areas, many hired specialists in painting, lacquer, textiles, and ceramics to instruct local artisans in the latest styles and techniques. Growing contact with urban artists and merchants and the resulting mutual currents of influence fostered national cultural homogeneity, even as it intensified regional cultural pride.

水天髣髴之 蒼波
舟之 月上 和上
不知方 下 世音
屇 返 六 一樂

Sericulture was an important source of income for many farm families, wherever mulberry trees on which to feed silkworms could grow, both in the Kansai and the Kantō. During the seventeenth century, craftsmen in Kyoto's Nishijin district had a monopoly on the production of the sumptuous fabrics for the court and feudal elite. After 1730, when 3000 of the Nishijin districts' estimated 7000 looms were destroyed by fire, however, silk-spinning and -weaving flourished in many regions, often under the patronage of local daimyo. In the Kantō, Kiryū (in modern Gunma Prefecture) and Ashikaga (Tochigi Prefecture) became especially noted for their luxury silks.

The development and diffusion in the late seventeenth century of new techniques for decorating textiles gave a boost to silk production throughout the country. Chief among these was a sophisticated method of paste-resist dyeing known as *yūzen* after Miyazaki Yūzensai, a Kyoto fan-painter whose intricate textile

108. TANOMURA CHIKUDEN (1777-1835) *Yet One More Pleasure* (*Mata mata ichiraku*), c. 1832. Album leaf, ink and colors on paper, 8 x 9" (20 x 23 cm). Neiraku Museum, Nara.

109. TAKE HIRATSUGI
Yūzen Dyeing, from *A
Picture-book of Kimono
Patterns* (*Ehon kimono no
moyo*), 1690. Woodblock-
printed book, 7³/₄ x 6″ (20 x
15 cm). British Museum,
London.

Pictures of professionals at
work had a long tradition in
Japanese art. Here a *yūzen*
artist decorates textiles by
brushing on the various
colored dyes, while his
assistant stretches out dyed
and washed cloth to dry.

designs were the rage in the Genroku era (1688-
1704). In *yūzen* dyeing, rice-paste resist is used
for fine outlining and dyes are applied with a
brush, enabling the creation of extremely com-
plex pictorial designs (FIG. 109). This technique
was used alone and in combination with tie-
dyeing and embroidery to create especially strik-
ing compositions (see FIG. 14). Unlike tradi-
tional textile techniques, which remained
closely held family secrets, Yūzensai's tech-
nique and designs were rapidly diffused
through printed books, the earliest of which
was published by a student in 1688. Within a
century, intricately patterned and richly col-
ored *yūzen*-style fabrics had become a special-
ity of Kanazawa, the seat of the Maeda domain.

Both cost and sumptuary laws restricted silken
apparel to members of the court and samurai
elite. While garments made of bast fibers such
as hemp, ramie, jute, and linen, were still
worn by peasants in some regions, over the course of the Edo
period they were gradually replaced by ones made of cotton.
Because it was easier to process and dye, warmer and more com-
fortable than bast fiber, cotton was also in demand in the city.

Cotton was an important crop around Osaka and Kyoto, and
initially the cotton processing industry was concentrated in this
area, but demand gradually led to efforts to grow, weave, and dye
it elsewhere as well. Despite the fact that cotton requires a warm
climate and rich, heavily fertilized soil, by the mid-Edo period it
was cultivated and woven throughout Japan except in northern
Honshū and Hokkaidō. By the nineteenth century, shops special-
izing in local textiles had sprung up along many of the major
thoroughfares. Arimatsu-bori, a kind of tie-dyed cotton, was a
local speciality of Narumi, one of the stages on the Tōkaidō
Road. In advertising the availability of this and other regional
specialities in his prints, Hiroshige contributed to both growing
urban demand and awareness of the distinctiveness of provincial
culture.

Of the many methods of dyeing and weaving cotton cloth,
none was as widespread as ikat (*kasuri*), in which the yarn is bun-
dled and pre-dyed in sections to form a predetermined pattern
when woven. Ikat originated in India, was transmitted to South-
east Asia and thence to Japan. The technique is thought to have
been first employed in the Ryūkyū Islands (FIG. 110). After 1611,

when the islands became a vassal state, cotton and bast fiber ikats became much-prized articles in the annual tribute sent to the Tokugawa shoguns in Edo.

Ikat is thought to have been first produced on the Japanese archipelago not in Kyoto or Osaka but in Echigo (modern Niigata Prefecture), on the Japan Sea coast, no doubt because of its situation along the western shipping route. By the mid-Edo period, however, the technique was in widespread use, and nearly every region had developed a distinctive range of colors and patterns. Garments with the distinctive stripes, checks, and other patterns produced using this technique were in great demand among the fashion-conscious people of Edo. Three of the beauties in Kiyonaga's *Enjoying the Cool of the Evening Beside the Sumida River* (see FIG. 57) are wearing robes of this type.

110. Okinawan kimono, nineteenth century. Indigo-dyed cotton with striped ikat pattern, 4'7" x 4'4" (1.4 x 1.3 m). Japan Folk Crafts Museum, Tokyo.

Although farmers and rural craftsmen were involved in the creation of utilitarian lacquer and ceramics, in many areas production of such valuable commodities was implemented by feudal lords for sale or gift-giving in Edo. Outside Kyoto and Edo, the most lavishly decorated lacquer was produced in Kanazawa, the seat of the Maeda domain. In the seventeenth century, Maeda Toshitsune (1593-1658), the third lord of Kaga, invited the lacquerer Igarashi Dōho (d. 1678), whose forebears had served the Ashikaga shoguns, from Kyoto to Kanazawa. A workshop was established and, under Maeda patronage, members of the Igarashi school continued to work there until the end of the Tokugawa period. Writing-boxes attributed to Dōho exhibit a level of technical and aesthetic refinement comparable to that of Kyoto lacquer (FIG. 111). Both the lacquer and textiles produced in Kaga have a strong Kyoto flavor owing to the Maeda's admiration for that city's aristocratic tradition.

In northwestern Kyushu, the availability of fine clays suited for both stoneware and porcelain, and the proximity of ports stimulated the development of ceramics production for both domestic consumption and export. Porcelain production began in the early seventeenth century in two fiefs in the Arita region (modern Saga Prefecture), one ruled by the Nabeshima and the other by the Matsuura. The Nabeshima kilns, carefully supervised by clan officials, were renowned for the high quality of

111. IGARASHI DŌHO
(d. 1678), attr.
Box for writing utensils,
seventeenth century.
Lacquer, metal and mother-
of-pearl on wood, 8⁷/₈ x
9⁵/₈ x 1¹/₄" (22.5 x 24.5
x 4.6 cm). Ishikawa
Prefectural Museum.

The evocative seasonal
decoration on this writing-
box was created by
combining lacquer, sheet
metal, and inlaid mother-of-
pearl, an elaborate
technique characteristic of
the lacquer produced in
Kanazawa.

their porcelain plates and other tablewares painted in overglaze
enamels. The strong pictorial quality of the decoration reflects
the influence of painting manuals or of textile and lacquer design
books (see FIG. 27).

Most Nabeshima wares were made for use by the clan or for
official gift-giving to other daimyo or shoguns. The porcelains
known in the west as Arita or Imari (the latter name comes from
the port where it was shipped), however, were made primarily
for export. Korean ceramic craftsmen brought back to Japan fol-
lowing Hideyoshi's invasion of Korea are credited with the dis-
covery of kaolin clay and development of porcelain production
in Arita (FIG. 112). At first blue-and-white wares predominated in
Arita but, after the 1640s, porcelains with overglaze enamel decor-
ation in a palette of red, green, and yellow were also produced in
several workshops there. Among these is Kakiemon ware, named
after the family credited with developing its enameling tech-
nique. Kakiemon ware, which was made in shapes and sizes
reflecting European tastes, is distinguished by its translucent,
milky-white body and dazzling colors (FIG. 113).

Artistic guidance from urban centers as well as the availabil-
ity of printed manuals and picture-books enabled Arita potters to
alter their forms and decorative schemes to meet changing fash-
ions. In the 1830s and 1840s, potters inspired by the intensified
interest in the world beyond Japan's shores began producing at
the Ōbōyama kilns in Arita large platters decorated with imagi-
native maps of Japan and the world (FIG. 114).

By the time these platters were produced, advances in cartog-
raphy had led to the creation of geographically accurate maps of
Japan and the world. In 1810 Aōdō Denzan (1748-1822), working

under the auspices of Matsudaira Sadanobu, had issued a copper-plate engraving of a map of the two hemispheres based on a European model of 1780. Such maps were not readily available to the public, however. Sightings of Russian and American ships had made the Tokugawa government increasingly uneasy about the threat of foreign invasion. Consequently, access to maps of Japan, and especially its coastline, was restricted.

It was against this backdrop of anxious ambivalence towards the outside world that potters in Arita incorporated world maps into their decorative repertory. That the maps decorating these platters are by no means geographically accurate probably mattered little to those who used them. What did matter was that they combined the familiar islands of Japan and the inhabited world beyond in a manner that was both reassuring and thrilling. The map acknowledged Japan's small scale *vis-à-vis* the rest of the world, but compensated for this by situating the archipelago at the center of the plate, protected by the turbulent seas from the unknown inhabitants of the distant continents.

Map platters give expression to the sensitivity to the reciprocal relationship between people and places that had long been a conspicuous feature of Japanese art. They testify to a new sense of the Japanese archipelago as an entity distinguished by urban centers and transcending domainal boundaries. They also testify to the preoccupation, which would grow more pronounced over the course of the nineteenth century, with the question of Japan's place in the world.

The urbanization of Japan during the Edo period promoted dramatic changes in the aesthetic assumptions and social practices of both artists and their audience. Until the late sixteenth century, art was a realm of experience limited to the privileged few.

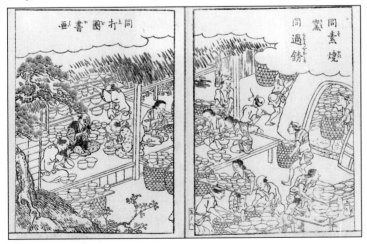

112. ANONYMOUS
Porcelain Production at Arita, from *Pictures of Famous Products from Mountains and Sea* (*Sankai meisan zue*), 1799. Woodblock-printed book, 10¹/₂ x 13¹/₂" (26.9 x 34 cm). British Museum, London.

In this view of a busy pottery, male and female workers are shown involved in various stages of porcelain production. From right to left: they remove pots from the kiln, sort and inspect them, and finally hand-paint each one.

113. Covered porcelain bowl with decoration of birds and flowers, eighteenth century. Arita ware, Kakiemon type, height (with cover) 14$^{1}/_{2}$" (37 cm). The Asia Society, New York.

One of twelve or thirteen kilns in the Arita area specializing in export wares, the Kakiemon kilns made porcelains of the highest quality. Although blue-and-white wares were also produced, Kakiemon wares were especially renowned for their fine white bodies and delicately painted bird-and-flower decoration.

The growth of urban culture had challenged this social monopoly. Through participation in artistic activities of all kinds, men and women proclaimed themselves members of an elite where standing was based on taste and discernment, not birth. Culture thus became the site of competition both within and among cities.

The cultural values of those living in outlying regions were not necessarily in opposition to those prevailing in the city. Indeed, to varying degrees, provincial and rural inhabitants saw themselves as participants in local variations of the same cultural dialogue. As the feudal rule of the Tokugawa shoguns came to an end, urban and regional loyalties were increasingly overshadowed in importance by the growing consciousness of Japan as a national polity. And yet, to a large extent, the unifying values on which this consciousness was based remained dependent on the cultural tastes, perceptions, and attitudes that had developed in Kyoto, Edo, Osaka, and Nagasaki.

114. Platter decorated with map of Japan, 1830-40. Arita blue-and-white ware, diameter 20" (51 cm). Fogg Art Museum, Harvard University, Cambridge, Mass.

Japan figures in the center of this map, with the names of its major cities (Edo, Kyoto, Osaka, and Nagasaki) clearly marked. Beyond the rolling seas to the right are North and South America and, to the left, the Asian continent with Korea, Russia, India, and other regions identified by name. On the periphery are the Countries of Women, of Pygmies, and of Cyclops. The inset gives distances from Japan to selected foreign countries.

GLOSSARY

Aragoto Literally "rough stuff." Flamboyant style of *kabuki* acting developed in the 17th century by Ichikawa Danjūrō.

Bijinga Literally "pictures of beautiful women," usually courtesans.

Bunjinga "Literati painting," often used interchangeably with Nanga ("Southern school painting") to denote work by "amateur" scholar-painters.

Chanoyu Literally "hot water for tea." Japanese tea ceremony.

Chōnin Literally "residents of the block." Townspeople, primarily of the merchant and artisan classes.

Chūban Print size, approximately 10¹/₂ x 8" (27 x 20 cm).

Daimyo Literally "great names." Feudal lords with fief's awarded by the shogun.

Fusuma Interior sliding screens or partitions frequently decorated with paintings.

Haiga Literally "*haikai* picture." Abbreviated style of painting that is the pictorial equivalent of *haikai*.

Haikai Form of linked verse from which modern 17-syllable *haiku* derives.

Jōkamachi Castle town.

Kachōga Bird-and-flower painting.

Kamigata Kyoto-Osaka region, synonymous with Kansai.

Kansai Southwestern part of island of Honshū centering on Kyoto-Osaka and distinguished from Kantō, eastern Japan. The traditional dividing line was the "Osaka Barrier" near Lake Biwa.

Kantō Northeastern part of Honshū centering on Edo (Tokyo).

Kosode Literally "small sleeved." Unfitted garment worn by both men and women in the Edo period.

Kyōka Literally "crazy verse." Thirty-one-syllable poems that parody classical *waka*.

Machi eshi Town painter.

Meishoe Picture of scenic place(s) made famous through literature.

Mitate Pictorial device in which contemporary "equivalent" is substituted for classical subject-matter; travesty, parody.

Ōban Print size, approximately 15 x 10" (39 x 26 cm).

Onnagata Male actor specializing in female roles.

Rakuchū rakugai-zu "Views in and around the capital." Panoramic view of Kyoto and its environs.

Rangaku Literally "Dutch studies." Study of Western natural sciences.

Sencha Steeped tea. Chinese-style tea ceremony favored by literati.

Shoin Literally "book hall" or "study." Normative style of residential architecture in the Edo period, characterized by *tatami* mats, picture alcove (*tokonoma*), and staggered shelves.

Shokunin Artisans, craftsmen. One of the four classes in the social hierarchy under the Tokugawa.

Sui Urbane, chic, elegant. Kansai counterpart of *tsū*.

Surimono Literally "printed thing." Privately commissioned print(s) for use as gifts, announcements, and mementoes of special occasions.

Tokonoma Alcove for displaying hanging scrolls and other *objets d'art*.

Tsū Literally "conversant with." Urbane, elegant, chic, the Edo counterpart of *sui*.

Ukiyoe Literally "pictures of the floating world," chiefly paintings and prints representing the theater and pleasure quarters in Edo.

Wagoto Literally "soft stuff." Style of acting developed in the Kyoto-Osaka area associated with sentimental dramas and domestic tragedies.

Waka Thirty-one-syllable poem first popular among aristocrats of the Heian period.

Yamatoe Literally "pictures of Japan," chiefly narrative picture scrolls and screens of the Heian and Kamakura periods focusing on native Japanese themes.

Zenga Literally "Zen picture." Used chiefly to denote painting and calligraphy by Zen monks, often rendered in an expressive manner.

	Kyoto	Edo
1600	**1615** Hon'ami Kōetsu to Takagamine **1620** Construction of Katsura Imperial Villa begins **1626** Construction of Ninomaru Palace begins **1637** Hon'ami Kōetsu dies **1643** Tawaraya Sōtatsu dies	**1603** Tokugawa Ieyasu becomes shogun with Edo as his headquarters **1616** Ieyasu dies **1621** Kano Tan'yū appointed oku eshi ("inner artist") **1629** Prohibition of female *kabuki* performers **1633-39** Five national seclusion (Sakoku) edicts issued **1634** Sankin kōtai ("alternate residence") begins
1650	**1651** Kano Sansetsu dies **1660s-70s** Construction of Shūgakuin begins **1662** Founding of Manpukuji **1678** Publication of *Honchō gashi*	**1650** Iwasa Matabei dies **1657** Great Edo fire **1674** Kano Tan'yū dies **1683** Gukei appointed *oku eshi* **1694** Matsuo Bashō dies Hishikawa Moronobu dies
1700	**1716** Ogata Kōrin dies **1730** Fire destroys Nishijin district, center of fabrics production **1743** Ogata Kenzan dies **1748** Publication of *Kaishien gaden* (first volume)	**1713** Kano Tsunenobu dies **1714** Kaigetsudō Ando dies **1716** Kyōhō Reforms, 1716-36 **1724** Hanabusa Itchō dies **1729** Torii Kiyonobu dies
1750	**1776** Ike Taiga dies **1781** Soga Shōhaku dies **1783** Yosa Buson dies **1788** Great Kyoto fire **1789-90** Reconstruction of imperial palace **1790** Publication of *Kinsei kijinden* **1792** First Higashiyama Exhibition **1795** Maruyama Ōkyo dies **1799** Nagasawa Rosetsu dies	**1764** Okumura Masanobu dies **c.1765** First nishikie (polychrome prints) issued **1770** Suzuki Harunobu dies **1780** Hiraga Gennai dies **1789** Kansei era Reforms (1789-1801) **1792** Katsukawa Shunshō dies **1797** Tsutaya Jūsaburō dies
1800	**1800** Itō Jakuchū dies **1811** Matsumura Goshun dies Rai San'yō settles in Kyoto **1820** Uragami Gyokudō dies **1832** Rai San'yō dies **1833** Aoki Mokubei dies	**1806** Kitagawa Utamaro dies **1815** Torii Kiyonaga dies **1818** Shiba Kōkan dies **1825** Utagawa Toyokuni dies **1828** Sakai Hōitsu dies **1840** Tani Bunchō dies **1841** Tenpō Reforms (1841-43) Watanabe Kazan dies **1846** Kano Seisen'in dies **1849** Katsushika Hokusai dies
1850+	**1854-55** Imperial palace rebuilt **1859** Ukita Ikkei dies	**1853** Arrival of US Admiral Perry **1855** Great earthquake **1858** Andō Hiroshige dies **1861** Utagawa Kuniyoshi dies **1865** Utagawa Kunisada dies **1867** Emperor Meiji (Mutsuhito) ascends throne **1868** Edo renamed Tokyo Beginning of Meiji period

Osaka & Nagasaki	Other Cities & Provinces
1612 Prohibition of Christianity **1615** Osaka Castle destroyed **1634** Deshima island built in Nagasaki harbor for Dutch traders **1641** National seclusion policy enacted, foreign trade restricted to Dutch and Chinese at Nagasaki	**1610** Construction of Nagoya Castle begins **1611** Ryūkyū begins sending tribute to shogunate **1637** Iwasa Matabei summoned to Echizen by Matsudaira Tadanao
1654 Yinyuan, founder of Ōbaku sect of Zen Buddhism, arrives in Nagasaki **1683** Ihara Saikaku dies **1691** Asai Ryōi dies	**1650** Matsudaira Tadanao, daimyo of Echizen dies **1658** Maeda Toshitsune, daimyo of Kaga dies **1658-59** First European orders for Arita porcelain **1678** Lacquerer Igarashi Dōho dies **1680s** Production of Kakiemon ceramics begins **1689** Matsuo Bashō's journey to north **1695** Enkū dies
1724 Kaitokudō founded **1725** Chikamatsu Monzaemon dies **1731-32** Shen Quan (Nanpin) in Nagasaki **1740** Sō Shiseki to Nagasaki	**c.1720** Production of Yūzen textiles begins in Kaga
1752 Hiraga Gennai to Nagasaki **1763** Painter and teacher Ōoka Shinboku dies **1788-89** Shiba Kōkan to Osaka and Nagasaki **c.1796** Tani Bunchō, Aoki Mokubei & Uragami Gyokudō visit Kimura Kenkadō	**1760** Ike Taiga's journey to three peaks **1769** Hakuin Ekaku dies **1780** Odano Naotake dies **1786** Satake Shozan dies **1789** Mokujiki in Kyushu
1802 Kimura Kenkadō dies **1813** Mori Sōsen dies **1820** Okada Beisanjin dies **1823-29** von Siebold in Nagasaki **1825** Onoe Kikugorō III arrives in Osaka **c.1836** Shunkōsei Hokuei dies **1847** Kikugorō retires; resumes career as Ōkawa Hachizō	**1810** Mokujiki dies **1812** Katsushika Hokusai to Nagoya **1820s-30s** Chikuden's travels **1830** Great Ise pilgrimage **1832** Andō Hiroshige on Tōkaidō Road **1834** Tanomura Chikuden dies
1859 Kanazawa, Nagasaki, Hakodate opened to foreign trade **1860** Kawahara Keiga dies **c.1865** Gosōtei Hirosada dies	**1859** Yokohama port opened

Bibliography

ADDISS, S., *The Art of Zen* (New York: Abrams, 1989)★

—, *Tall Mountains and Flowing Waters: The Arts of Uragami Gyokudō* (Honolulu: University of Hawaii Press, 1987)

BELLAH, R., *Tokugawa Japan: The Cultural Roots of Modern Japan* (New York: The Free Press, 1985)

BERRY, M. E., *The Culture of Civil War in Kyoto* (Berkeley: University of California Press, 1994)

CAHILL, J., *Scholar Painters of Japan: The Nanga School* (New York: Asia Society Galleries, 1972)

CLARK, T., AND O. UEDA, *The Actor's Image: Print Makers of the Katsukawa School* (Princeton: Princeton University Press in association with the Chicago Art Institute, 1994)

FRENCH, C., *Shiba Kōkan: Artist Innovator and Pioneer in the Westernization of Japan* (New York and Tokyo: Weatherhill, 1974)

—, *Through Closed Doors: Western Influence on Japanese Art, 1639-1853* (Rochester, Mich.: Oakland University, 1977)

FRIEDMAN, M. (ed.), *Tokyo Form and Spirit* (Minneapolis, Minn.: Walker Art Center; and New York: Abrams, 1986)

GLUCKMAN, D. C., AND S. S. TAKEDA, *When Art Became Fashion: Kosode in Edo Period Japan* (exh. cat.; Los Angeles, Cal.: Los Angeles County Museum of Art, 1992)

HALL, J. (ed.), *The Cambridge History of Japan,* vol 4: *Early Modern Japan* (Cambridge/ New York: Cambridge University Press, 1991)

HASHIMOTO, F., *Architecture in the Shoin Style: Japanese Feudal Residences* (trans. and adapted by H. M. Horton; Tokyo, New York and San Francisco: Kodansha, 1981)

HAUGE, V., AND T., *Folk Traditions in Japanese Art* (exh. cat.; Washington, D.C.: International Exhibitions Foundation, 1978)

HICKMAN, M. L., 'Views of the Floating World,' *Museum of Fine Arts Bulletin*, 76 (1978): 4-33★

HICKMAN, M. L., AND Y. SATŌ, *The Paintings of Jakuchū* (New York: Asia Society Galleries, 1989)

HIBBETT, H., *The Floating World in Japanese Fiction* (Rutland, Vt., and Tokyo: Tuttle, 1975)

HILLIER, J., *The Art of the Japanese Book* (2 vols; New York: Sotheby's Publications, 1987)

JANSEN, M. (ed.), *The Cambridge History of Japan,* vol 5: *The Nineteenth Century* (Cambridge/New York: Cambridge University Press, 1989)

JENKINS, D. (ed.), *The Floating World Revisited* (Portland, Ore.: Portland Museum of Art, 1993)

KAEMPFER, E., *The History of Japan* (3 vols: Glasgow, 1906)★

KEYES, R., AND K. MIZUSHIMA, *The Theatrical World of Osaka Prints* (Philadelphia: Philadelphia Museum of Art, 1973)

LANE, R., *Images from the Floating World* (New York: G.P. Putnam and Sons, 1978)

—, *Hokusai: His Life and Work* (London: Barrie and Jenkins, 1989)

MASON, P., *History of Japanese Art* (New York: Abrams, 1993)

MINER, E., *Japanese Poetic Dictionaries* (Berkeley and Los Angeles, University of California Press, 1969)★

MURASE, M., *Japanese Art: Selections from the Mary and Jackson Burke Collection* (New York: The Metropolitan Museum of Art, 1975)

NAKANE, C., AND S. ŌISHI (eds), *Tokugawa Japan: The Social and Economic Antecedents of Modern Japan* (Tokyo: University of Tokyo Press, 1990)

PONS, P., *D'Edo à Tokyo: Mémoires et Modernités* (Paris: Editions Gallimard, 1988)

RATHBUN, W. J. (ed.), *Beyond the Tanabata Bridge: Traditional Japanese Textiles* (London: Thames and Hudson in association with Seattle Art Museum, 1993)

ROSENFIELD, J. M., AND S. SHIMADA, *Traditions of Japanese Art: Selections from the Kimiko and John Powers Collection* (Cambridge, Mass.: Fogg Art Museum, Harvard University, 1970)

SANSOM, G., *A History of Japan, 1615-1867* (Stanford, Cal.: Stanford University Press, 1963)

—, *The Western World and Japan* (New York: Knopf, 1951)

SASAKI, J., *Ōkyo and the Maruyama-Shijō School of Japanese Painting* (St Louis, Mo.: St Louis Art Museum, 1980)

SHIMIZU, Y. (ed.), *Japan: The Shaping of Daimyo Culture: Japanese Art 1185-1868* (Washington, D.C.: The National Gallery, 1988)

SHIMIZU, Y., AND J. ROSENFIELD, *Masters of Japanese Calligraphy: 8th-19th Century* (exh. cat., NewYork: Japan House Gallery and Asia Society Galleries, 1984-85)

SHIVELY, D., 'Sumptuary Regulations and Status in Early Tokugawa Japan,' *Harvard Journal of Asiatic Studies*, 25 (1965): 123-64★

TAKEUCHI, M., *Taiga's True Views: The Language of Landscape Painting in Eighteenth-Century Japan* (Stanford, Cal.: Stanford University Press, 1992)

THOMPSON, S.E., AND H.D. HAROOTUNIAN, *Under-currents in the Floating World: Censorship and Japanese Prints* (New York: Asia Society Galleries, 1991)

WATSON, W. (ed.), *The Great Japan Exhibition: Art of the Edo Period 1600-1868* (exh. cat.; London: Royal Academy of Arts, 1981)

WHEELWRIGHT, C. (ed.), *Word in Flower: The Visualization of Classical Literature in Seventeenth-Century Japan* (New Haven, Conn., Yale University Art Museum, 1989)

WILSON, R., *The Art of Ogata Kenzan: Persona and Production in Japanese Ceramics* (New York and Tokyo: Weatherhill, 1991)

YAZAKI, T., *Social Change and the City in Japan* (trans. by D. L. Swain; Tokyo: Japan Publications, 1968)

Picture Credits

Unless otherwise stated, museums have supplied their own photographic material. Supplementary and copyright information is given below. Numbers to the left refer to figure numbers unless otherwise indicated.

Title pages: see page 91
page 9 detail of figure 3
2 © British Museum
6 © British Museum
page 21, detail of figure 20
9 Spectrum Colour Library, London
10 Werner Forman, London
11 National Museum of Ethnology, Leiden, the Netherlands. Collected by Philipp Franz von Siebold between 1823 and 1829.
13 © British Museum
15 Courtesy Eskenazi Ltd (Oriental Art), London
16 Courtesy Christie's, New York
18 photo Carl Nardiello, New York
22 National Museum of Ethnology, Leiden, the Netherlands. Collected by Philipp Franz von Siebold between 1823 and 1829.
24 Courtesy of the Arthur M. Sackler Museum, Harvard University Art Museums, Bequest of the Hofer Collection of the Arts of Asia
page 51 detail of figure 46, Trustees of the Victoria & Albert Museum, London # c.1324-1910 (Salting Bequest)
31 Spectrum Colour Library, London
32 Wim Swaan, New York
33 Courtesy Bruce Coats, California
34 The Metropolitan Museum of Art, New York, The Harry G.C. Packard Collection of Asian Art, Gift of Harry G.C. Packard and Purchase, Fletcher, Rogers, Harris Brisbane Dick and Louis V. Bell Funds, Joseph Pulitzer Bequest and The Annenberg Fund, Inc. Gift, 1975 (1975.268.48)
35 The Art Museum, Princeton University. Museum purchase, gift of William R. McAlpin
36 Photo by Gakken Co. Ltd
37 The New York Public Library, Astor, Lennox and Tilden Foundations
39 Freer Gallery of Art, Smithsonian Institution, Washington D.C. # 06.231/06.232
41 Freer Gallery of Art, Smithsonian Institution, Washington D.C. # 03.1
42 Freer Gallery of Art, Smithsonian Institution, Washington D.C. # 07.84

43, 44, 45 photography by Carl Nardiello, New York
46 Trustees of the Victoria & Albert Museum, London # c.1324-1910 (Salting Bequest)
51 Museum of Fine Arts, Boston, Fenollosa-Weld Collection, # 11.4513.4
52 Collection of Etsuko and Joe Price; photo courtesy Los Angeles County Museum of Art
53 The Metropolitan Museum of Art, New York, Rogers Fund, 1957 (57.156.7)
54 © British Museum
page 89, detail of figure 74, © British Museum
57 © British Museum
63 Honolulu Academy of Art, The James A. Michener Collection # HAA 21,638
68, 69, 70, 71 © British Museum
72 Collection of the Grunwald Center for the Graphic Arts, University of California, Los Angeles. Purchased from the Frank Lloyd Wright Collection.
73, 74, 76 © British Museum
77 Courtesy Christie's, New York
78 © British Museum
79 Freer Gallery of Art, Smithsonian Institution, Washington D.C. # 70.22
80 © British Museum
82 The Cleveland Museum of Art. Purchase, Leonard C. Hanna Jr. Bequest
page 127 detail of figure 94
84, 85 © British Museum
90 Trustees of the Victoria & Albert Museum, London # E 3873 1916
91 Trustees of the Victoria & Albert Museum, London # E.5516 1886
95 ©British Museum
97 The Museum Yamato Bunkakan, Nara; photo: Seiji Shirono
page 149 detail of figure 101, © British Museum
99 Sackler Gallery, Smithsonian Institution, Washington D.C. # S1985.1, Smithsonian; photo: John Tsantes
100 Wim Swaan, New York
101 © British Museum
107 Photo factory Mihara, Kyoto
109 © British Museum
111 Courtesy of the Ishikawa Prefectural Museum of Art, Cultural Property designated by Ishkawa Prefecture
112 © British Museum
113 The Asia Society, New York: Mr. and Mrs. John D. Rockefeller 3rd Collection 1979.234 a,b
114 Courtesy Harvard University Art Museums, Gift of Philip Hofer 1984.494

Index